"Ken Foster has given us an expansive 'why-to' book. It's a call to action to become proactive practitioners of social change, to be energized by challenges, and to forge the future of arts leadership with a renewed sense of purpose."
— *Dan Froot*, Performance Artist and Professor of Creative Process and Business of the Arts, UCLA, USA

"Arts Leadership: Creating Sustainable Arts Organizations is a thoughtful, comprehensive, and inspiring new book that offers valuable insights and perspective about the arts, arts makers, and leadership. Kenneth Foster's experience and wisdom as an arts leader informs and shapes ways of doing and thinking about leadership and running organizations that is practical and draws its power from the creative process."
— *William J. Byrnes*, author of *Management and the Arts*, USA

Arts Leadership

The contemporary world faces unprecedented upheaval and change forcing institutions of all types to rethink how they are designed and how they must now function if they are to survive into an uncertain future. The performing arts are no exception; in an era of constant change and technological transformation, arts organizations and their leaders face significant organizational challenges if they are to maintain their relevance.

Arts Leadership: Creating Sustainable Arts Organizations provides a contemporary overview of the field of arts leadership, focused on the performing arts. It examines what these challenges are, how they are affecting the performing arts and arts organizations in general and proposes creative ways to reimagine, build and lead sustainable arts organizations in an uncharted environment. With a global perspective drawn from his extensive experience advising arts organizations around the world and based on his own work successfully leading important performing arts organizations in the United States, Foster proposes an innovative approach to organizational design, systems and structures for arts leaders in the 21st century that is based in ecological thinking and the creative process that is intrinsic to the arts.

In disrupting conventional arts leadership practice, the book provides an exceptional tool to understand a unique sector, and is essential reading for students and practitioners across the creative and cultural industries.

Kenneth Foster has more than 30 years experience as an arts organization leader. He is currently Director of Arts Leadership at the University of Southern California. His first book, *Performing Arts Presenting; From Theory to Practice* was published in 2007.

Mastering Management in the Creative and Cultural Industries
Edited by Ruth Rentschler

Creative and cultural industries account for a significant share of the global economy and working in these sectors is proving increasingly popular for graduates across a wide array of educational institutions. Business and Management skills are a vital part of the future of these sectors, and there are a growing number of degree schemes reflecting this.

This series provides a range of relatively short textbooks covering all the key business and management themes of interest within the creative and cultural industries. With consistent production quality, pedagogical features and writing style, each book provides essential reading for a core unit of any arts / cultural management or creative industries degree and the series as a whole provides a comprehensive resource for those studying in this field.

Entrepreneurship for the Creative and Cultural Industries
Bonita M. Kolb

Marketing Strategy for the Creative and Cultural Industries
Bonita M. Kolb

Strategic Analysis: A creative and cultural industries perspective
Jonathan Gander

Managing Organizations in the Creative Economy: Organizational Behaviour for the Cultural Sector
Paul Saintilan, David Schreiber

Visual Arts Management
Jeffrey Taylor

Artist Management: Agility in the Creative and Cultural Industries
Guy Morrow

Arts Leadership: Creating Sustainable Arts Organizations
Kenneth Foster

Arts Leadership
Creating Sustainable Arts Organizations

Kenneth Foster

LONDON AND NEW YORK

First published 2018
by Routledge
2 Park Square, Milton Park, Abingdon, Oxon OX14 4RN

and by Routledge
711 Third Avenue, New York, NY 10017

Routledge is an imprint of the Taylor & Francis Group, an informa business

© 2018 Kenneth Foster

The right of Kenneth Foster to be identified as author of this work has been asserted by him in accordance with sections 77 and 78 of the Copyright, Designs and Patents Act 1988.

All rights reserved. No part of this book may be reprinted or reproduced or utilised in any form or by any electronic, mechanical, or other means, now known or hereafter invented, including photocopying and recording, or in any information storage or retrieval system, without permission in writing from the publishers.

Trademark notice: Product or corporate names may be trademarks or registered trademarks, and are used only for identification and explanation without intent to infringe.

British Library Cataloguing in Publication Data
A catalogue record for this book is available from the British Library

Library of Congress Cataloging in Publication Data
Names: Foster, Kenneth J., author.
Title: Arts leadership : creating sustainable arts organizations / Kenneth Foster.
Description: New York : Routledge, 2018. | Series: Mastering management in the creative & cultural industries | Includes bibliographical references and index.
Identifiers: LCCN 2017058578 | ISBN 9781138740211 (hardback) | ISBN 9781138740297 (pbk.) | ISBN 9781315183619 (ebook)
Subjects: LCSH: Performing arts--Management. | Organizational change.
Classification: LCC PN1590.M23 F67 2018 | DDC 791.06/9--dc23
LC record available at https://lccn.loc.gov/2017058578

ISBN: 978-1-138-74021-1 (hbk)
ISBN: 978-1-138-74029-7 (pbk)
ISBN: 978-1-315-18361-9 (ebk)

Typeset in Bembo
by Taylor & Francis Books

Contents

	List of illustrations	viii
	Acknowledgments	ix
	Introduction	xi
1	The changing environment	1
2	Reverberations of change	20
3	Making systemic change	31
4	Why performance matters	46
5	Art is life: ecosystems, resilience and sustainability	57
6	Foundational Documents	64
7	Creating a sustainable organization	82
8	Ideas into action	91
	Bibliography	120
	Index	123

Illustrations

Figures

1.1 Faustin Linyekula, "Statue of Loss," Theaterformen Festival, 2014. Photo by and copyright by Andreas Etter 10
2.1 Qudus Onekiku, Africaman Original, 2015. Photo by Logo Olumuyiwa 24
2.2 Faustin Linyekula, "Sur les traces de Dinozord," Photo by Steve Gunther/Calarts REDCAT 2017, Los Angeles, 2017 25
3.1 Liz Lerman Dance Exchange, Virginia Commonwealth University Dance and community members in Liz Lerman's *Still Crossing*, as staged with Dance Exchange in 2017. Photo by Sarah Ferguson 36
4.1 Faustin Linyekula, "Statue of Loss," Theaterformen Festival, 2014. Photo by and copyright by Andreas Etter 51
4.2 QDanceCenter, QTribe Iwa L'Ewa, 2015. Photo by Logo Olumuyiwa 51
4.3 QDanceCenter, QTribe Iwa L'Ewa, 2015. Photo by Logo Olumuyiwa 53
4.4 Liz Lerman Dance Exchange, "The Hallelujah Project," Tucson, AZ. Photo by Stan Barouh 55
5.1 East West Players, world premiere of Rogue Artist Ensemble's *Kaidan Project: Walls Grow Thin* – produced in association with East West Players – an immersive theatrical experience inspired by Japanese ghost stories, with performances held in a secret, Mid-City warehouse, 2017 61
6.1 "Pang!" Dan Froot's triptych of live radio plays about families hungering for change. Photo by Will O'Loughlin 79
6.2 Donna Simone Johnson in "Pang!" Photo by William O'Loughlen 79
7.1 Kronos quartet, Kronos Festival. 2015. Photo by Evan Neff. Courtesy of Kronos Performing Arts Association 83
7.2 East West Players, world premiere of Rogue Artist Ensemble's *Kaidan Project: Walls Grow Thin* – produced in association with East West Players – an immersive theatrical experience inspired by Japanese ghost stories, with performances held in a secret, Mid-City warehouse, 2017. Photo of Randi Tahara by Chelsea Sutton 86
8.1 David Rousseve in "Stardust". Photo: Yi-Chun Wu 105

Table

8.1 Environmental Scanning Matrix 94

Acknowledgments

The ideas that I have developed for this book draw extensively on more than 30 years of experience working as the Executive Director of performing arts organizations throughout the United States including the Town Hall Arts Center in Littleton, Colorado, Kirkland Fine Arts Center at Millikin University in Decatur, Illinois, the Center for the Performing Arts at Penn State University in State College Pennsylvania, UA*presents* at the University of Arizona in Tucson, Arizona and Yerba Buena Center for the Arts in San Francisco, California. My experiences at each of these institutions contributed profoundly to the evolution of my thinking about the arts and the role of the performing arts in our society. I am grateful to the staff, Boards and communities of each institution for everything I learned while I had the privilege of leading each of them.

I especially thank the staff and board of Yerba Buena Center for the Arts (YBCA). My experience there was the culmination of my performing arts presenting career and was without question the most challenging and rewarding position I could ever have had. My current thinking about arts organizations and the contemporary world changed and expanded during my time there and I was able to explore and implement many of the ideas that are in this book while leading that organization. That learning is reflected in this book. Two of the Board Chairs during my tenure there, Diane Sanchez and Diana Cohn, taught me how valuable a great Board Chair can actually be and were instrumental in whatever success I had, as was my friend Priya Kamani and many other Board members of YBCA. Staff members Joël Tan and Scott Rowitz, as well as many others with whom it was my pleasure to work, made leading YBCA the meaningful and fulfilling experience for me that it was and are genuinely responsible for the success we had working there. Thank you. I am forever grateful for the decade I spent at that remarkable arts organization.

My work as a founding member of the African Contemporary Arts Consortium, an organization committed to building connections between contemporary artists and arts leaders in Africa and the United States, profoundly changed my understanding of what arts leadership means. What I learned from my African colleagues: Qudus Onekiku, Faustin Linyekula, Béatrice Kombe and all the women of Tchétché, Opiyo Okach and so many others, about life, and friendship and struggle and renewal and creating art and community because you are driven to do only that, has been insightful and invaluable. I hold all of you deeply in my heart along with my American colleagues Ann Rosenthal, Cathy Zimmerman, Vivian Phillips, Shay Wafer, Laura Faure, Joan Frosch, Philip Bither, Marj Neset and Leatrice Elizy.

I have spent my entire career working closely with the Association of Performing Arts Professionals (APAP) in a variety of capacities. Thanks to this organization, I was gifted

with a community of presenters and managers, many of whom became very dear colleagues and friends. Special thanks to Janet Cowperthwaite, Sue Endrizzi, Marc Baylin, Mikki Shepard, Maurine Knighton, Linda Brumbach, Jed Wheeler, Lisa Booth, Olga Garay, Pam Green, Margaret Lawrence and so many more of you. You are my APAP community and I am ever so grateful for your wisdom and support through these many years.

Perhaps the greatest joy of working as a performing arts presenter is to be continually inspired by working with extraordinary artists. The list of artists that it has been my unique privilege to know and learn from includes David Rousseve, Dan Froot, Tim Miller, Liz Lerman, David Dorfman, Bill T. Jones, Margy Jenkins, Meklit Hedero, David Harrington, Ron Brown, Marc Bamuthi Joseph, Todd Brown and so many more. My life is ever so much richer because of you.

In 2014 Mario Garcia Durham, CEO of APAP and Scott Stoner, Director of Programs asked me to join with them in launching the University of Southern California (USC)/APAP Leadership Fellows Program. Thanks to their commitment I was privileged to work with an exceptional group of arts leaders who helped to design and then lead the program: janera solomon, Carlton Turner, Clyde Valentin, Jacob Yarrow, Barrie Steinberg, Georgiana Pickett, Sixto Wagan, Ben Johnson, Rika Iino, Cathy Zimmerman, Dan Froot, Stephanie McKee, Beatrice Thomas and Andre Perry. You inspire me with your wisdom and your willingness to share it with others in the field. By now, 75 extraordinary mid-career arts leaders have taken part in the USC/APAP Leadership Fellows Program. I am honored to call them friends and colleagues and they too have taught me so much about what it means to be an arts leader in the contemporary world.

In 2012, Robert Cutietta, Dean of the Thornton School of Music lured me away from YBCA with the offer to design and launch the Graduate Arts Leadership program at USC, based largely on the philosophy I had developed over my career and as expressed in this book. Multi-disciplinary in scope but housed at the Thornton School of Music, I have spent the past five years working with extraordinary students from all over the world whose energy and passion for the arts and for making change in the world inspire me every day. This book is for them.

My colleague and, himself also a writer Andre Perry, gave me such great encouragement and guidance about the writing process. He also did me the greatest favor possible by connecting me with the extraordinary Ariel Lown Lewiton whose clear, sharp editing of the manuscript has been instrumental in honing and shaping the final version of the book. It would not be the same book without her guidance, suggestions and thoughtful questioning of my work.

My two sons Aaron and Brandon have always been there for me, whatever decisions I made, encouraging me all the time while pursuing their own passions with the same vigor and commitment that they saw in me. They make me proud every day for being kind, compassionate men and loving fathers to their remarkable children. My sister Leslie remains my best friend forever and her wife Jane is a loving sister to me. The Shah/Javeri/Parikh family has welcomed me with such enormous love and embraced me fully with the gift of a huge, loving family community.

My life partner Nayan Shah, a brilliant scholar and elegant writer such as I could never hope to be, has enveloped me with his love and care in a way that makes it possible for me to be and do so much more than I ever thought possible. With all my love to you Nayan, thank you.

Introduction

On October 3, 2008, Yerba Buena Center for the Arts (YBCA), a contemporary multi-disciplinary arts center in downtown San Francisco for which I was Executive Director, hosted our biennial fundraising gala event called "The Artist's Ball." Not unlike the fundraising galas that many arts organizations produce, it featured relatively high priced tickets to a catered dinner with corporate sponsor tables and auctions, both live and silent. Two years earlier in 2006, the event had netted $100,000 for the organization. This year, our goal was $150,000.

It had been a difficult path to get to this night. Despite the best efforts of our Board and gala committee, we had been unable to sell all of the tables in advance, a key to a successful gala. Hoping to build on corporate sponsorships from 2006, another key to a successful gala, we were met with worried looks and "not this year" responses to our requests. A few stalwarts stayed with us but at lower levels of support.

On the other hand, we had some great auction items: an all expense paid trip to Paris, free tickets to symphony, opera and ballets, vacation condo experiences and more. As I wandered past the auction tables however, I saw very few names on the silent auction lists. It seemed that many items would be sold for far below their value. But there was always hope in the live auction. We had been able to recruit the legendary Willie Brown, former mayor of San Francisco and a local celebrity, to be the auctioneer. If anyone could get wealthy people to part with their money to buy luxury goods in support of a nonprofit arts organization, it was Willie Brown. Sitting at one of the front tables and looking around me, I was still hopeful that we would come out of this ahead. Sure I wasn't quite feeling the buzz of excitement in the air that I had in 2006, but maybe that was just me.

Mr. Brown started the auction with smaller items and the bidding was slow. He would start with a minimum bid, get no takers, drop the minimum and then maybe one or two people would bid. Silence followed and the item would close out for less than we had hoped and expected. By the time he got to the big prize – the trip to Paris, first class hotel and tickets to the Nuit Blanche festival, the pattern had been established. I don't recall what the trip went for; but I vividly recall the sinking feeling in the pit of my stomach that this was not going to end well. And it didn't. A few days later, after we had added up all the revenue and expenses, a nonprofit's worst nightmare had occurred. The event cost more to put on than it brought in for revenue.

We are certainly not the first nonprofit, nor the last, to try to pull off a fundraising event and to have it underperform. But previous history had told us this was not supposed to happen. We had worked harder, were better prepared and better staffed and executed better than ever. All that planning and work resulted in a worse outcome than ever. How did this happen? And why?

Reflecting on the evening, I found it impossible to shake the feeling that something was off. The exuberance and generosity that had characterized our last gala was missing completely, replaced by an atmosphere of worry, uncertainty and caution. Clearly, something in the world had changed.

In retrospect, the gala was a signal, confirming what we had been thinking might be the case; that with the recent economic crash, we had entered a new era quite unlike what we had been used to. By December 2008, it was clear that we were deep into the Great Recession of 2007–2009. Its effect on the nonprofit arts was being felt broadly and deeply by organizations large and small. Trying to get a grasp on what was happening and how arts organizations were responding, YBCA, in collaboration with the Association of Performing Arts Presenters (APAP) and the Hewlett Foundation, hosted a gathering of Bay Area arts presenting organizations to see if we could find out more about how these organizations had been affected by the economic downturn and what their leaders were doing in response. Over 100 organizations participated.

It's fair to say that there was desperation in the air. Almost without exception, the arts leaders in the room were stunned by the severity and breadth of what had happened. Organizations had seen both their contributed and earned incomes take steep dives, with a speed we had never experienced before. I heard Executive Directors talk of donor pledges of significant size that were not going to be fulfilled; of previously robust tickets sales suddenly becoming anemic. Worse, we were bereft of ideas about what to do beyond our well-worn toolbox of conventional arts management solutions: cutting costs, monitoring spending, doing shorter term planning, "hunkering down." The only longer-term strategy we could think of seemed to be: hold on and hope we can survive until everything "returns to normal."

We were accustomed to experiencing periodic downturns, but this was a crisis of a different magnitude. Even more disturbing to me as I participated in this convening, was the recognition that, while we were/are the creative sector, we had almost no new ideas for how to move forward. Of course, still in the early stages of crisis, a certain amount of shock and reactive thinking can be expected. It's hard to talk of redesigning the organization when you are simply trying to keep the doors open. But as time progressed and the recession got worse, it was disheartening to see very few innovative ideas or creative solutions emerge. Nor was there any significant recognition or discussion that, in the face of this dramatically changed environment, it might be time to radically rethink our usual ways of working.

The Great Recession affected all aspects of life in the United States and around the globe, not just the arts. Lives and livelihoods were upended on a dramatic scale. But this is only one part of the story. Change has been happening through several other disruptive environmental shifts that are occurring in the world and all at the same time. Mass movements of people across the globe are disrupting the identities, borders and boundaries of nation-states that we once believed were settled, enduring entities. In many regions of the world, tribalism is on the rise as groups of people, fearful of what might come next, take refuge in what they think is a place of safety and surety – "their own kind," however they define it. "Security" is the all-consuming concern of our time; affinity groups of all types are arming and rearming for seemingly endless war, whether they be cultural, social or political. The perceived triumph of Western liberal society, undergirded by a neo-liberal capitalist ideology that was widely believed to have vanquished all other economic systems, is today looking at an uncertain future. Imaginings of a "post-capitalist" and "post nation-state" global society are emerging with increasing frequency. The weakening of

the European Union; China's extraordinary economic growth, the demise of stability in Latin America and the rise of right-leaning governments; these phenomena and many more signal a world that is both unsettled and unsettling.

Eight years after the crash, and after the stable, thoughtful, scandal-free presidency of Barack Obama, the United States elected failed businessman and demagogue Donald Trump to the presidency. In a triumph of image over substance, rhetoric over action and fiction over reality, desperation reached its depths and the United States put its trust and faith in a huckster who famously promised to "make America great again."

We are, it seems, in an era of rapid and convulsive change. We are not just experiencing the usual chaotic effects of an ever-changing world; rather we appear to be in the midst of an epochal shift that is remaking our world in ways we did not see coming and could not imagine. From this vantage point, ten years later, the recession of 2007–2009 seems more than ever as the outward manifestation of a profound societal change that actually has been occurring for some time and that we can no longer ignore as just "the evolving world." Those of us working in the world of arts organizations are facing critical questions, not just of structure and economic survival, but of purpose and meaning. What role can, should and will the arts play in our unpredictable and changing new world? What will it take to sustain our organizations and our communities through this epochal shift? What does the future hold for us?

If we look at the various events that have occurred over the last decade both in the United States and globally, it seems clear that our responses have tended to be reactive rather than proactive. We can't seem to get out in front of the change that is occurring. We wonder: How did the recession happen, and how do we fix it now? How did Donald Trump get elected, and what do we do now in direct response to this election? How did Brexit happen and what do we do next? How do we deal now with the worldwide refugee problem? And what about changing weather patterns, melting icecaps and the increasing frequency and severity of hurricanes, floods and fires? What actions do we now need to take in response to these phenomena?

By dealing only with the immediate aftermath of any given external event, we create short-term fixes rather than enduring solutions. Simply responding to change at the moment of impact does not enable us to get to the root of what's happening; nor does it enable us to create effective strategies for dealing with what is clearly a world of constant change. Starting with that gathering of arts leaders at YBCA in 2009, I began to reflect on our collective response as arts leaders to the recession and came to the realization that the short-term remedies we devised in response to the economic crash were not going to lead to the type of systemic change that we clearly needed. I came to believe that as arts leaders, we would need to engage in a much deeper understanding and analysis of the underlying trends that had brought us to this moment from which we could then develop creative strategies for action that were proactive and systemic, not just reactive. This is the purpose of this book: to help arts leaders to explore and discover new ways of thinking about themselves, their organizations and the environment within which they live and work. From these explorations and insights, we can then begin to build unique and sustainable organizations capable of realizing the promise of the arts.

Perforce, this work begins with a more comprehensive look at the trends of change occurring in the world and the intersectional, ongoing and cumulative effect that they are having on the external environment in which we work. It is only from this analysis and understanding, that we can then develop new ways of working in an environment of constant change. I will propose a framework within which we try to understand the

contours of that change and, based on that, a new way of thinking and working that not only liberates arts leaders from inherited assumptions about "the way things are supposed to work" but also away from the conventional business-based organizational model that has dominated arts organizational thinking since the 1960s. Instead, I propose that we develop systems and models of working as an organization that cohere more closely with the practice of artist and arts makers – one that acknowledges the unsettled world and creates innovative ideas and strategies that can flourish within a framework of instability. It is by embracing a new way of thinking and working that emanates from the arts and artistic practice that we can remake the field and redefine our role as arts leaders who are shaping and guiding the aesthetic and cultural evolution of our countries, our societies and our world.

As arts organizations, our core reason to exist is to provide meaning for ourselves and the world in which we operate. It is not to create jobs. It is not to build beautiful buildings that revitalize downtowns. It is not to provide social status, generate profits, build endowments or have a string of deficit free fiscal years. It is not to organize or proselytize for a political agenda. And it is surely not to create art for art's sake, however one interprets that phrase. These might be laudable byproducts of the work we do. But it is not why the arts exist. Art exists to create meaning for individuals, communities and societies. Arts organizations exist to make sure that this happens.

We have, I think, nearly lost this core sense of purpose. We have become obsessed with the metrics of achievement that have been imposed upon us by a society and a system that is essentially hostile to what we do and why we do it. Any arts leader who has tried to twist the accomplishments of their organization into the rubrics demanded of them by government agencies and foundation reports knows exactly what I am talking about. We find ourselves in the impossibly paradoxical position of endlessly trying to succeed using methodologies that undermine rather than support our core reason for being. With this book I want to explore a new way of thinking and working that makes it possible for us to design and create organizational systems and strategies that cohere with, rather than contradict, our core values as artists and arts workers. In so doing, we can begin to make the meaning that can, and will, reshape the societies in which we live in ways that are proactive and productive rather than reactive and even damaging.

To begin, it is useful to look briefly at how we got to where we are today. I look at this chiefly through the lens of the development of nonprofit arts organizations in the United States because it is the system I know best and of which I have the most experience. Thanks to global capitalism however, the U.S. system of support for the arts has (somewhat unfortunately) become something of an aspirational model for other cultures. Over the years I have worked with arts leaders in Mexico, Britain, Russia, Spain and several African countries, all of whom have sought to in some way adapt the U.S. model to their own systems of government and governance. In each case, while sharing my own experience, I have also noted the weaknesses and flaws embedded in the U.S. approach to the arts and encouraged my global colleagues to develop their own way of working; one that integrates the most effective practices of what they already know and what they might take from the U.S. system.

The modern history of the nonprofit arts organization in the United States is probably best understood in the context of the creation of the National Endowment for the Arts (NEA) in 1965. The NEA emerged from an essentially democratic impulse – that the arts should be available to everyone regardless of age, income or social class and that the government, federal, state and local should join with private foundations to insure the

proliferation of the arts and of nonprofit arts organizations throughout the country. (Bauerlein and Grantham, 2008) However, in order for government and foundations to be assured that their investment in arts organizations would be appropriately used, the legal structure and status of the nonprofit corporation became the model. Becoming a nonprofit organization required legal incorporation and the formation of a Board of Directors to oversee the organization and essentially hold it in trust on behalf of the community it is meant to serve. Thus the somewhat schizophrenic philosophical construction of how an arts organization works has emerged in which a nonprofit arts organization is organized and expected to operate as any corporate entity. At the same time, it can't/doesn't make a profit (i.e. returning excess revenue over expenditures to shareholders) and it is supposed to serve a community benefit or charitable purpose. This is the reality we work within today in which the higher purpose of "charity" is blended with the structure and methodology of "business."

Given the market-based ideology of the United Sates, it is no surprise that the "business" side of the organization has almost inevitably overtaken the "charitable" purpose, a circumstance that has far-reaching consequences. To take just one example, to receive a grant from the NEA, most state arts councils and private foundations, organizations must submit extensive documentation to help the reviewing committee assess whether the organization is worthy of receiving the grant. In most cases, although "artistic excellence" is stated as the primary criteria for awarding a grant, "organizational capacity" is equally vital. Artistic excellence has always been problematic to define, even for the panels of professionals who often advise foundations and government agencies on whether to award a grant. Organizational capacity is more concrete and thus seems easier to measure and assess. Who (status, position, wealth) is on the Board and how well they function (regular meetings, minutes, legal documents written and filed, etc.) became accepted markers of success. Does everyone on the Board give and/or get donations? Is there stable, ongoing professional leadership and management? A stable and/or growing staff? Has there been slow, steady growth over time ("Please provide your three year budget plan and explain a deficit or surplus of 10 percent or greater in any given year.")? Grantmakers want to know for certain that if they give money to an arts organizations it will not be wasted (artists are not to be trusted) nor will the organization disappear due to the unpredictable actions of those running it (administrators are not to be trusted either).

The noblesse oblige paradigm of the nonprofit Board design and structure, in which "outside experts" are expected to monitor and oversee the work of the professional staff, became the gold standard of "good governance." Coinciding with this arguably patronizing governance model was the corporate business model that featured a CEO, senior staff that reported to him (nearly always a *him*), managerial staff and administrators to execute strategic plans, marketing strategies, development departments, financial reporting, project management and assessments based on quantifiable metrics. The performing arts industry and the business of the arts was born.

The nonprofit performing arts has become firmly entrenched as a corporatized business. The performing arts event itself has become a product to be created, bought and sold according to the desires of the marketplace. In the 1980s, Reagan's presidency ushered in the glorification of global capitalism and the primacy of neoliberal economics. The arts sector fully participated in the exploitation of labor through its widespread use of underpaid staff, community volunteers and unpaid "interns" to perform many of the key tasks required to survive. With our endlessly rising ticket prices and the extensive "perqs" devised for our major donors, we solidify and codify a class-based system of arts

participation. By focusing on annually growing budgets and building stability through endowments, we support the accumulation of capital as a marker of success. Rather than remaining outside of the corporate model, as our nonprofit status suggests we should, we have joined it.

In so doing, we have also sown the seeds of our own eventual demise. The recession of 2007–2009 revealed that the artistic experiences that we revered and to which we devoted our life's work had, through our own complicity, become a commodity, a product as disposable as any other product in the marketplace. In 2008 when the Recession was being felt so deeply and broadly, the arts were on virtually everyone's list of "things I can do without in tough economic times." As a field we now understood what it meant to be successfully embedded in the economic life of the society, but not in its existential or socio-cultural life – the kind of meaning-making that drew most of us to the arts to begin with. No wonder we did not know what to do and that our responses were limited to business-based tactics.

Arts organizations have survived so many downturns, so many negative trends, so many tough love admonitions to "behave like a business, do more with less, do less with less, downsize, right-size, raise prices, lower prices, forget about government support, don't rely on foundations for support, embrace risk, mitigate risk" and more; the list of prescriptive strategies for a healthy arts organization, prescriptions that conform to the corporate business model, is long and filled with practical advice and deep contradictions. Because arts organizations and artists are generally creative, most of us have made it through the economic ups and downs of the late 20^{th} century by shifting from one approach to another. Now, facing the worst recession of our lifetimes, the general belief in 2008 seemed to be that if we just held on, we could make it through this one as well. But it wasn't long before we began to realize that this time, things really were different; that many of us would not survive, and those that did might be so dramatically reduced in size and scope as to be unrecognizable. I began to seriously question whether this endless quest to "do more with less" or "do less with less" was destroying rather than saving us.

For at least as long as I had been in the field, the arts have been in this endless spiral of adjusting and readjusting and tweaking. But to what end? Were audiences growing? Not so much. In fact, data from the National Endowment for the Arts on what they refer to as "cultural participation" showed annual declines in attendance year after disheartening year from 2002 to 2012 (Iyengar, 2015, p.3) even as arts organizations were growing in numbers, proliferating across the landscape in such a way that in 2011 at a new play development conference in Washington DC, NEA Chairman Rocco Landesmann was quoted: "You can either increase demand or decrease supply," he said. "Demand is not going to increase, so it is time to think about decreasing supply." (Isherwood, 2011). As artists and arts workers, we should have uniformly found this point of view dispiriting, baffling and even horrifying. Many did; but many agreed enthusiastically with Mr. Landesmann, so thoroughly indoctrinated had we become in this market-driven view of the performing arts in America.

Can there really be such a thing as too much art in the world? Too many arts organizations? Too much "product on the shelves?" This is not the way many of we self-described arts leaders think about the arts and their role in society, nor is it what many artists believe. And yet, this was the call from "the national arts leader." Something was seriously wrong here. Had we lost our way? Or had society finally and fully ascribed to the arts the irrelevance that we suspected they truly believed?

Most of us who enter the performing arts field do so not only through a love of the arts but also with the conviction that the work we are doing is profoundly important to

the world we inhabit and the society in which we are embedded. Generally arts leaders are not naive; they know that the work is challenging, even in the best of times. Still, the thrill of a shared performance experience with an attentive and engaged audience has been enough to keep us going and taking on the challenges that present themselves daily.

But then, in 2009, when the effects of the recession caused us to reflect on what we had built, we had to ask, to what end? If at the end of the day, the performing arts are a product and we are the chief salespeople for that product, is this really what we had in mind when we entered this field? For most of us, I believe the answer is no. I think that it is now clear that we need to revisit the fundamental assumptions we have been making in relationship to three key areas, each of which is a focus of a section of this book, and from there develop a whole new way of working. We need to consider:

1 *The external environment.*

What happens in the world around us has a profound impact on how an arts entity organizes itself to accomplish its work. It is more vital now than ever before that arts organizations engage the world more thoughtfully, more expansively and more deeply than we have previously.

As artists and arts leaders, we like to think of ourselves and our organizations as a vital and important part of the communities within which we live and work. Contradictorily, we also like to view ourselves as "outsiders." In our ideas, beliefs, practices and identities, many artists and arts leaders are holding important space outside the mainstream of social, economic and political discourse. Personally, we are often not the best students, the good kids who did what they were told as they climbed the ladder of success into middle class respectability. Many of us knew from an early age that we were set apart from the world of our peers. So when we discovered a home in the arts, it was a relief to be around others who are very deliberately and specifically committed to working against the values and lifestyles of conventional societal thinking. Many arts workers see this as their central role – to provide the alternative, to show a different perspective, to challenge conventional thinking.

This is a vital role for the arts and the arts organization. Our world needs the outsider perspective of the artist, the creative thinker, the individual and the organization. But to be effective, to create the change many artists and arts organizations want to see in the world, we also need to be sufficiently engaged with the external environment that we know what people around us are experiencing, thinking and feeling, in order that our organizations can both respond to and shape the community discourse. If we don't engage fully and completely with our rapidly changing world, we will lose our ability to do what we are meant to do – to provide that alternative, that different perspective, that provocation that enables a much more robust development of our society and culture. To that end, the first section of this book examines what I think are some major trends that are occurring in the world and also suggests the implications of those changes on the world of the arts.

2 *Our core purpose.*

Why do the performing arts matter at all? What human and/or societal need do they address that justifies their reason for being? All appearances to the contrary, most arts organizations really do believe that they are engaged in an endeavor that

transcends the business methodology that has become the foundation for accomplishing their work. This seems difficult to grasp in the face of mass scale entertainment, a society that celebrates financial achievement above all else, and an exploding art market that treats artistic product as an asset class rather than the highest expression of human imagination. Many arts leaders have lost their grip on that sense of purpose, usually in favor of either social status (being an "important" organization), size (being the biggest organization, with the most tickets sold and the most donors) or financial success (an organization with a balanced budget, a healthy and growing endowment and cash reserve).

In order to delve into this more deeply, I want to reconsider the performance as a lived experience, from the perspective of the artist and the audience. What happens when a group of people gather together to witness a performance event? Is it merely a diversion from our day to day existence, the "real work" in the "real world" as it is so often characterized, or is there something deeper, more vital and, finally, more essentially human that occurs? And if that is the case, how does that happen and what role can/should an arts organization play in enabling this to happen? Answering these questions will serve as the foundation for what we do and why we do it – the *meaning* – and the work that follows will help insure that we don't lose this sense of purpose again.

3 *Sustainability*.

Our final step is to devise ways of working to create and sustain an arts organization that can thrive and remain relevant in this ever-changing environment. Here, I provide a framework and some general concepts for arts leaders to consider as a new way of thinking about their organization and how they work in the contemporary world. I do not believe in prescriptions or "best practices." However, I believe that if we think deeply and creatively about who we are, why we exist and what is happening around us, we can develop specific and distinctive frameworks within which to work and organize ourselves to make progress towards our organizational vision.

Since 1982 when I began working as an arts administrator and organizational leader, I have held five different leadership positions in organizations large and small, urban and rural, conventional and alternative. In every case, I can say that I entered the organization at a moment of organizational need, sometimes crisis. Whether I was there for two years or ten, when I left, I had accomplished most of what I set out to do. Each organization was artistically more vibrant, more relevant to its community and had the financial and organizational underpinnings required to sustain it for the foreseeable future. This was not because I was a magician. But I did understand what the purpose of the organization was, I assessed accurately what was happening around us, and I built structures and systems that allowed us to make progress towards the vision that we had set for ourselves. Over these 30 plus years, by working not only in my own organizations but also with a vast number of other arts organizations as adviser or consultant or simply interested colleague, I have learned a great deal, and those insights are infused throughout this book. In the end though, the core purpose of this book is not to share my wisdom but instead to provoke yours. My hope is that by sharing my insights and ideas with you, you will find – or create – that path to success for you and your organization that all of us want and that our current society so desperately needs.

Before proceeding to the specifics, I want to address some issues of terminology that have no doubt already arisen for you and will continue throughout the book. I noted already that I am operating largely from a U.S. perspective, though I draw substantially on my work internationally with different organizations and systems. Second, my work has primarily been with the performing arts and I will more often refer to "the arts" as a way of encompassing all of the different arts modalities that exist in the contemporary world. My experience at Yerba Buena Center for the Arts, a multi-disciplinary institution with programs in film and visual art as well as performance, confirmed my belief that while there are some key differences among organizational practice within institutions committed to only one art form, we actually have more in common than what we might want to admit; many of the insights I have gained can have relevance to arts leaders in other arts disciplines besides performance.

Finally, you will note throughout the book my use of "arts leaders" and "arts organizations." In using the term "arts leaders" I am referencing those whose primary work is organizational leadership and whose background may well include a past and/or current practice as an artist. To identify as an "arts administrator" seems both inaccurate and also too limiting. I also use the term "arts organization" because the book is addressed primarily to arts leaders who are running organizations that enable the work of artists. I propose throughout alternative ways of thinking about organizational purpose, design, systems and structures that can be useful for and adapted to any arts organization, regardless of its legal structure or tax basis. In the end, organizations are simply collections of people who come together to accomplish something of value to society and to themselves.

With that said, I begin by looking at the external environment and what seems to be going on out there.

1 The changing environment

A few years ago, I was at a social gathering at a colleague's home in Los Angeles which brought together a variety of people from various professional sectors: academia, the arts, the film industry and more. At one point in the evening I found myself in conversation with a film curator for the Sundance Institute. When I asked her about her curatorial work, she told me instead about her interest in and excitement about a new technology that she was working with, Virtual Reality (VR). While I had vaguely heard about VR, I really didn't know too much about it so I asked her to tell me more. In response, she reached into her bag and pulled out a cardboard device that looked a lot like the old View-Master of my childhood. Inserting her phone into it and then giving me ear buds to put on, she said, "Here, take a look."

What happened next was a revelation. Holding it up to my eyes and plugging in the earbuds I suddenly found myself transported into a world that I knew intellectually was imaginary, but felt vividly and viscerally real. With music playing in my ears, I was visually transported to a bucolic field of grass and trees. When I moved my head it was as if I were actually walking through this field. If I looked to the side or tilted my head upward, the environment changed with my movement, just as it does in "real life" when we move through space. Animals appeared, crossed my field of vision and disappeared. Colors changed, the scenery changed and the sound changed with it. It was incredibly disorienting to "know" that I was still standing on the patio of my colleague's home but also "being" in a completely different world at the same time. It was also beautiful. Magical even. And unlike watching a film or performance and feeling a critical distance from it, with this makeshift device I found myself in the center of what could only be called an alternative reality.

Ever since that night, I have been unable to shake the sense that what I experienced was something more than just a quirky new entertainment device within the tiny, specialized world of technology, destined to become another toy, a new tool in the artist's tool box or just a new medium through which artists will explore and create new performance work. Doubtless it will be all of those things. But more than just changing the performance itself, VR also changes the context within which the performance occurs. What I saw was an early experiment in creating an alternative environment – an alternate reality – in which the very idea of what we understand as a "live" performing arts experience might be fundamentally changed. Even with this rudimentary device, I could begin to imagine a world in which we could potentially experience multiple realities, each of them as "real" and thus as "live" as the other.

Up to now, we have understood a live performance experience as being real people in a real place, sharing a performance event together in real time. We have an implicit

understanding of what reality is and what it means to "live in the real world." In that context, we can grasp how the "live" performance we are experiencing both mimics and comments on "the real world." But imagine the implications for the field of the live performing arts if we were able to create and work within multiple alternative realities? Once our concept of what is real and what is imaginary is disturbed, then the very idea of a live performance event is unsettled. Is a live performance in an alternate reality still a live performance? Is a virtual performance in a VR also a live event? For those of us who are deeply invested in the value and importance of the live performing arts, these are profoundly provocative, even disturbing questions. We can begin to see that the implications of this particular technological advancement on the very idea of what we mean by the "live" performing arts has the potential to significantly change the world in which we work.

VR is a particularly dramatic illustration of *emerging technologies*, one of three key drivers of macro level change that are fundamentally transforming the environmental context within which arts leaders must learn to guide their organizations.

More than 20 years ago I was asked by a national foundation to serve as a site visitor for a proposal by a theater company in San Diego, California seeking funding for the development of a community-wide theater project. The project involved the company creating a new work within a neighborhood of San Diego known as City Heights. As part of my site visit I had a tour of the neighborhood with a number of community leaders who were working with the theater company. I had never been to San Diego, knew nothing of the City Heights neighborhood, so it was quite a revelation. I will never forget the community leader telling me that whenever a massive socio-political event – political upheaval, military coup, economic disaster – occurred in the world, its ramifications would be subsequently felt in City Heights when refugees from that event made their way to the United States. San Diego was one of several gateway cities in the United States for refugees and City Heights, because of its "inner city" location near social services, its relatively low cost housing and the presence already of multiple immigrant communities from around the world who had launched food stores, restaurants and shops that carried goods that new immigrants needed and desired, was where refugees tended to gravitate once they arrived. Some stayed and others moved on but the worldwide diversity of the people living there was extraordinary. What struck me then as an outsider to the city, was a recognition of the remarkable multi-cultural complexity of a city that, "at a distance," I had thought was pretty mono-cultural.

What seemed remarkable to me at the time is now a reality for dozens of cities and towns in the United States, many far from the usual ports of entry like San Diego. Formerly settled enclaves are dealing with rapidly changing populations, upsetting and even overturning settled notions of who comprises our communities and therefore how we define ideas of what is "our culture." This is a global phenomenon and is a second driver of this epochal change that we are experiencing. Although some people find they are able to ride the waves of socio-political change in their home environments, many more have been compelled to leave their homes and venture across oceans and continents, into unknown and often unfriendly territories. This is not a particularly new phenomenon; large-scale global migration is, as it always has done, reshaping the culture of the places people leave as well as the locales in which they resettle. Immigrants bring their culture, customs and practices with them, and assimilate within their newly adopted cultures, but to remarkably divergent degrees, creating a society of diverse relationships of individuals to the larger culture within which they (now) reside and disrupting any ideas of a fixed,

universal culture. The countries receiving these migrants are also responding with varying degrees of welcome, from friendly and humanitarian accommodation to, in many cases, resentment and outright hostility. Developed countries like Britain, France and the United States have often turned hostile to immigrants, especially from non-Western countries.

The socio-cultural effect on our ideas of art and culture caused by these mass migrations and resettlements across the globe are complex and challenging, especially for arts leaders whose organizations are fundamentally concerned with ideas of belonging, community identity and cohesion. *Changing demographics*; the mass migration of peoples around the world, both voluntary and involuntary, is a phenomenon that is destabilizing cultures, states and societies, as they have previously understood themselves. Our understanding of what it means to inhabit a unifying, collective culture is being disrupted. Like emerging technologies, changing demographics is a trend of enormous consequence for arts leaders, their organizations and, of course, their communities.

During the late 1980s and early 1990s I lived in central Pennsylvania while I worked at Penn State University. I had never been to this part of the country before so often took time to explore this rural location. One weekend I drove over to visit Centralia, Pennsylvania whose history was described as follows:

> Located on a rich seam of anthracite coal, Centralia was settled as a mining town in the mid-1800s. After reaching its peak population of 2,761 in 1890, Centralia was home to around 1,400 people when the mines began to close in the 1960s.
>
> In 1962, something happened that would transform Centralia from a quaint and lively small town into a bleak and hazardous wasteland: an underground fire began to burn out of control.
>
> The exact cause of the fire is still disputed – some argue that it resulted from the volunteer fire department's annual burning of landfill, while others claim that a coal fire from 1932 was never fully extinguished, and had been slowly spreading towards an abandoned strip-mine pit.
>
> Despite growing awareness of the fire burning uncontrolled beneath the town, the scale of the problem did not become widely apparent until 1979. That year, mayor and gas-station owner John Coddington was checking the fuel levels of his underground tanks when he discovered that the gasoline had been heated to 172 degrees Fahrenheit.
>
> A real shocker came in 1981, when the ground tried to swallow Todd Domboski. The 12-year-old was walking in his backyard when the ground gave way and he fell eight feet into a smoking sinkhole. Domboski was able to hold onto tree roots at the sides of the hole and got pulled to safety, which is just as well: the sinkhole was later found to be about 150 feet deep and filled with lethal levels of carbon monoxide.
>
> Following these troubling incidents, the government began claiming Centralia properties under eminent domain and relocating residents. The population fell from 1,017 in 1980 to 21 in 2000. Centralia lost its ZIP code in 2002.
>
> The eight residents of Centralia have been granted the right to stay there for the rest of their lives, after which the government will take possession of their properties. Meanwhile, the fire rages on.
>
> (Morton, 2014, pp. 1–2)

I was riveted by the nearly apocalyptic nature of this story and what it meant for us as a culture that we could allow the destruction of an entire town in this way. It's an extreme case to be sure, but we are increasingly aware of equally catastrophic stories of environmental degradation in which, generally in the name of "building the economy" or "job creation," we have allowed our land, water and air to, as was the case in Centralia, be destroyed by human endeavor. Whether it's the Flint water crisis, mountaintop mining in West Virginia, Love Canal poisoning or any number of other environmental disaster stories of which we know, we can see the cataclysmic effects of industrialization, extraction and mankind's intervention generally in the ecosphere; intervention that is causing dramatic change in the environment that supports the very substance of human life – the air, water and food that we require to survive. Yet, we continue with self-destructive activities and we increasingly see their manifestations in global climate change: melting icecaps, rising sea levels, increasing frequency of dramatic weather events like earthquakes, droughts, floods and fires.

This is the third major driver of global change: our growing awareness of and concern about *environmental degradation* brought about by human exploitation of natural resources. For those of us who don't live in regions regularly afflicted by floods, hurricanes, fires and droughts, environmental change may have seemed more easily ignored than the dramatic changes we've seen in technology and demography. But as climate change accelerates, grappling with its consequences will pose unavoidable challenges for arts leaders in every region. Some may see little immediate connection between their work as artists and arts organizations and a rapidly degrading environment, but we ignore it at our peril. The physical world is changing around us and the role of humans, including artists and arts leaders, as responsible stewards of the environment has become more crucial than ever before.

These three macro-level drivers of change – technology, changing demographics and environmental degradation – are the primary forces underlying our current sense of turmoil and disorder in the world. Our biggest challenge as arts leaders is to understand how to lead, govern, manage and create in this environment of upheaval.

One could argue that these are not new phenomena; that change in the world has always have been an integral part of human existence. Although that is certainly true, what distinguishes this particular moment is, first, the incredible speed with which these changes are occurring and, second, that these phenomena are interconnected, and that intensifies their overall effect. This era of ongoing change is how we need to understand our reality, our "new normal."

The sensibility that many arts leaders are beginning to recognize, that we are living in a world that is heading off in directions we had never imagined, is neither surprising nor without foundation. This changing external reality also means that the work of our arts organizations will be vastly more complicated than we had once thought. Our challenge is to learn how to create sustainable organizations in an increasingly unpredictable world. To start, we should look more closely at the trends themselves, their extended effect on the world generally and their effect on the organized performing arts specifically.

Technology

In 1982, I began working in the nonprofit arts as Executive Director of a small performing arts organization, the Town Hall Arts Center in Littleton, Colorado. With just three of us on staff, we were, like many similar organizations, a small team with big ideas

and big ambitions. We were working hard to churn out more work than we probably should have. By some miracle, we were able to purchase a Kaypro computer for the office. A Kaypro, cutting edge at the time, was called "transportable." About the size of a small suitcase, I could carry it home, insert a floppy disk and begin work on a document in Word Perfect or Lotus 1-2-3 to be printed out later on our dot matrix printer. I could share the computer with the other staff so they too could produce more work, or at least more documents. The Kaypro became a vital piece of our organization; it seemed almost as valuable as another employee.

In the ensuing 30 years, my subsequent organizations, like most arts organizations, traveled the technological pathway: desktops, then laptops, local area networks, social media, smart phones, the cloud. Along the way, technological change not only increased our speed and efficiency, it transformed many aspects of the way that we conducted our organization's work. Who needed a receptionist if technology could answer the phone and direct your call? When email became commonplace, communication patterns, protocols and structures changed dramatically, even if it seemed to create as many problems as it solved. Soon we were all adding "email policies" to our employee handbooks while simultaneously haranguing our staff to actually talk to the person in the adjacent cubicle, not just send an email. Instant messaging and texting made communication even faster so that now we have to figure out each person's preferred method of communication if we want a response.

In 1998, the first recorded use of "google" as a verb occurred and the era of "search" was upon us. (Page, 1998) With Internet search, vast amounts of information became instantly accessible to anyone with a computer, inside or outside the organization, creating newly porous knowledge boundaries. Artists created websites, which we could "search" for information, history, biographies, etc. We could read blogs, follow hyperlinks and trace one idea to another to another, all the time gaining greater knowledge, insight and information about whatever we chose. Arts organizations also could, and did, create websites making performance information available to our constituencies. All they needed to do was "search" for it.

Of course soon we realized that simply creating a "searchable" website was one thing. "Driving traffic to it" was another and we tended to rely on "analog" tactics like press releases, ads, subscription booklets, posters, flyers and the rest that featured our web address with the hope that potential buyers would go to it.

In February 2004, Facebook was launched and with it a whole new world of communication began. (Carlson, 2010) Up to now, web based communication was linear – you asked, you searched, you got an answer. With the advent of Facebook and its subsequent and multiple variations, we were in the multi-faceted, multi-directional age of "social media" when we could still reach out to a single person but more often what we said and wrote was seen and heard by any number of publics. Information became pervasive and ubiquitous, and (increasingly we are learning), sometimes with questionable validity. Now arts organizations too could be everywhere, could "push" notifications and our very arts-centric aspiration that people could and would discover us and our work became more of a reality than it had ever been before. What had been the porous boundaries created by the Internet evaporated in the age of social media and the ability for everyone to see, hear and know about everything, all the time and instantly was upon us.

Many of us working in arts organizations embraced emerging technologies as keys to helping us to "do more with less," especially in our ability to communicate with our

colleagues, audiences and communities faster, more easily and with greater frequency than we could ever have imagined. Others of us moved ahead somewhat grudgingly, decrying each technological advance as alienating and dehumanizing, longing for the days when we could speak with a human being and not an avatar or a disembodied, computer generated voice. Before long, those in my generation found our workplaces swarming with "digital natives," young employees for whom technology was second nature. It became crucial to build, and find funding for, ever-expanding IT departments and also to learn how to manage a work force with diverse relationships with these technologies. Ignoring changing technology was not an option.

But if we think about emerging technologies only in terms of the different or better ways we now have of doing what we had always done, if we focus only on managing our responses to the latest devices, we will miss the deeper, more fundamental change that is occurring in the structural and ideological concepts that underlie these new technologies and the game-changing impact of technological thinking on the world and on arts organizations. In order to get at this idea, we return to the basics of the Internet, the concept behind it and the way it reorders how, through an alternative way of thinking, we not only communicate but also create relationships.

One of my first IT Managers, Dave Knerler, once tried to explain to me how email worked. In my pre-technological mind it seemed like a giant telephone system – the direct, linear, one-to-one way I then understood communication – in which you "reached out" to someone, they answered, you spoke back and forth, all in real time. Dave asked me to instead visualize a "web;" an interlocking series of pathways connecting multiple "nodes" (of which I was only one), the others being other people, websites, sources of information, etc. Because it is a web and not a single, exclusive line, or even a central hub with spokes radiating out from the center, information like my email traveled as a "packet," following multiple lanes and lines as it worked towards its end point. Because all of the "nodes" were doing this at the same time, the popular notion that a straight line was the fastest way to get from point to point, no longer was operative. Rather, the information "packet" would try multiple routes to get to where it was headed, avoiding or working around obstacles as it found its way from origin to end point. The Internet was the underlying structure that made this system work.

With its creation, we didn't just get a new technology. Rather, we got a profoundly new way of thinking about how we connected with each other. The advent of the Internet launched a conceptual transition away from linear, vertical thinking and connecting to web-based horizontal thinking; from limited, managed and controlled information sharing and relationship building to virtually unlimited and uncontrolled access and possibility. What does this mean?

In my early Kaypro days, I wrote a document and was able to share my "diskette" with my colleagues by passing it around, one at a time. I am now able to create a document in Google Docs, or any of a dozen other similar file-sharing applications that a group of us can collectively read and edit in real time. I can get on Zoom and have a video conversation with people in multiple locations around the world. I can "hang out" on any number of social media platforms and watch, overhear and, if I choose, participate in explorations and conversations about almost anything.

Many of the young artists with whom I work are engaged in creative composition and performance with other artists who are variously "live and in person" or located elsewhere and connecting into the project through the Internet. Information and ideas now flow more freely and more openly and in multiple directions at once. Relationships

proliferate, created and sustained by this unfettered access. For artists, this collaborative and somewhat anarchic way of thinking and working is not new. Many artists draw their inspiration and develop their work from a multiplicity of sources as they head towards the completion of their work. Conceptually for these artists, this is not a new way of thinking and working. For arts organization leaders however, invested as they have been in hierarchical organization charts and "chain of command" management thinking, it represents a revolution.

For some of us, this idea of unlimited access is seen as an extraordinary opportunity and exciting beyond measure. For others, it creates worry and the fear that unlimited access will lead to unbridled chaos. Thus the attempts by governments, and not only authoritarian governments, to limit or shut down Internet access. Thus the attempts by corporations to restrict or enhance Internet access through pay models, monetizing greater speeds through paid network "fast lanes" or a firewall: technological barriers created to try to prevent access. Thus too, internal organizational technology policies that strive to manage information flow with internal passwords and firewalls. Attempts to regulate the anarchy of the Internet continue: but as one attempt succeeds, it is invariably hacked and another emerges. This is the reality of the contemporary world, in which safeguards can be and are hacked and rendered useless, in which privacy is becoming an anachronism.

The consequences of living and working in this anarchical, networked world have had profound implications at all levels of human interaction. From social and political movements like Arab Spring and Occupy Wall Street to social media "celebrities" who share the mundane details of their daily lives with millions of followers, to Internet trolling that leads to acts of real violence, to viral videos that celebrate the ordinary or testify to acts of institutionalized brutality, to the first reality show President of the United States, the line between fact and fiction, actual and virtual is not just blurring, it is disappearing. What are the consequences for arts leaders of living in a world in which we cannot confidently ascertain what is true or real? Does this make what we do irrelevant or does it make what we do more vital than ever before?

If we look at the way much of performance work is created, we see the metaphor of the Internet and its networked approach to exploration, discovery and creation already embedded in the creative process. Theater is almost always a collaborative process: even when the director brings a strong vision to a written script, each ensemble reinterprets what they have in front of them. The best theater emerges from a collaborative process; one that enables the full participation of actors, designers and technicians with the director's guidance to produce the desired work of art. Chamber music ensembles work as a collective and draw their inspiration, artistry and creativity from a networked, integrated approach to playing and interpreting music written decades or centuries earlier. Classical chamber music is often described as a "conversation" among the various instruments in the ensemble. Many modern and contemporary dance choreographers see their dancers as co-creators, not simply human movers to be manipulated according to the grand plan of the choreographer. Ensemble theater companies doing devised work engage in deeply collaborative creation across boundaries from the outset. Traditional dance and theater companies whose work reflects community-based cultural values thrive across generations and sometimes across continents on the strength of the participants' creative energy and shared understandings and not just a singular individual's artistic vision. The open-sourced, crowd-created (to reappropriate some terminology of technology), collaborative, team-based approach to creating and working is second nature to many, if not most, artists.

I point this out so that as arts leaders we recognize that this "new" networked way of thinking actually coheres with the artistic process that characterizes much of the work we know and care so deeply about. Why would we not forego the vertical, closed, hierarchical organizational methodologies of working in favor of a horizontal, open-access, networked approach to running our organizations in the same way that artists use it to create their work?

In addition to prompting us to reimagine the way that we work, emerging technologies also challenge our notions of what it means to be an artist and who gets to make that determination. In an open-sourced world, many of the barriers to participation in the arts as a "creative" have been removed and the diminished power of the gatekeeper (i.e. the director, the curator and/or the critic) has opened a floodgate of creative activity. Maker's Fairs and DIY artists proliferate. Filmmaking, which used to require a substantial investment in equipment, is now available to anyone with an iPhone. Musicians can create their own CDs and/or distribute their music via online streaming. Online compositional collaboration has meant that recordings can be made with musicians in different parts of the world who may never see each other or be in the same room together. A YouTube channel or a Soundcloud account is simple to create and sustain and enables creators of all types to have access to potential consumers. Crowdsourcing enables works of art to be funded, created, produced and disseminated through the efforts of not just one individual, or the structured and directed efforts of the Development and Marketing Departments, but by the very consumers for whom these works are intended.

These developments are made possible by innovations in software and hardware. But it is the openness of network thinking that drives these innovations. The age of the heroic leader, the singular expert, the omnipotent and powerful curator or artistic director with the final say in what happens, now seems obsolete. The rise of the Internet and networked communication has the potential to free us to pursue more innovative organizational design and operation in a way that is more in tune with the world around us.

Yet an inevitable backlash is occurring, both generally and within the arts field, as we begin to question whether all of this "openness" is producing a devaluation of truth, excellence and artistry. In the era of crowdsourcing, we wonder what will happen to the role of the Artistic Director. Is there still space to cultivate a single individual's vision? Is the single artist's passion destined to vanish as we "devolve to the middle" and engage in groupthink? Who gets to determine excellence? The market? Does excellence no longer matter if "the crowd" decides what gets produced and disseminated? What exactly is the role (or is there one) for the curator; what is the role (if any) of the critic if anyone can write anything about a performance and have it widely disseminated quickly and easily? What is the nature of the dialogue between the arts organization and the community it purports to serve? If anything goes, does anything matter? These questions are substantially different from the question that has consumed arts organizations for the past 30 years or more: "How do we create an artistically excellent but still marketable product and sell it to the public?" It is time for us to adjust to the idea that technology is creating a world of continuous change and that as arts leaders and arts organizations it is necessary for us to fully engage with the difficult questions that technology raises, in the context of the work we do.

Return to my VR experience to consider one example of what this particular change portends and the issues it raises. From photography to movies to television to advances in recording technology and live streaming, the ways in which we experience art have been

enhanced and advanced. The performing arts sector has adapted to these changes, even as the live performance experience remains the core of our work. But VR raises something altogether different.

Imagine that instead of going to a movie theater, without even leaving your home, you put on a headset and enter an alternate reality. You are not in a theater with a crowd of people sitting in a chair facing a screen of projected images and surround-sound. Instead you are in a completely alternative environment that you are experiencing through the mechanism of VR; different in context but indistinguishable in its "realness" from the one you came from. Perhaps you are sitting right behind the cello in a chamber music concert; on a chair on the set of a stage where a play is occurring, in the middle of a dance performance in which the dancers are surrounding you and dancing around, above and even through you. Imagine as a dancer approaches you that you smile at her, and she smiles back. You tap the shoulder of the violinist and he looks up at you. Maybe he hands you his violin and you start playing it. We are not talking about the willing suspension of disbelief but the unavoidable suspension of disbelief. There are no signposts and no markers to remind you that there is a "real world out there." Rather the "real" world is where you are and comprises the events happening to you; the reality in which you are participating. In the not so distant past, this would have seemed a fanciful impossibility, the product of some sci-fi imagination of a world several centuries from now. Today, it seems not only possible but also viable. Even in its nascent state, VR technology challenges our long-held understanding of live performance as unique and irreplaceable.

While I am certain artists will develop new projects using VR technology, what separates this particular technological advancement from others is that VR changes the *context* within which the art is performed, rather than the art form itself. Concert halls, theaters, dance studios and arts organizations have been created and designed, using "bricks and mortar," to create a specific context for experiencing art. We tend to think of them as backdrops, surroundings or encasements for the art and not always inherent to the art itself. The nature of touring performances, for example, reinforces the idea that the art is singular while the context is interchangeable: performances are thought to "remain the same" as they move into different environments. By replacing the "context" of the performance, VR could allow us to support the unique artistic experience. But it also may obviate the need to build these halls and present events in them if artists can create a VR space instead. That changes everything. I raise these questions because they are emblematic of the types of radical changes that are stimulated by emerging technologies and that we need to consider if we are to build and sustain arts organizations into the future.

I recently was at a talk by the eminent Congolese choreographer Faustin Linyekula. During his discussion of his work he spoke of his body as being ancient. He talked about the memory that exists in our bodies and how it is passed down from multiple generations, different from written formats that Western ideologies view as the repository of truth. He went on to talk about the irreplaceability of live human beings in a room together, breathing the same air, sharing the same experience through their bodies. But he also noted that his own children experience much of the world through their screens and devices and that perhaps the day will come in which the "live" experience is not anticipated, expected and revered in the way that it is today. For many of us this is a shocking thought. Yet these ideas demand our full attention as we guide our organizations into the future.

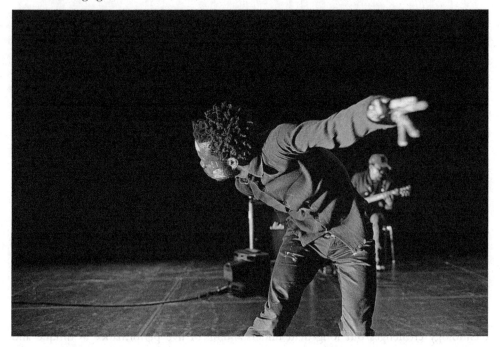

Figure 1.1 Faustin Linyekula, "Statue of Loss," Theaterformen Festival, 2014. Photo by and copyright by Andreas Etter

Changing demographics and the mass movements of people

Several years ago I attended a conference of presenters from the upper Midwest United States to talk about strategic planning, curating and artistic decision-making. At one session, a woman told a story that made a remarkable impression on me and helped to shape my thinking about the impact of mass movements of people and the changing demographics that ensue from that phenomenon. She was the director of a local arts council in a small town in rural Minnesota. She told the story of a new industry coming to town; a meat-packing plant. The company did a nationwide search for workers and within a few months had staffed up with several hundreds of workers whose countries of origin were largely Central America and Mexico. Seemingly overnight, a town that was nearly 100 percent white people of European origin had become one with a majority Latino population. She noted for us the dramatic effect this had on the arts council whose mission was to "serve the artistic and cultural needs of the local community." This remarkable demographic shift caused them to rethink how they understood their community's composition, character and culture and what programs they needed to create and support. Was it going to be Dickens' *A Christmas Carol* at the holiday season or was a La Posada fiesta now more meaningful to this community? Support the Ballet Company or the Ballet Folklorico? Sponsor the orchestra or sponsor the Mariachi Ensemble that was developing? This one small town's demographic shift changed everything about how the local arts council understood the needs of the community, what art would be relevant to their community and what types of programs and services they now needed to create and provide.

In one form or another, this is a story that is being repeated all across the United States and shows no sign of abating. In fact, the U.S. Census Bureau concludes:

The point at which the non-Hispanic White alone population will comprise less than 50 percent of the nation's total population has been described as the point at which we become a "majority/minority" nation. According to these projections, the majority/minority crossover will occur in 2044. While the non-Hispanic White alone population is projected to remain the largest single group, no group will have a majority share of the total and the United States will become a "plurality" of racial and ethnic groups.

(Colby and Ortman, 2014, p. 9)

On a more global scale, It seems that hardly a day goes by that we don't hear or read about another displacement of people; of huge numbers of individuals leaving, sometimes voluntarily but often not, to move to some other country or even continent to find a better life for themselves. Although it is true that migration of people worldwide is not a new phenomenon, it seems more sweeping than ever. At the end of 2014, the Migration Policy Institute noted:

The number of people forcibly displaced by conflict or persecution reached 51.2 million – the highest total recorded since World War II ... Refugee flows, while striking on their own at an estimated 16.7 million, are dwarfed by the staggering number of internally displaced persons (IDPs) in the world today The number of IDPs worldwide stood at 33.3 million people at the end of 2013, the highest ever recorded.

(Esthimer, 2014)

The effects of these mass movements of people, both across national borders and within individual countries, is creating an impact on the work of arts organizations that arts leaders have not always had to consider.

Given this reality, how will any of our largest and most well funded Foundations, our flagship arts and cultural organizations, many of which were founded on and embody the singular dominance of a now diminishing culture, continue to thrive in such a dramatically changing world? In the United States, we are facing a demographic sea change in which the people whose art has been characterized as "minority" or "ethnic" are rapidly becoming the majority of the population in rural and urban areas alike.

We often see these "culturally specific" art forms presented and celebrated in informal settings – festivals, street fairs, community celebrations – but rarely with the formal, well funded and societally supported infrastructure that sustains western European art forms. For some time now, access to funding support for anything other than large, Euro-centric organizations has been skimpy. In 2011 the National Committee for Responsible Philanthropy noted:

(Arts) Groups with budgets greater than $5 million represent less than 2 percent of the total population of arts and culture groups, yet in 2009, these organizations received 55 percent of all contributions, gifts and grants. In 2008, the top 50 recipients of foundation grants for arts and culture received $1.2 billion; in 2009, the top 50 received more than $800 million. Many of the top recipients are encyclopedic institutions that house or showcase works from around the world, but *none of them is rooted primarily in non-European aesthetics, or founded and run by people of color.*

(Sidford, 2011, p. 8, emphasis added)

In major cities, large arts organizations find it increasingly difficult to attract new audiences to the Euro-centric programming that has served them well for decades. Each year ticket prices go up but the attendance numbers remain flat or even decline. Major (primarily white) donors are aging and their children, despite inheriting their wealth, are less interested in these cultural icons than their parents were. The organization creates "outreach and education" efforts to "underserved communities" but these efforts generally produce little or no change in audience demographics for their ongoing programming. What does the future hold for an organization like this? How long can (or should) they hold on to "the way things have always been" before it is too late to change and the organization declines or disappears?

These facts of demographic change create complicated questions about purpose and intention for arts leaders and their organizations. What art survives and thrives in a rapidly changing socio-cultural landscape? Do we allow the market to determine the answer to that question? Are the huge dollars currently directed to large, traditional arts organizations to keep them afloat in a changing world appropriate, or is it time for that funding to shift to historically underfunded organizations whose work speaks directly to the communities they serve; communities that are rapidly becoming the majority culture? The challenge faced by my colleague in Minnesota is one that we share as a field. Crucially, will arts organizations see demographic change as an opportunity or a crisis, how will they shape their response and, more importantly, how will they remake their organization to reflect the changed reality of their communities and therefore remain cultural leaders?

These demographic shifts represent an extraordinary opportunity for arts organizations to not only embed themselves in the life of their rapidly changing communities but also to make a global impact. Governments tend to view migration and refugee crises through the lens of law and/or economics and search for a response in those arenas as well. They focus our attention on such things as the legal status of the refugee/migrant or what effect they might have on the local economy. Economically speaking, are these new immigrants a net positive, adding to the workforce and often doing the jobs that our home population is unable or unwilling to take on? Or are they a net economic negative, pulling on state-funded services that are already stretched to their limits? When the discourse is centered in these terms, it can bring out the worst of human instincts and behavior; individuals are seen as numbers on a ledger and not as the human beings that they are.

What is rarely considered is how these mass migrations place stress on the art forms and cultures of the migrants themselves, whose lives have been disrupted and displaced. In many cases the art and performance that is critical to their cultural and human identity has had to be left behind. The individual migrant or refugee now finds herself in an alien culture; often alone and isolated from everything she knows, understands and loves about herself as a cultural being. Once in a new country, immigrants are subtly, and not so subtly, compelled to adopt the culture of the country to which they have migrated and to move away from their home culture. This is a tragedy on so many levels; the loss for the individual to be sure but the loss to the world of specific cultural identities that have developed over centuries. We should wonder what will happen to Afghan, Syrian and Somali art and culture as those countries are decimated and their citizens dispersed across the world. We are shocked and appalled at the destruction of art pieces and artifacts in war torn countries; but we don't often think about or consider the less visible destruction that occurs to cultural identity when these forced mass migrations occur. Arts

organizations in the aggregate can, and should, play a prominent role in both sustaining traditional cultural expressions and creating cross-cultural and trans-cultural understandings and appreciations. Leadership by the arts in this endeavor can help create and sustain a full and enriched life for the individual, for the displaced culture and for the receiving culture as well, which now has the opportunity to redefine itself based on a changing population.

Some argue that it is the role of the migrant to adapt to the culture of the place to which they have come and there is some merit to this argument. Indeed this process of assimilation, diminishing or even abandoning one's native culture in order to accommodate socially to the adopted culture is a well-known immigrant strategy for coping with an alien environment. But how much richer for the society if it is able to assimilate new cultural offerings by: 1) accepting and supporting efforts to sustain the various cultures that are entering; 2) facilitating and encouraging the participation of new immigrants into the established culture of the society; and 3) facilitating the growth and evolution of a new, hybrid culture, one that is dynamic, progressive and speaks insightfully and authentically to the reality of an increasingly hybrid environment.

Simply continuing with "business as usual," especially under the misapprehension of the universal appeal and value of the dominant cultural expressions, is not a sustainable option. But for many of the dominant culture, this feels like loss. Defensive responses that ensue often stridently advocate for the intrinsic value of western European culture. This argument prevents adaptation in favor of cultural conservatism. I am thinking of the classical arts organizations in particular whose patrons resist mightily the introduction of anything new (new being a relative term) into the ongoing programming of the organization. Western European classical art forms deserve to exist and sustain. But so do other cultural expressions, especially when they are resonant for a growing majority of the population. It is not the destruction of western European aesthetic that is at stake but rather the recognition that artistic expressions from multiple cultures can and should be valued and supported as robustly as we have historically supported western European art forms.

This significant demographic and cultural shift also presents an opportunity to redefine what we think of as "mainstream" art and culture. In the same way that technology has democratized access to knowledge, changing demographics provides us the opportunity to build an inclusive and equitable culture, one that reflects the diversity of our people and the hybridity of their cultural expression. Arts organizations can play a vital role in both supporting that exploration and working to make it the norm rather than the exception, creating programming that reflects all of the members of our society, not just the privileged few. Imagine a symphony program that provides equal weight and prominence to classical work from cultures other than Europe; that presents, for example, classical Persian and Indian music alongside Beethoven. Rather than diminishing the European aesthetic, such a programmatic approach elevates the finest artistry of all cultures and provides insights into our shared humanity. It not only helps all members of our communities see themselves fully represented in the work of the organization, it also creates a growing realization that, in fact, profound artistic expressions occur in all cultures, crossing the tribal and cultural boundaries that too often seem to divide us.

Another demographic trend with which we need to contend is the shifting values of new generations. In the United States, the so-called Baby Boomers who built the nonprofit structures and organizations of contemporary America are now leading organizations increasingly staffed with people from subsequent generations, commonly referred to as

Generation X and Millennial.[1] Although these generational categories are not monolithic, it is worth noting that very often arts leaders are dealing both internally with their staff and externally with the communities that they seek to reach, with at least three different generational values and beliefs frameworks that are having an impact on how we shape the art and culture of our time, including its production and dissemination as well as its appreciation.

Boomers tend to be movement-driven organizational people who want to get everyone in a room and figure out how we are all going to work together to get from point A to point B. Hillary Clinton is a classic Baby Boomer and we saw that in her political campaign messaging that emphasized "stronger together." Boomers may wrangle about strategy but in the end, the idea is for everyone to "get on board" and follow a single path forward to the desired outcome. We see this idea played out graphically in the organizational structure and processes of most arts organizations with its nod to teamwork, but focused around a single organizational strategy or goal and a collectivized effort to get there.

Next-Geners had the (dis)advantage of growing up in the Reagan era, which tended to generate cynicism and "reality-based thinking" in response to the idealism of the Boomers. Gen-Xers are less taken by the expansive goals of the Boomers and more interested in simply getting the work done. To continue the political framing, Barack Obama was an excellent example of this, which is why one could say that he actually accomplished a great deal given the forces arrayed against him, but also incurred the displeasure of the bracketing Boomer and Millennial generations, both of which were disheartened by his general lack of "inspiration" as a leader (with some extraordinary exceptions, such as his all too infrequent speeches on race in America). Gen-Xers are gaining ground in the arts leadership world as Boomers retire, and may be what is keeping many arts organizations afloat – the "nose to the grindstone" ethos that focuses on strategy and implementation.

Millennials are truly ascendant and recently surpassed Boomers in sheer numbers as the largest generational cohort in the country. (Fry, 2015) They are the age cohort that, like the Boomers in their time, is categorically remaking our ideas about work and the meaning and purpose that underlies organizational being. This generation brings a new perspective to Boomer idealism and seeks to incorporate individual satisfaction with a desire to improve the world. This generation also grew up working in small groups at school, so they are comfortable with a more diverse and interconnected approach to accomplishing work. They can tend to be fiercely independent, chafe at the overarching authority figure and deeply committed to their individual ideas and ideals, within a social responsibility framework.

Broad generalizations about generations are ultimately less relevant than how arts leaders understand and work with a multi-generational staff who hold different outlooks and are motivated by different factors. Managing a workforce that is both generationally and culturally diverse presents a complex challenge, particularly for the current arts leaders of the Boomer generation, who tend to thrive when everyone is "on the same page" and may have difficulty accepting and working with groups of people whose values and approaches to work are so vastly different.

It's even more important to consider the changing generational nature of both the audiences for the arts and the communities themselves within which these organizations exist. This is most graphically illustrated with more traditional classical forms like opera, classical music and ballet, which have been financially supported by an older generation

and may now be expending extraordinary amounts of time, energy and money trying to "attract a younger audience." There isn't a time when the arts field wasn't decrying the lack of arts education in the schools, the pernicious influence of popular culture and blaming poor attendance at "classical" arts events on forces beyond our control. Arts organizations have devised all manner of schemes to "bring in the next generation" to meet and love this art form. Children's concerts have been de rigueur for virtually every arts organization for some time now and family programming for parents and children together appears now as an actual genre. Yet, if we look at the attendance trends for most arts organizations, this is an effort that has not borne fruit. As Sunil Iyengar indicates in his 2015 *National Endowment for the Arts* survey on arts attendance in the United States,

> Since 2002, adult attendance rates have declined for a core set of arts activities tracked consistently by the NEA. Thirty-three percent of adults attended one of those selected activities in 2012, compared with 39 percent a decade earlier. The declines were steepest for non-Hispanic whites, adults from 35 to 54 years of age, and higher educated adults (those with at least "some" college education).
>
> (Iyengar, 2015, p. x)

One of the problems with the much-used "special initiative" approach to "bringing in the next generation of audiences" has been their basis in generational misunderstanding and misplaced intentionality. Essentially, one generation believes that, through tools and strategies that worked for their age cohort, it can entice, educate or market another generation into not just participating but actively supporting forms of art and culture that do not speak to, or cohere with, most of that generation's cultural values. The idea in classical music, for example, of pre-concert talks or program notes as a way to bring in "the next generation" of audience is pursuing the next generation audience with the last generation's tactics and is seldom effective. Classical performing arts have great appeal for people of a generation (Boomers and older) that tends to value order, design and a quiet contemplative experience of listening and responding to performance that is deeply and personally felt. We like to sit quietly with our own thoughts and reactions to what we are seeing and hearing and are not necessarily interested in sharing our responses at the moment with those around us.

Later generations, however, can find this experience completely strange and even alienating. One need only attend a popular music concert in a stadium or arena to realize that the experience is about the audience almost as much as it is about the performer. This is a world in which the audience tends to stand and dance more than sit; of drinking and smoking during the performance; of unbridled camera use; of talking and texting; and of fireworks, real and imagined. It's tough to "sell" the interior, contemplative classical music experience to people whose concert experience is more, shall we say, energetic in nature. Both of these experiential desires are understandable and valid, and of course are not limited to age cohorts. In recognizing these values-based differences however, the implication that usually follows that one type of response to music is superior to another is clearly false. In today's culturally and generationally diverse world, we are called to accept not just an extraordinary diversity of art forms as having value, but also to accept that extraordinarily diverse responses to art are equally valid; and therefore equally supportable.

One other demographic change that is often overlooked by arts organizations, and which deserves our attention, is the topic of income inequality and the role this plays in the accessibility of cultural resources across communities. The performing arts in

America, as we have historically known and practiced them, are a largely middle class endeavor. We might rely on the wealthy to provide the multi-million dollar donation base for our organizations, but we also rely on the middle class, which is much larger, to purchase tickets. As a significantly smaller number of people control the vast majority of wealth in this country, that vital middle class has eroded; we have become a country of the very rich and the very poor. (Egan, 2017)

Underlying the ethos of nearly all performing arts organizations are two key ideas that create additional difficulty in relation to income inequality. One is that the arts must "pay for themselves" – that ticket sales should cover the cost of the art. Art that pays for itself is still held as a gold standard, even though if that were the case, there would be no need for the nonprofit arts organization, as the "product" would generate enough revenue to sustain and grow the organization. It does not and there is no evidence that it can. Whether it's government support or private funding sources, the arts are not (and should not be) a "pay as you go" phenomenon.

The rise in acceptance and prominence of neoliberal economics in the 1980s drove this shift in focus generally away from the "common good" and towards a deep and potentially destructive "every person for themselves" ethos. The result has been a commodification of the arts manifested in such beliefs and practices as a commitment to charge the highest price for a performance ticket that the market will bear. The challenge for the arts leader (or the arts marketer) was to find what that "sweet spot" was and price tickets accordingly. As this type of thinking took hold, we have inexorably drifted away from the idea that art should be accessible and available to everyone regardless of their income, wealth or class status. It is true that we have tended to maintain that posture in our "arts for all" rhetoric, but too often we have undermined that rhetorical belief, even when it was positioned as a core value of the organization, by charging the highest possible prices for tickets. We also did this because, having been edged into a mode of increasing earned revenue to support the work of the organization, we needed the revenue to survive. The result is what we see today: "ordinary people" – purportedly the primary audience for our work – are priced out of the experience, never mind individuals for whom financial survival is a constant challenge.

The more that the country separates into an ultra-wealthy leisure class and a significantly poorer working class, the more the arts return to earlier models of privilege and patronage. The development of the arts in the mid-1960s in the United States was predicated on the democratization of arts. In returning to the oligarchy that once prevailed, we move away from "arts for all" to "arts for a few," accompanied by some nominal outreach for the underserved. This should be an unacceptable result for all arts organizations.

Whether it's the increasing influx of immigrants into the community, the rising birth rates of what we once called minority populations, generational and economic shifts or the greater acceptance by society of diversity of genders and sexualities, there is no question that demography is remaking our constituencies. We will have to go well beyond outreach programs and special diversity initiatives to rectify the fundamental disconnect between what we say we value, how we think about and design our plans and programs and how we can possibly remain relevant to and receive the support of the communities we purport to serve.

Environmental change

In 2008, the rivers of the upper Mississippi flooded. In Iowa City, Iowa, the venerable Hancher Auditorium, cornerstone of the performing arts presenting program at the

University of Iowa, was underwater, closed and ultimately needed to be completely rebuilt. In the years between 2008 and 2016 when "the new Hancher" opened, the organization had to restructure its programming and find new performance venues and opportunities outside of what had been its performance home for decades.

In 2012, Hurricane Sandy struck New York City and the Chelsea gallery district, located on the west side of Manhattan and its Hudson River border, was particularly hard hit. The *New York Times* reported:

> "AXA Art Insurance, one of the largest art insurers, estimated that it would be paying out $40 million, and a Reuters report last week quoted industry estimates suggesting that insurance losses for flooded galleries and ruined art may come to as much as $500 million – or the rough equivalent of what the art insurance business takes in each year. That would amount to the largest loss the art world and its insurers have ever sustained.
> (Kozinn, 2012)

As recently as September 2017 Hurricane Harvey descended on Houston causing untold millions of dollars of damage to the city including a number of buildings in the renowned Theatre District in downtown Houston. (Granberry, 2017)

In each of these cases, the damage is primarily measured in the destruction of physical facilities or the art objects themselves, which is not to be discounted in any way. But what can't be calculated, and often is missing from the headlines, are the intangible recovery costs – not just what it costs to rebuild buildings, significant as that is, but the cost of rebuilding performance companies, programming initiatives and the audiences who had come to depend on these sites of cultural activity. Also overlooked in the drama of these environmental cataclysms are the smaller, more "close to the ground" grassroots arts organizations who are as vital to the health of the arts ecosystem as the large organizations. Chelsea, Hancher and the arts buildings in Houston will struggle but they will recover. Many smaller organizations will not. They are precarious organizations and an event like a hurricane or flood can mean the end of their existence.

These examples are vivid representations of one type of climate change devastation occurring in what scientists are calling the Anthropocene era, defined by the significant impact of mankind and its activities on the world's ecosystems. (Carrington, 2016) Although Houston, Iowa City, New York City and other locales might experience climate change as a sudden dramatic weather event, it is also happening in subtler and more long-term ways. Similar to the changes in technology and demographics, human-caused climate change is also occurring at an increasingly rapid pace, with hotter temperatures, global warming, rising sea levels, animal and plant species degradation and extinction, to list just a few. Technology has led to the development of fracking and other ways of extracting fossil fuels from the earth at the same time as electric vehicles are emerging as a serious alternative to the fossil fuel-reliant internal combustion engine, a major contributor to air pollution. The fluctuation of fuel costs destabilizes the planning and cost management efforts of every organization. Responsible organizations now look for ways to diminish their environmental impact in an effort to tread more lightly on the world around them, but often at great financial cost. Increasingly, we are all called to rethink our collective planetary impact and arts organizations are no exception.

As with changing demographics and emerging technologies, climate change presents both challenges and opportunities for the arts sector, stimulating us to consider innovative thinking about industry models and alternative ways of working that respond to the

changing external environment. Awareness of industrial food production, for example, and its harmful effects on humans and the environment has stimulated a resurgence of interest in local and artisanal food production. "Farm to table" means a closer relationship between the producer and consumer of food. It also means a heightened awareness on the part of the consumer of both the ingredients and the processes that have gone into the creation of the food we eat. In many ways, this can serve as a model for the live performance experience as its own "artisanal" experience; local, unique and accessible.

Similarly, over the last decade or so, many consumers have begun making decisions informed, at least to some degree, by concerns about environmental impact: fuel consumption, air and water pollution, resource consumption including water and fuel sources and a developing interest in renewable resources of all types. We see a growing awareness of how personal activity relates to a larger ecosystem, and what responsibilities this entails. A shift in thinking towards a vision of living in harmony with the earth and with those around us bodes well for society in general. The arts and their ability to address beliefs, values and ideologies can also benefit from this shift in thinking away from simply cost effectiveness and maximizing revenue and towards a more holistic view of what we do and how we exist on the planet.

Like technological change and demographic shifts, this is not a straight-line evolution. The voices of climate change deniers continue unabated, in spite of ample scientific evidence to the contrary. This is especially true in the United States, which seems to have taken a disturbingly isolationist turn with its withdrawal from the Paris Climate Treaties and rhetoric (if not yet action) by its President to build walls, both real and imagined, to try to isolate the United States from the rest of the world. Many of us in the arts can see this for the failing strategy that it is, but for now, it contributes to growing anxiety not just about climate change but about the sustainability of life as we know it on the planet.

In June of 2000, a film entitled *The Perfect Storm* was released which told the "based on a true story" saga of a fishing boat off the coast of New England caught in the confluence of two weather fronts and a hurricane. The "perfect storm" destroys the boat and all of its crew are lost at sea. Of late, the phrase "the perfect storm" has entered our lexicon as shorthand for this coming together of multiple unavoidable cataclysmic events to create previously unimagined devastation. I reference the phrase as a way of thinking about the nature of the world that we are all dealing with now, including the arts organizations that we are charged with leading. These three meta-trends are not operating in isolation from each other; in fact they are interconnected and interrelated and feeding on each other. No one disputes for example that the presence of social media has both hastened and exacerbated the impact of the demographic and environmental shifts occurring in the world.

Our initial response to this "perfect storm" is to either "hang on and ride it out" or "turn around and revert to a simpler way of life;" one that we once thought we understood and that provided us with the safety and security that we craved. But both routes are misguided and will take us in directions that, over the long term, contain the seeds of our ultimate failure. So how to proceed?

An insight I have gained from many years of leading arts organizations is that when confronted with an "intractable" problem for which no solution seems obvious, the answer often lies in reframing the question. That is, I contend, very much the case here. The question is not how to withstand the degree of change that we are in. The question instead is, how do we remake our organizations in such a way that they can get ahead of

these trends and can thrive in this world of rapid, dramatic and constant change. That is the focus of the next part of the book as I look more closely at what the specific implications of these change dynamics might be and then how we might set about reimagining our organizations to embrace the perfect storm.

Note

1 I use the generational definitions set out by the Pew Research Center (Fry, 2015, p.1) as follows: Millennials – Born 1981 to 1997 Gen X – Born 1965 to 1980 Baby Boomers – Born 1946 to 1964 Silent Generation – Born 1925 to 1945.

2 Reverberations of change

In the previous chapter, I looked at three macro-level drivers of change that are remaking the external context for the work that we do as arts leaders and arts organizations. Each of these meta changes reverberate in other areas of our world as well so I next want to look at some of the broader and deeper implications of these disruptive changes and what that might mean for our work as arts leaders.

Changing political/economic status

How vividly I recall the fall of the Berlin Wall in 1989 and the subsequent collapse of the Soviet Union in 1991. These two events were historical moments for the Western world with enormous real and symbolic power, appearing to represent the triumph of democracy and capitalism over authoritarianism and communism. Post-World War II global politics had been defined by the uneasy but accepted "balance of power" between two seemingly permanent superpowers, the United States and the U.S.S.R., also bringing us their proxy wars, diplomatic skirmishes and economic competitions. But with the undoing of the Soviet Union, liberal democracy with capitalism as its economic engine took on a triumphant aura of inevitability (not to mention moral goodness) as the sole viable economic system, at what in retrospect may have been the apogee of the 20th century.

In 1989 Francis Fukuyama published "The End of History" in which he argued, "The triumph of the West, of the Western idea, is evident first of all in the total exhaustion of viable systematic alternatives to Western liberalism." (Fukuyama, 1989, p.3) Although many scholars disagreed vehemently, the idea gained widespread popular currency.

What has transpired since then? Global political turmoil in all areas of the world including the West, the meteoric rise of (communist) China as a global superpower, the fragmentation of the European Union, extreme right-leaning political parties drawing noticeable support in all parts of the Western world, the continuing confusion and dissolution of politics and systems in the Middle East, Catalonian and Kurdish separatism and more seem to show that Mr. Fukuyama spoke too soon. By 2017 the idea that Western liberal democracy has triumphed seems absurd. If anything, we seem to be facing an even more unknown and unknowable political future than before.

The triumph of capitalism has also brought us a level of extreme economic inequality that seems nearly intractable and cements an ideology of big winners and big losers with very little room between these two poles. Multi-national corporations like Apple, Nike, Facebook, Exxon/Mobil, Honda, Royal Dutch Shell and dozens of others have arguably become the new political states as they create a global operating environment for themselves that transcends the political powers of the nation-state,

setting their own policies, picking and choosing where to "locate" to their best tax and (non)regulatory advantage.

Correspondingly, those who have been disenfranchised by the capitalist system are beginning to fight back. Movements like the Arab Spring, Occupy Wall Street, Black Lives Matter and any number of others across the world are emerging as a response to the oppression people are experiencing at the hands of those who control social, political and economic capital. We see these movements being driven largely through social media and immediate access to information that prior to the meteoric rise of social media as a communication platform was certainly slower and also controlled more tightly by the state.

Not surprisingly, a backlash to these movements can also be seen in the rise of religious fundamentalism, right wing ideologies and a host of policies and practices that were once considered "extreme": racism, violence, propagandizing and more have moved from the margins into mainstream political discourse in many countries. There is a growing sense, even or especially among those of us who may have thought otherwise, that we are entering a world of much greater political and economic unpredictability than we had thought we would be dealing with; one in which the accepted political realities are no longer the expected political realities. In fact, we don't know what to expect from our socio-political environment going forward; anything could happen and previous assumptions about "how things work" are no longer operative. Contemporary arts organizations are struggling to find a place within, not outside of, this contentious and unpredictable political environment.

Globalization has been redefined

Recently, a student of mine from China made the assertion that people in China know all about America; that they probably know it better than Americans. He attributed this to their watching television and movies and other media; that America is the idea of "the good life" that all Chinese aspire to. Although we might not be surprised at the reach of cultural distribution through technology, the truly important – and disturbing – part of the student's assertion is how he assumes that through cultural consumption, he believes he fully understands American cultural values, "better than most Americans." To my American students it revealed the reality that it's not just the event itself – the movie, the TV program, the consumer product – that is being shared with the world. Rather it's the cultural values communicated by the event, both implicit and explicit, that are transmitted along with the performance, whether we plan that or not.

Because the United States is so dominant in the global culture, it is easy to focus on the direct "U.S. out to the rest of the world" track. The networked effect of technology however, means that an American can similarly experience the art, culture and values of other cultures from around the world. It is this sharing of cultural values in such a prolific and widespread way that is indicative of how technology has helped change the dimensions of globalization beyond the import-export model that has dominated to one that is more diffuse with broader implications than just "learning about another culture." Technology allows us to immediately and often quite viscerally experience the complexities of "the other" including the cultural values embedded in every culture's art and performance.

Technological advances in communication have also made it possible for us to know, almost instantaneously, of any phenomenon, natural or man made, occurring anywhere on Earth. Many of us here in the United States were glued to our screens watching the events of the Arab Spring unfold in real time in Tahrir Square in Cairo, the uprising that

though probably not caused by social media was certainly intensified and widely distributed via Twitter and Facebook as much or perhaps more than more conventional broadcasting means. This happens repeatedly and in all parts of the world, many of them quite distant and remote from whatever our "real world" location is.

Moreover, we don't just know about these phenomena; of whole communities and societies confronting poverty, war, feast and famine, political disruption, human trafficking and exploitation. Thanks to sophisticated technology, we also more deeply feel the immediacy and the intensity of their pain, their suffering, their joys and their sorrows. We experience them being played out for us on our (increasingly higher definition) screens at all times and places. It is difficult to watch what happens in the world and not feel a sense of outrage and an urge to "do something" while at the same time feeling powerless to actually do anything.

Technology has also forced us to reckon with not just how interconnected we are but how interdependent we are. From an economic perspective, consumption in one part of the world arises from production in another. Drug producers in one country require drug users in another. Isolation in any form; economically, politically, socially and, yes, artistically, is both a myth and an impossibility. In addition, nationalist fantasies of state control and isolation notwithstanding, climate change and environmental degradation also are not beholden to political boundaries established through war and occasionally diplomacy. Global warming, rising seas, melting icecaps and destabilizing weather patterns are global events. When a volcano erupts in Iceland, the ash blankets the whole of Europe and disrupts air travel for the entire globe. Pesticides sprayed on one farmer's fields are borne on the wind to other farmers' fields, and infects their crops.

While conversations strategizing about how (or whether) to adapt to globalization proliferate (Davos, the G7 summits, the World Economic Forum to name only a few), they too often exist primarily in the realms of economics, politics and the military. Rarely are arts and culture driving this dialogue, marginalized as they are in categories of "soft power" or "cultural exchange" – nice to have but not central to the conversation.

If we are to truly understand and reckon with what it means to live in an interconnected and interdependent world however, we will have to understand and reckon with the core issues of identity, empathy and meaning that are the substance of cultural creation and artistic production. By excluding the arts from the global discourse, globalization conversations, policies and practices become contextualized largely in terms of power, dominance and control rather than compassion, collaboration, mutual respect and cultural comprehension. Acknowledging the relevance of the arts to the way we approach the challenges of living in a globalized world and inserting the arts fully into the global discourse, we might do better at finding ways to create, not just destroy, human relationships of hope and possibility.

Globalization is also paradoxical in that humans strive to belong to both tribe and planet. We want to be surrounded and nurtured by those who are like us, even as, in this era of interdependence, we want to be included in the globalized world. As arts organizations in a globalized world then, it's not enough to simply present and produce work from other countries. It's not enough to create one to one artist exchanges as a way of learning about "the other." Through the arts we find ways to create multi-faceted and multi-directional conversations about culture and identify within our communities and in collaboration with communities quite distant from us as well. We can experience and explore our differences and our commonalities as people through art and culture;

and we can begin to chart a course towards a new vision of humanity that can co-exist in an interdependent global environment.

Sentiments such as these are often dismissed for their "lack of reality," their naiveté and their "softness." But most of us who work in the arts have witnessed performances in which individuals from multiple cultures come together to celebrate and discover their common humanity. One of my favorite arts experiences was the Buena Vista Social Club tour of the 1990s when this band of legendary Cuban musicians made an extensive tour of the United States that showed Americans what the human cost, to us and to the Cubans, had been of the decades long failed political/economic policy of the United States towards Cuba. You couldn't watch that concert without feeling an immense sadness at how our country's intransigence had deprived these musicians of their voice and deprived Americans of their unique artistry, emanating as it does, as all art does, from a profound cultural sensibility; often one that is not dissimilar from ours or that of others.

Similarly, my multiple experiences with African contemporary dance companies like Faustin Linyekula/Studios Kabako from Congo, Compagnie Tchétché from Côte d'Ivoire and Qudus Onekiku from Nigeria have only increased my deep respect for and appreciation of their approach to their work. In each case, their artistry is at the center of their work, but it emanates from there to survival strategies, community building and even peace making in an often-violent world. My experience with each of these companies has been one of profound artistic engagement. Enabling audiences to see themselves through the creative work of artists so geographically and culturally distant from us can be a transformative experience. If the arts and culture were, in fact, integral to the globalizations discourse we would likely find many more avenues to create a collective humanity that recognizes the interdependent world of the 21st century.

Institutions are devolving

With decentralization and the networked relational dynamic of the Internet comes the devolution of institutions built on the hierarchical, linear structural models of a previous age. This includes government, education and religion as well as the arts. We struggle to maintain those hierarchies and centralized systems of governance, even as the contemporary world tells us something quite different about how best to organize our institutions of collective purpose. One of several places we can see this is in the evolving structure of public education in the United States.

Built on an 18th century model that first met the needs of agriculture and then of 19th century industrialization, public education's idealized purpose was to create and develop an educated populace to insure democracy's viability as a governing system. Classrooms and curriculum were created on a centralized model of socialization and a "universally accepted" body of knowledge that an educated person needed to know. That body of knowledge was built on a Euro-centric foundation as was the system itself, with the white, male property owner its primary beneficiary. As contemporary society has diversified and as formerly marginalized groups began to emerge into positions of power demands were placed on the system for new ways of thinking, learning and teaching that could more effectively respond to the changing and diversifying environment. The public education system as we had known it could not withstand this degree of change without having to remake itself, a process that is currently, and controversially, underway, calling into question the very viability of a centralized public education system as we have known it. Not unlike the deterioration of the "arts for all" concept, "education

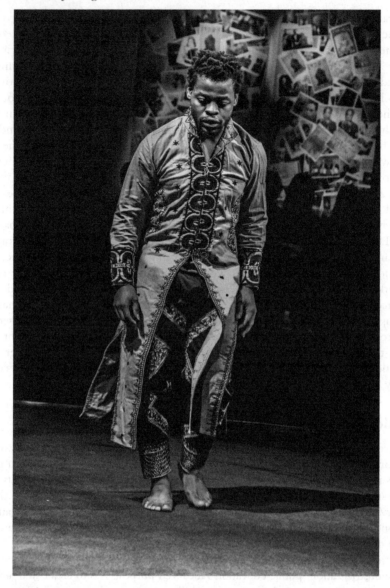

Figure 2.1 Qudus Onekiku, Africaman Original, 2015. Photo by Logo Olumuyiwa

for all" has also devolved into "education for those who can most afford it." Alternative ideas, strategies and programs are emerging that can create a new system that embraces and accounts for a diverse population with diverse values, experiences, desires and needs. But the speed of change in the external world to a globalized, networked, technology-based world has outpaced our ability to transform public education to meet the realities of that changing world. The consequence is a patchwork of ideas, ideologies and schemes (charter schools, vouchers, home schooling, etc.) that suggest potential innovation but also signal a decline in our societal commitment to free, universal public education.

Figure 2.2 Faustin Linyekula, "Sur les traces de Dinozord," Photo by Steve Gunther/Calarts REDCAT 2017, Los Angeles, 2017

A similar process is occurring in the world of the organized performing arts in which previous models of "the way things work" are proving to be inadequate for a changing environment. Frustrated by inaction and a lack of ability for many of what we understand to be our major cultural institutions (symphony orchestras, ballet companies, opera companies, regional theaters, arts centers, museums, etc.) to adapt to a changing world, alternative voices are emerging calling for new models, new ways of working and a re-evaluation of the centralized, corporatized, nonprofit governance model as the primary mode of operation. Large and mid-sized organizations, built and developed on these models of the previous century, are finding themselves stressed on multiple fronts (revenue, audiences, staffing). Smaller organizations are striving for "scalability" but are also exploring new ideas of what exactly that might mean. Does it really mean becoming more like the organizations to which they have to this point served as an outlying alternative? Or does it mean creating a whole range of diverse, innovative organizational models that will more effectively respond to the contemporary world; smaller, more local, nimbler, adaptable and embedded deeply in the community? As with public education, it is frightening for some, especially the formerly dominant culture, to imagine the demise of what they have known as the stability of the "institution." But for many others, it is energizing to imagine the possibilities of what new institutional paradigms we might create for a changing world.

The interaction between an arts organization and its community can, and should, be the signal of the life and vitality of the organization, not its budget size nor its staff size nor the prestige of its Board or the architectural significance of its building. By focusing more on the energy of the art, the importance of and immense possibilities inherent in the interaction of art, artist, organization and community, and much less on the

structures that created and support the institution, arts organizations can redefine institutionality as something vital and dynamic and not the deadening force that we have come to understand as the essential character of the institution.

Embracing new realities

Having looked at the environmental shifts that are occurring and some of the implications these hold for understanding the world, it is clear that for many arts leaders, it is time for an "attitude adjustment," something that can be quite difficult for those of us of a certain age who have invested a substantial portion of our lives and careers in learning how to effectively function within the system as we have known it. But with that system changing the way it is, so fundamentally and so quickly, we cannot hope to continue to be successful by playing the new game by the old rules. So here are some thoughts on new perspectives about how we work that can help guide our thinking as we move our organizations forward into this new era.

Context matters more than ever

Sometimes in talking with colleagues, it's as if none of the changes of the last decades have occurred. With print media in full-throated decline for years now, many arts leaders still obsess over whether the major daily newspaper will run a review or not. Looking out at a sea of white hair in our audiences, we still worry about whether our core audiences will accept "new forms" and whether programmatic change will alienate those core supporters. We often lose our nerve and end up catering to those audiences, replicating programming from decades past, then wonder why we aren't getting younger audiences. This "donor tyranny," this paralyzing fear that "too much change too fast" will alienate our core audience and we will lose them, even though they are an ever-diminishing subset of our community, hinders our adaptability. We want new, younger, more diverse audiences at our performances, but we want them on our terms. We then cannot understand why audience development and diversity "initiatives" that employ old tactics in a new environment don't lead to change.

Ironically, by refusing to change the programs we create and the context within which we create them in ways that acknowledge new community realities, we are losing, not preserving, our future. For years we operated with the maxim that it is easier and cheaper to sustain current audiences than to find new ones, and we built systems and structures that supported this idea. But now, those audiences are aging out of our organizations. The organizations that thrive in the future will be the ones that recognize the changes in demographics, politics, socio-economics, technological and cultural shifts that I have discussed so far, and be willing to reinvent themselves to take advantage of the opportunities provided by new audiences and new communities.

There are no certainties

As much as we would like to have the assurance of some immutable and unchangeable "certainties;" that there is a "way things work" that we can all strive for, it seems clear that this is not the reality of the contemporary world. It's not just that the "old ways" are no longer working and we need to find "new ways of working," though certainly that is true. But the underlying premise of any strategy for moving our organizations into the

future must be based on the idea that whatever works now will only work "for now," and that we can't get too attached to present day strategies as our permanent solution. I often use the metaphor of surfing to describe the nature of the new environment in which we are operating. We are riding a wave that for short periods of time feels solid, but the truth is it is not solid at all. In fact, it requires every possible skill we have, and some muscles we are not accustomed to using, to stay on top of that wave. It also means that we occasionally will "wipe out" and have to swim our way to shore, start over and try a different approach, especially now that the winds have shifted and the waves are more treacherous than ever before. I can't think of a better way to describe arts leadership today.

Uncertainty about sources of revenue too often remains the dominant concern for arts organizations and we spend far too much time and energy trying to find that magic bullet of stable, ongoing funding for our organization so we can stop worrying about it. It's not there. I once heard Suze Orman, the pop financial adviser, say on her television show that money was like air – no one claims it's their life's work to get air, but no one can live without it. That is a good way to think about the need for revenue for arts organizations. It's not why we exist; but we have to have it to survive.

We must accept a level of economic precariousness as the reality of being embedded in the market-based economic system. We may wish for an alternative, and there is no doubt that we should work to discover and implement an economic system that reduces the vulnerability to which the market ideology subjects our artists and our arts organizations, but until then our very real challenge is to accomplish our work in an atmosphere of extreme and ongoing revenue precarity. Perhaps our most creative work, and the work we need to continuously pursue, is to find, develop, exploit and maximize every possible revenue source we can that enables us to create art.

We also need to let go of any idea that there is a permanent fixed structural state to which we can or should aspire. Over the years, we have developed huge administrative infrastructures that often dwarf the artistic staff, to support our work. We adopted the "C-suite" lexicon of the business world and now we have CEOs, COOs, CFOs and CTOs (Chief Technology Officers) to run an arts organization. We fill our Boards with business leaders who intimidate arts leaders with their exhortation to "behave like a business" and punish those who don't. Yet it is the art, the performance experience, that needs to survive, not the structures we have built around it. The new word of the moment in the arts world is "nimble" and not just for small emerging organizations. Even major institutions need flexible, adaptive structures and systems that can respond quickly; growing and diminishing as needed.

As someone who has successfully run several large arts organizations and worked with dozens of artists to create their performance projects I know full well that producing and creating art does in fact require infrastructural support. My argument is not that art does not need infrastructure but rather that our priorities and emphases have become skewed; we have invested far too much in creating and sustaining the perceived stability of infrastructure. Now that we know this is a dead end for us, how can we build infrastructural support – organizations, systems, processes and people – that enable rather than overwhelm the creative process?

Loosely organized works in progress

I recall speaking with a choreographer once about a new work she was creating in which she had been able to bring on multiple presenters as commissioners, including me. At a

meeting with the presenters, the conversation turned into a bit of a dust up over who would get "the premiere." Since we were all giving equal amounts of commissioning money, it was not immediately obvious. Finally, after being quiet for some time, the artist explained to us that her work was always in a state of progress and development; that each performance informed the next one and in different ways so, frankly, we could all claim the premiere if we wanted to because the performance was going to be different at each venue. She wasn't striving for the "fixed end" for the piece; it was a continuous work in progress. What was most interesting about her intervention was that it brought clarity to the contradiction inherent in the way artists think about their work and the way we as organizational leaders, who have invested in the commodity production model for art, think about art.

Unlike my choreographer colleague, arts leaders tend to think of artistic creation in terms of a planned, linear process focused on the production of a neatly completed outcome. We produce a season of plays, rehearse an orchestra and create a dance piece to be toured to several theaters across the country. We plan our seasons multiple years in advance and develop our organizational support, including key elements like our development, marketing and communication strategies, to accommodate that process. But when we look at the actual creative process of artists, we see that many artists are working to create live experiences that do not fit neatly into our predefined timelines, systems and structures. The concept of loosely organized works in progress would be a remarkable and energizing way to think about our organizations.

It's a world of mash-ups and mixtapes

Last year I went to see a performance event in an abandoned storage facility in downtown Los Angeles that allowed the audience to freely roam among the installation; a nightmarescape of seemingly randomly placed objects. Above us a string quartet played classical music on an overhanging balcony; costumed actors wandered among us reading poetry and it all culminated in a visual and aural cacophony of music, video, theater and visual art. The crowd, mostly in their twenties, loved it.

We have entered an artistic world of mash-ups, which combine disparate samplings of creative output into a loosely bounded performance experience and audiences are demonstrating an appetite for this multi-faceted, hybrid work. Technology has extended the creative reach of artists beyond the confines of the proscenium theater and opened up these possibilities of augmented reality, mixed media, multi-media, trans, cross and multi-disciplinary creative work, much of which defies categorization. This concept of the mixtape and the mash-up, of loosely organized chaos, is exactly right for the 21st century. People can, and often do, hold disparate ideas, cultures and experiences in their heads at one time. Arts leaders can also create mash-up organizations and support systems that cohere with rather than fight against the process of artistic creation. Moreover, audiences have expressed a willingness to embrace this loosely organized chaos as an experience they desire. Organizational survival will now rely less on structure and discernable patterns and order and more on the mash-up of different elements, loosely organized to work together. The fixed rules of theater etiquette, for example, start on time, sit quietly in your seat, no cell phones, no cameras, no unwrapping of candies, no talking, etc., may need to go by the wayside in favor of our ability to create a more energized and "live" experience that appeals to an audience that is comfortable with the unexpected, live performance experience.

Reassessing ideas of growth and sustainability

In the last several years, we have finally begun to acknowledge and contend with the results of mass industrialization in all sectors of our society. Food production and consumption is one particularly relevant place to look for insight into how we are rethinking the idea that "bigger is better" and "more is even better" and that any strategy to increase output, even at the expense of quality or safety, is desired. After decades of industrial food production, we have come to the recognition that there are significant downsides to this mass production of food. We have sacrificed unique flavors and extensive diversity of food for low price and convenient access. Off-season fruits have little specific taste, and the energy required to ship blueberries from Chile to the United States may ultimately cost us more than we can afford from the standpoint of environmental sustainability. We also know that extensive uses of pesticides, genetically modified food and other synthetic approaches to food production have created losses not just in taste but also in health that potentially offset any decline in price or increase in accessibility. Getting what we want, when we want it and at a price we are willing to pay has proven more costly in unanticipated ways. As a result, we have seen a rise in "slow food" and the desire (not just among the economic elite) for what we might call a more artisanal approach to what we grow and eat.

If we apply that same artisanal thinking to the arts, it opens us up to imagining multiple new sustainable, artistic opportunities. We want to be able to create transformative performance experiences for audiences and communities that also respect the environment and recognize the resource consumption required to produce them. In an age in which we can go to our nearby, very comfortable, movie theater to experience the large, prestigious performing arts ensembles like the Metropolitan Opera or the National Theater of Great Britain, how can local arts organizations compete in the traditional fields of production values, talent and prestige? Most likely, they cannot. But what they can do is change the rules of engagement and the metrics of success, reinventing themselves as a source of creative, intimate and deeply satisfying live arts experience against which issues of scale cannot effectively compete. Many are doing this already and quite successfully. But their success is based on creating a transformative live experience, not on the prestige of the company itself and not by striving to become larger arts organizations.

There is an extraordinary and unique value in the relationship that develops between a community and the artists who live and work within that community; it's a chance to build a lasting connection and a rapport between artist and audience that also has the potential to deeply embed the art and the artists into community life, reaching individuals who actually don't know (or care) who the Royal National Theater is but who are yearning to see themselves and their lives reflected on the stage. It's a chance for the community to recognize art as integral to their life and their community and not simply a high profile visit by an "accomplished master" of the art form. These are not mutually exclusive experiences; in a healthy community, the large-scale, expensive event can exist alongside the small, locally produced event. The commonality should be their transformative effect on the individual audience and on the life of the community.

Adopting an ecosystemic point of view

These major environmental shifts are interrelated phenomena. But through the linear, compartmentalized methodology that we usually apply to our work, we have tended to

focus both separately and sequentially in the way we think about the challenges we face. We often see this in our discussions of "priorities;" what is going to (or has to) happen first and what is going to happen later, if at all. Although it all seems very sensible, the thinking behind it leads us into a narrow, linear framework of dichotomous choices: if we do one thing we will have to sacrifice another. It also leads us into the unfortunate question of "balance;" whether it's work-life balance, programming balance or budgetary balance, the end result is always the same: something has to give way or be sacrificed for another. This is not healthy thinking for the arts.

An ecosystemic point of view turns that thinking on its head as it recognizes the interrelatedness of our endeavors and the need to integrate our work rather than "make the hard choices," another very popular phrase that more often than not ends badly for the organization. Just as the Internet has established for us a networked way of thinking, communicating and sharing information, an ecosystemic way of thinking views the organization as a dynamic, ever changing entity of loosely linked "organisms" that fully integrates all aspects of the organization to create a healthy and vibrant ecosystem. This metaphor extends externally as well. Our organization is only one ecosystem interacting with a range of other ecosystems (social, political, financial, etc.) that comprise our larger community of which we are a necessary and vital part. Our community fails if we are not actively engaged with the other ecosystems in advancing our work together towards a healthy state of being.

What does this mean in real terms? It means that as an organization we recognize and promote our interdependence and interrelatedness. It means we have no time for turf battles or internal competition for resources but rather take a holistic view of what we are accomplishing and work to create a healthy internal ecosystem. With an ecosystemic approach, we recognize loosely defined boundaries but acknowledge that they are overlapping and porous. We understand that any action we create in one area (art, budget, audience) will have an effect on the others and we need to think about this holistically, not in isolation from each other. We welcome the mash-up and the mixtape as models of ecosystemic thinking and acting and are eager to see what happens when competing arts and ideas collide.

The work we do as arts leaders is some of the most important work of contemporary civilization. But we have for too long succumbed to a limited vision: to be popular and financially successful; to contribute to the local economy; to create a better quality of life for people engaged in "more serious" pursuits; to provide a diversion from a life we frequently find difficult and depressing. We have accepted the free market, business-based ideology and tried to shoehorn ourselves into that framework and we have too often lacked the creativity of thinking to re-envision how we do our work. It is now time to be bold about the ideals we pursue and to be both creative and relentless about making sustainable arts organizations.

How we make that happen, how we remake the way we work to meet the demands of a changing external environment is the subject I turn to next.

3 Making systemic change

At the beginning of the Obama administration and in the depth of the Great Recession, Chief of Staff Rahm Emanuel famously said in an interview with the *Wall Street Journal*, "You never let a serious crisis go to waste. And what I mean by that is it's an opportunity to do things you think you could not do before." (Emanuel, 2008). Although he was subsequently rebuked for what appeared to be a callous disregard for the very real suffering of people, a kernel of wisdom was embedded in this thought: when a crisis emerges and the old institutions, systems and perceptions of the world no longer seem to apply, there is an opportunity to try new approaches and create new solutions. That is the challenge that arts leaders face now and we would indeed lose an extraordinary opportunity were we to step away from that challenge. But to meet that challenge, we need to make significant changes in both how we assess the external environment and, most importantly, how we change the way we work if we are to develop strategies that move us forward rather than remain mired in current thinking that no longer applies. Our first step is to let go of some cherished assumptions about "the way things work" so that we can make room for the innovative thinking that is required of us.

Reframing the challenge

In 1982, when I began working at the Town Hall Arts Center (THAC) in Colorado, the organization was what we would now call a "start-up;" a community volunteer driven project to renovate the old Town Hall of Littleton into an Arts Center and launch it with programming of local and regional origin and interest. I was the first Executive Director. With our staff of three and a Board of "community leaders," we were an idealistic bunch with ideas that far outstripped our ability to accomplish them. We were "bootstrapping" our start-up arts organization, using the traditional structures and practices of much larger organizations: forming a Board, writing bylaws, job descriptions, etc. We were building slowly, and as best we could with limited funding, to create an arts center for our community in an environment that we all, as longtime residents, thought we knew pretty well.

About a year into the job, as we were still trying, with our very limited resources, to get our feet on the ground and establish a place for ourselves in the arts world of the Denver metropolitan area, I picked up the newspaper one morning to learn that a major entertainment complex was going to be built, with city support, a few blocks from our location. Suddenly, a level of competition (bigger, better funded, more glamorous) had appeared on the horizon. Overnight, the external environment had changed dramatically.

We turned to a local advertising agency for some pro bono assistance and went into a "planning" mode that began with a SWOT (Strengths, Weaknesses, Threats and Opportunities) analysis, as a basis from which we could develop a plan to move forward. This was an energizing process for us as a staff and we created what seemed to be a great plan for moving ahead; a plan that called for a bold new vision that would require a dramatic increase in resources. Too dramatic. The plan called for additional capital, both human and financial, that was well beyond the scope of our nascent organization. After a lengthy Board discussion, the plan was shelved and we were left to soldier on as best we could, convinced that our "ongoing efforts" would enable us to survive. We limped along for about another year or so trying to sustain the organization but the capital we needed was not there. We were underfunded and unrealistic in what we thought we could do and what we thought the community wanted from us. Frustrated at my inability to make the organization thrive and stymied by a Board that refused to face the realities of the current environment, we "mutually agreed" that I should leave the position. The organization went quiet for some time and eventually, some years later, re-emerged as a community-based theater with significant city tax support; something that had been denied to us while I was there.

The lessons I learned from this position are many and varied. But the one that had the most long term impact on my future work was that in a dramatically changing external environment, conventional problem-solving tools (the SWOT analysis, the strategic plan) were not necessarily up to the task of making the changes that would be required for us to thrive in the new environment. The planning process and the SWOT analysis we did at the time were helpful, but they didn't give us the dynamism we needed; nor the insight into how we needed to rethink our organization nor the vision for the future that would enable us to build an organization from the ground up.

Most planning work, beginning most pointedly with the SWOT analysis, proceeds within a framework that accepts current practice as the norm and sees external (and internal) changing circumstances as counterpoints to "the way things should be." The Strengths and Weaknesses of the SWOT analysis that are more internally focused usually center on staff, funding, facilities and other key determinants of some ideal organizational infrastructure. Inevitably what comes up in these sections are deficiencies of resources – human, financial, physical, etc. – and the need to fix and/or increase them. In the more external areas of Opportunities and Threats, the Threats are easily identified: impending government budget cuts, a declining economy, the arrival of a major competitor (as was the case with the THAC), etc. The Opportunities section, which should be the place where the most generative, future oriented ideas can emerge, is invariably the weakest part of the plan. This is largely due to the fact that most organizations are entrenched in the work of our day-to-day survivability, the ongoing challenges of our internal weaknesses (there is *never* enough money, time or staff) and the specter of misfortune posed by our external threats. Who can think of opportunities or possibilities in this context? Let's just try to improve what we are currently doing!

The SWOT analysis can be the most depressing part of the planning process because, even under the best of circumstances, we too often come to the conclusion that our only way to advance from our current circumstance is to either "work harder," "work smarter" or (only semi-facetiously) "pray for a miracle," all of which are self-defeating ideologies that only make our work harder, not easier, and certainly not better. Although all organizations can certainly improve the way they work, I have rarely encountered an arts organization that isn't filled with people working as hard as they can and as "smartly" as

they can to accomplish an incredible amount of work with extremely limited resources. In that case, the SWOT analysis and subsequent plan do little to help us truly advance our agenda. If we are trapped by our need to sustain current organizational paradigms and preferences, our action options become focused on building and/or sustaining "what is" rather than discovering "what might be."

Let's look, for example, at a commonly noted Threat that I have seen in almost every arts center plan I have worked with: the "increased competition for the consumer's leisure dollars and time." Underlying this conclusion are some basic assumptions we accept without questioning: 1) performance experiences are a commodity consumption activity, 2) performances are a "leisure" activity, which certainly implies *optional*, and 3) that we are engaged in a zero-sum game: if another "leisure activity" consumes someone's time and money, it is *de facto* a net loss for us.

To address this threat then, we have implicitly set ourselves up for a limited range of problem-solving strategies and solutions: we need a bigger marketing budget so we can advertise and compete with other leisure activities; we need to reduce our programming because the market is saturated; we need to lower prices so we can (theoretically) attract larger audiences. We become trapped in a loop of conventional and ineffective responses, engaged in a struggle we cannot win. This is what worried us at the THAC about the event center opening down the street; how could we compete? Our planning process revealed to us that we could not; at least not with the resources we had available to us.

What we did not understand at the time was that the way forward could only be found if we could reframe the challenge. Reframing the challenge would mean changing our thinking about the context within which we elect to operate and asserting our identity, purpose and strategy accordingly. For example, rather than trying to compete with the entertainment center as a competing "entertainment provider" we could have reframed the context within which we were working and imagined ourselves instead as a cultural resource for the community rather than a presenter of entertainment. We could understand our purpose more broadly as being akin to a library or a museum; a creator and repository of cultural expressions to be shared with all of our community. In that framing, we wouldn't have worried that a huge event center was going to open just blocks from us. We would instead have positioned ourselves as something quite different; redirecting our messaging towards community value over sales, long-term over short-term impact, human scale over mass entertainment, meaning over amusement. We could have freed ourselves to create plans, programs and measures of success that cohered with our reframed context and a reinvigorated understanding of who we were and what we were really there to do. And within that new framing, new sources of revenue would have become available to us. By reframing the organization as a cultural resource, we could have likely tapped into funding from civic minded individuals, foundations and possibly even the city funding that had so far eluded us, rather than expecting, as we did, that if we could just do more "popular" programming we could sell more tickets and increase revenue that way.

If we apply this reframing idea to a larger context and not just specific organizational decision-making, we begin to see how our organizations, and the arts in general, can create a much stronger impact on our culture and our society. As an example, over the past several decades, many long established arts organizations in the United Sates, particularly those whose artists and audiences have been predominantly white have, in SWOT analysis terms, seen the changing demographics around them as a Threat to their ability to continue to operate as they have. Diversifying the program of an organization

in response to changing community demographics has too often been understood by such organizations as a "problem" to be solved or an "issue" to be addressed.

In order to make progress on this particular "issue" or "problem," organizations devised strategies to either supplement their "mainstream" programming with diverse artistic alternatives ("Black History Month" programming; "Discovery" Series, etc.) and/or create marketing strategies to convince "diverse" audiences to attend performances of what continues to be widely understood as the mainstream aesthetic. Within this framing, organizations trying to diversify actually end up solidifying a mainstream that centers the work of artists of the dominant culture and positions the work of other cultures as alternative. How many times have we heard an arts administrator bemoan that she created or presented work by artists of color, which attracted audiences of color, but those audiences didn't return for the "mainstream" program? If, however, we were to reframe the challenge of changing demographics as an opportunity to redefine "mainstream art," we might make some real progress in diversifying our art, our audiences and our organizations.

A former colleague of mine, Lenwood (Leni) Sloan, an African-American choreographer turned arts administrator, is the one who helped me to see this. Leni always said that "the mainstream is the stream you are standing in." In the early 1990s, he was speaking at a conference for performing arts presenters that I attended in Philadelphia, at which time he was the Senior Program Officer for Presenting and Inter-Arts at the National Endowment for the Arts (NEA). He had been asked by the organizers of the conference to present a session on diversity and the performing arts. I recall how he opened the session by saying first that he hoped he would one day be invited to speak at a conference about something other than diversity, a comment that served to subtly remind everyone in the room that we had already marginalized his voice to a specific, narrow channel. I'm sure the organizers thought of this as an important "issue;" it certainly was much discussed in the field. As one of the few African-American staff at the NEA, no doubt they thought he would be a powerful and important speaker. And he was. But he was still there primarily to "speak to the issue of diversity."

His simple, clear and direct message to performing arts presenters who want to diversify their programs was: "Book the work." Stop forming committees, commissioning studies, surveying audiences about "what they want," worrying about who is going to think what about your programmatic changes and inviting consultants to help figure this out. Just "book the work." With this direct call to action, he reframed for me and for others in the room how we could actually make progress.

Leni's words became a truism for me as, over the next 30 years, I reframed the programming context for every institution that I worked in to reflect the community we inhabited (locally, regionally, nationally and even globally) and the artists whose work I knew would be powerful and transformative. I worked to change the idea of the mainstream by "booking the work." And lots of it.

Season after season at organizations large and small, urban and rural, I "booked the work" of artists of color. I strived for every season to be fully integrated with a substantial amount, sometimes a majority of any given season, of performance work by artists of color who spoke eloquently and profoundly to all of my community. I did it not just because it was the right thing to do, which it was, not just because it sold tickets, which it did, not just because it was great work, which it was, not just because it would expose audiences to work with which they were unfamiliar, which it did, and certainly not just to attract audiences of color, which it also did. I did it because Leni's words caused me to rethink my programmatic framing and when I did that, the right strategies emerged.

Arts leaders have the power to reimagine and reframe the idea of the mainstream. Denying equity of access to artists of color in this country has meant that "essentially white" cultural expressions have predominated; not because the work was necessarily superior but because of the power inherent in the act of claiming place and framing the conversation in these terms. The artistic reframing that we all must do now is not to address "the issue of diversity" but rather redefine how we think about art and culture in the context of the contemporary world. A SWOT analysis and strategic plan will not get you there.

We are all familiar with the phrase "If it ain't broke, don't fix it." But another colleague of mine whom I admire and respect, Jed Wheeler of Peak Performances at Montclair State University in New Jersey, has noted that a better maxim for arts leaders might be, "If it ain't broke, break it." Our major challenge going forward is to challenge and, more often than not, break the inherited paradigms that underlie our approach to our work.

Caring about the wrong things; dethroning data

As a performing arts presenter at the University of Arizona, I was both blessed and cursed with a single, 2,500 seat theater as my only available performance space. The blessed part was the "conventional wisdom" that with that many seats one could conceivably do performances that would pay for themselves through ticket sales. The curse is that a substantial number of the artists that I sought to bring to our community were not creating work large enough in scale to really fit such an enormous theater. Over the years we found some alternative spaces but in many cases, we had no choice but to present work in the huge Centennial Hall. When an artist came to town, I would find myself in the uncomfortable position of explaining that there would actually only be a few hundred people in the audience, not a few thousand. Most artists understood that; they had never expected that they would draw an audience that large anyway and were grateful for what we were able to do.

I remember in particular however the first performance in Tucson by Liz Lerman Dance Exchange in which I had this conversation with Liz before the performance. Liz very kindly said in response, "Ken, we dance for who came to see us. We don't worry about who is *not* here." Of course this made me feel better at the time, but it also illuminated for me the contradiction we face as arts leaders; that what we should (and usually do) care most about is the artistic experience of the audience. But what we often wind up caring about more is the numbers – attendance, revenue and statistics that serve as proxy measurements of success. Especially in the last decade or so, data, data analytics, mega-data and other quantifiable measures have been internalized by arts organizations as the primary markers of success. We spend enormous amounts of time and money to track and analyze our audiences; we count success by the numbers – total attendance, percent of house, net revenue and other such quantifiable measures.

Organizations crave "objective affirmation" that what we are doing works; i.e. that the strategies we are pursuing are successfully moving us along the path to a fixed goal. Our funders and other supporters demand this same data; "objective proof" that we actually accomplished what we set out to do. To that end, we have become smothered in data; in SMART (Specific, Measurable, Achievable, Realistic and Time-bound) goals as the holy grail of organizational planning, a rubric that is guaranteed to produce a careful, prudent arts organization, but often one that is also unimaginative, uninspiring and

Figure 3.1 Liz Lerman Dance Exchange, Virginia Commonwealth University Dance and community members in Liz Lerman's *Still Crossing*, as staged with Dance Exchange in 2017. Photo by Sarah Ferguson

lacking in heart or making meaning for our community. We have created a widely adopted paradigm of success that tries to squeeze our vision, our passion and our artistry into the quantifiable boxes of data demands.

We see this happen in so many ways: programming conversations that often center around "what sells" more than what is brilliant artistry or particularly relevant to the community; "artistically successful but financially weak" programs that get pushed aside in favor of the "money makers" and the "tent pole" events; budget conversations and marketing projections that center on ROI (Return On Investment) and "percent of house sales." Conversations about impact, about how an individual or a community is transformed through art, about beauty, or ideas, or passion or joy are viewed with suspicion; unquantifiable and therefore "not really reliable" and too often dismissed as interesting but of no real value.

The overreliance on quantifiable data also undermines our belief as artists and arts leaders, as well as audiences, that we can turn to our own intrinsic, instinctive responses to art as a way to make assessments about things like truth, beauty and meaning. It is time to reframe our thinking and redirect our passion to "dethrone data" and advocate ceaselessly for the primacy of storytelling and witnessing, emotion and feelings, spirit and soul as markers of success.

Our overreliance on data has other problems as well, with far reaching consequences for the arts. The use of algorithms to define "preference," we now know narrows rather than expands our choices and our thinking, providing us with more and more of what we already know and like. Anyone who has experience with a music or video streaming service knows what that means. "Here are more songs, or more movies that you might like because you liked these songs and these movies." The echo chambers that we live in

become ever smaller as reliance on data causes us to constrain what opportunities we have to encounter anything outside what we already know. As artists and arts leaders, we need to be at the vanguard of arguing long and hard for expanding horizons and providing platforms for new and alternative voices, for the beauty of complexity, for the necessity of nuance and for the value of indefinable and unquantifiable phenomena.

Releasing the grip of data and quantifiable metrics on our organizations will, almost by definition, inject a certain degree of ambiguity into our orderly arts organization world. Imagine the Board member or Foundation Program Officer reading our programming report to attempt to assess a performance's value but without the numbers. Instead of a quick glance at attendance and revenue data, it would require reading and digesting diverse stories and competing perspectives: few people attended, but some of those that did described it as a transformative life experience. Success or failure? Hundreds of people attended, many but not all had a good experience, but only a few call the experience life changing. Success or failure? Money was lost on the engagement but audiences are clamoring for a return visit by the artist. Success or failure? The artist was not feeling well and stumbled through what he or she considers a subpar performance. But the audience loved it. Success or failure? These are common scenarios for arts organizations to experience. The data we usually look at to judge the success or failure of any given performance, or even of our organization as a whole, tells only a part of the story.

Funding and success measurements should no longer be just easily assessed data points. We need the stories, we need the testimonies, we need the ambiguity and the uncertainty that is embedded in human response to art. While I was at YBCA, we developed a multi-dimensional matrix for program evaluation that included not just the usual attendance figures and box office revenue but also our own assessment as curators of the artistry and impact of the program, the artist's assessment of his or her own experience and qualitative response to the performance, audience testimonials about impact and external critical response to come up with a fuller assessment of the value of what we were doing. We would bring these assessments to staff and Board meetings for discussion and review. Data was the least of it. Although arts administrators may be challenged by such an approach, artists and arts leaders will rejoice if we elevate multi-dimensional, qualitative assessments over data-driven snapshots.

Redefining the "mainstream," de-emphasizing data in favor of a complex, human-centric approach, and using these perspectives to frame how we begin thinking about alternative futures for our organizations will be a challenge for us. But it is work that we must do.

If we start with these two meta level changes in thinking – reframing rather than just tweaking the current context and prioritizing human response to art over data points on a spreadsheet, then arts leaders will have begun the process of making their organizations more relevant and responsive to the world around them. But there are other practices and beliefs that have seeped into our thinking that also need to be challenged if we want to make forward progress. Many of these I would put under the heading of *best practices*, an insidious idea that has appeared in our thinking that needs to be rethought, remade or even abandoned.

There are no best practices

Several years ago I was on the Board of a nonprofit arts organization that was struggling mightily with issues of equity and diversity. The group had recently made some

deliberate efforts to diversify the Board (i.e. we had asked more people of color to join the Board) and it was now more culturally and ethnically mixed than it ever had been. The leadership however had remained largely white and the culture of Board meetings, discussion and processes was relatively unchanged from the practices of the previous 30 years of the organization's existence.

At a planning retreat that year, we sat around a table discussing the immediate future of the organization and some contentious ideas were beginning to surface. The Chair of the Board was running an effective meeting, following Robert's Rules of Order for meeting discussions, keeping careful track of who wanted to speak when (who raised their hand first) to insure fairness in giving everyone the chance to speak and be heard. Of course, this often meant that threads of conversations were disjointed, as people wanted to respond to something someone said five comments ago. Ideas were being advanced but progress wasn't really occurring. People had their equal opportunity to speak but so often out of context that it was difficult to know where the conversation was headed. And it wasn't even really a conversation but more of a series of declamations by individuals who had something to say about which they cared deeply. Finally, one of the members of the group, a Latina woman, had had it. "What is this Robert's Rules of Order thing?" she asked. "In my world, everyone talks when they want and we actually have real conversations! And everybody gets a chance to speak!"

I was not alone in being both surprised by her outburst and, at first, quite certain that she was wrong. This was the way "professional" meetings were supposed to be run. Most of us shared this unspoken understanding. To do what she suggested would, we assumed, lead to conflict and potentially chaos. And, besides, while it was certainly a highly structured process, it nonetheless seemed fair in that it allowed everyone an equal chance to speak.

What we missed was that the process itself was getting in the way of our ability to have what we really wanted: a full and frank discussion among people of diverse backgrounds about what our organizational priorities needed to be. We were prioritizing structure over content; rules of engagement over substantive dialogue. This may not have been what we intended, but it was the consequence.

It was a challenge for those of us steeped in this culturally constructed way of working to recognize that in fact we could, and probably should, change how we managed this conversation. But we did.

We loosened up the speaking order to allow for freer discussion; we let conversations ramble on rather than "stick to the point" in order that people could fully express their point of view. We learned to encourage, not stifle conflict and the expression of different perspectives and point of view. And we stopped raising our hands and keeping a list. Yes, the conversations were a bit more unruly. But they also were more energized, more helpful, more fun and more meaningful for the participants and for the organization. And they more closely reflected our core values as an organization about open communication, robust dialogue and consensus building. It was worth the sacrifice of "order" to get to the richness of subsequent conversations.

This is just one example of a basic assumption we make about "the way things are supposed to work." While the very concept of *best practices* seems laudable – that in any given area of arts organization structure and operation there is an optimal way for us to manage our challenges – it is a fundamentally flawed idea. Every arts organization is different and every community is different, so both the nature of challenges any organization faces and the potential strategies – the *best practices* – to address those challenges are necessarily going to be different.

A few years ago, I was working with Kaleidoscope, a new start-up chamber orchestra in Los Angeles. The founders, all young musicians, had begun with what was, for them and their world, a radical innovation: they would be a chamber orchestra without a conductor. This is not a unique idea – Orpheus Chamber Orchestra in New York has successfully pursued this musical model for decades. But in the world of orchestras, it remains very much the exception, not the rule.

Kaleidoscope's first few concerts, though artistically strong, drew depressingly small crowds. Although they were innovative as an ensemble, when it came to promoting their concerts, they relied on *best practices*: set a reasonable ticket price, create a website, hope for good press and then wait for the buyers to show up. Not surprisingly for a young, unknown orchestra in a crowded field of classical music ensembles, ticket sales were anemic. Then, as each concert date approached, the musicians were given free ticket allotments to distribute to their friends and families. The net result: audiences remained relatively small and most were not paying the ticket price. It seemed like a dead end.

Serving as an informal adviser, I suggested that they consider a "pay what you can" or "pay what you think it's worth" approach. I knew of several small to mid-size arts organizations who, often in their start-up phase but sometimes well beyond it, pursue this strategy as a way of building an audience base while adhering to their mission of being widely accessible to the community. Classical music often carries a very high ticket price, so the idea of the audience electing to pay what they could (or wanted to) was challenging for many of them, running counter to what they knew as *best practices* for a classical music concert.

Although several members of the group were enthusiastic about the idea, others were adamantly opposed, sure that people would start attending without paying even the minimal ticket price that they had been charging at that time and leading to a net loss of revenue. Furthermore, believing as they did in the important and laudable idea that "good art is worth paying for," the pay-what-you-can approach seemed to them demeaning. You should have to pay for something of quality, not be given the option. Others pointed out that the amount of revenue they were getting from ticket sales was already quite small so there was relatively little to lose on that front. Also, as a new ensemble they had an invisibility problem and that at this stage, at least doing "pay what you can" might encourage people to give them a try. It would also cohere with another of their underlying ideas, which is that even a rarefied art form like western European classical music could appeal to a much broader audience. The chance that wealthy, dedicated classical music lovers who could easily afford the ticket price would take advantage of the "pay what you can" model, seemed a risk worth taking if it would enable them to reach a broader audience of people, deterred by the conventional ticketing strategy, who were not the usual classical music lovers.

Eventually, they decided to take a leap of faith and embrace the "pay what you can" model. As young innovators, they also put their own spin on it. At a free "Bach in the Subways" concert at Union Station in Los Angeles where thousands of passers-by heard them play for free, they distributed "free tickets" for their next concert to everyone in attendance. They believed, rightly as it turned out, that such an approach would jump start attendance and help get the "pay what you can" model up and running. Things began to change.

Over time, audiences for their regular season concerts grew to better-than-respectable levels. Today, they take in larger amounts at the door, though it is still a small percentage

of their total revenue. But their audiences have increased dramatically and their visibility as a viable ensemble has also increased significantly, at least in part due to this unconventional approach to ticketing. Press is better, word of mouth is better and fundraising (primarily through crowdfunding campaigns) is vastly better. In the same way that the musicians felt excitement about being part of this experimental, conductor-less chamber orchestra, audiences and supporters were also being given the opportunity to share the excitement of new thinking through this innovative ticketing model. Reframing their endeavor more holistically as an experiment that included the audience and the community, and abandoning the *best practice* of ticket sales as a success marker, the ensemble's success grew. When they started thinking like the artists they are – willing to experiment, risk and make changes, even radical changes – everything changed.

All of us know arts leaders, perhaps even ourselves, who follow various *best practices* and whose organizations are quite successful. But we also know dozens of leaders of organizations who are stuck, frustrated by their inability to move in the direction they carefully mapped out at the board retreat, or meet the financial goals they set at the beginning of the year, or manage their way out of an unforeseen crisis. How many carefully crafted strategic plans are shelved for lack of relevance when the environment changes, or ignored altogether as staff work in perpetual crisis mode? *Best practices* tell us that Boards should be comprised largely of business people who "know how the real world works." *Best practices* also tell us that the leader of the organization needs to be someone with extensive experience running similar organizations in a successful (i.e. financially successful), business-like fashion, that the organization needs a strategic plan to guide its systematic and controlled growth and development and that it needs quantifiable annual metrics against which programs and personnel are evaluated if it is to be judged a successful, sustainable organization. But how many Executive Directors are beyond frustrated with the "business people" on their Boards who try to apply the principles of business to a nonprofit arts organization with altogether different challenges and expected outcomes? How many arts organizations have been artistically decimated by Executive Directors making the "tough, business decisions" that devastate the organization? How many arts organizations are stifled by their methodical strategic plans and unable to achieve their aspirational ideals? More, I would say, than we care to admit.

One *best practice* that I particularly want to challenge is the notion that a balanced budget is a *de facto* sign of organizational health, an idea that is deeply embedded in our cultural psyche (of the United States in particular, but not only the United States). Considering a balanced budget ("break even or better" as one organization I worked with described it) as a meaningful indicator of success, however, can lead to damaging decisions such as halting important programs, letting go of key staff and generally creating a culture of precarity that informs and underlies all decision-making, causing arts leaders to hesitate, to hold back and even to scuttle entirely new ideas for the organization. It also can inculcate a mindset of short-term and narrow thinking instead of expansive, imaginative, creative thinking as everyone worries about the "bottom line." Executive Directors and their organizations often boast of "x years of no deficits" as a sign of stability and even organizational excellence. Yet these are primarily signs of the ability to manage to a balanced budget. As arts leaders, we can easily get our priorities mixed up as we focus far more on the money than on the art.

I am not suggesting that money doesn't matter to arts organizations. Smart management of financial resources is, of course, an important component of a successful arts organization. But too often it has become the ultimate objective, and one wonders at

what cost to new ideas, imaginative programs, staff morale and community impact. Healthy, sustainable organizations recognize that resources are a liquid, not a solid. They ebb and flow around us. Some years are better than others, and fluctuations in income and expense are vital for a vibrant entity to survive.

Another particularly popular *best practice* that I want to challenge is that building an endowment is a goal that will enable an organization to exist in perpetuity without worrying about the uncertainty of revenue fluctuations. After working over the years with many organizations that wish they could build an endowment, I can think of few practices more misguided than this quixotic quest for financial stability.

To begin, let's debunk the idea of endowments as security. One need only check in with major endowed institutions like private universities and major cultural institutions and how they fared during the recession of 2007–2009. Suddenly this "steady stream of predictable income" was neither steady nor predictable. With the stock market crashing, endowments wreaked havoc on the operating budgets of all organizations that depended on them for anything more than a modest revenue line item. Though the Great Recession was exceptional, it provides us with an important lesson: in a volatile environment, no revenue source is a sure thing.

It is true that an endowment can be extremely helpful if it is one of many revenue streams. But because building an endowment is seen as a "*best practice*," organizations can misdirect their priorities, using staff time and resources to engage in an endowment campaign, taking revenue off the table to sequester in an endowment fund where, at least theoretically, it cannot be accessed. Donors are tapped for large dollar amounts to start or build the endowment, putting resources beyond the immediate reach of the arts organization. A healthy reserve for temporary, unforeseen disasters is a worthy aim, and a line of credit can serve much the same purpose for many organizations. But building an endowment too often prevents the flexibility and innovation that is required for an organization to function effectively from day to day.

I have already noted my skepticism about another *best practice*: the strategic plan, which creates an illusory sense of security by conflating the plan itself with action. The marketing plan, the development plan, the operational plan, the financial plan and more supplement the strategic plan. We are awash with plans and planning processes, which although helpful in many respects are also highly overrated because we confuse "making a plan" with actually doing something.

At one time, there was a need to introduce strategic planning into the thinking of arts leaders. When I first entered this field in 1982, I recall how helpless my colleagues and I felt about the health and future direction of our organizations. Essentially we saw our job as arts administrators to get art created and presented. Some years went well, others not so much. Who could guess what would "work" or not? It was out of our control. Strategic planning shifted our thinking towards the idea that we could exercise some deliberate thought and direction about the future of our organization. Over time, however, the idea of planning for the unknown future evolved into the deadening idea that we could, through an extensive, expensive and grueling process, create a three, five, ten, even fifty year plan with achievable goals and carefully calibrated strategies and tactics that would lead us to success. But the world rarely if ever followed the trajectory we expected or desired.

As time went on and this particular *best practice* became even more embedded in our work, strategic planning became an entity unto itself, as if the plan, like a balanced budget, was a sign that the organization was under strong management, stable and

fundable. Consultants were hired, Board retreats held, goals, objectives, strategies and tactics developed and articulated with timelines, budgetary implications and success metrics. The strategic plan took on an aura of near sacredness, massive three ring binder documents that, after we celebrated finishing the agony (and expense) of writing them, more often than not wound up on bookshelves in arts organization offices, only rarely referenced. If we referred to them, it was only to note our failure to meet the demands of "the plan." When one Board I worked with ultimately decided to abandon the concept of the strategic plan in favor of the more fluid approach that I will describe in Chapter 8 ("Ideas into action"), the incredibly creative artistic director heaved a sigh of relief and said, "The plan always felt like a straitjacket to me."

A fourth *best practice* that requires debunking is the notion that a strong Board of Directors is the key to organizational success. Perhaps no other aspect of arts leadership causes as much consternation, and delivers as little actual impact, as our collective obsession about "the Board." As arts organization leaders, we want a Board that "governs but doesn't manage," a distinction that few of us understand and even fewer practice. We say we need a strong Board; a Board that is engaged but mostly stays out of the way and "lets me do my job" is actually our preferred construction. We want the Board to be committed to the art of the organization but we definitely do *not* want them involved in the artistic decision-making process. One thing we all agree on is that the Board needs to fundraise, even if too many organizations and their Boards are exceedingly vague about how that is supposed to actually happen.

There is widespread disagreement and confusion about the purpose of the Board of a nonprofit arts organization. I have worked for and with organizations that have thrived with a "weak Board" because they have a strong Executive Director and a committed staff. I have also seen organizations wither and die because the "strong Board" led the organization in directions that were unproductive or unhealthy. But our *best practice* wisdom tells us not just that we have to have one, but that we have to nurture it (one Executive Director I know said she spent 40 percent of her time "managing the Board") and that it has to be a "strong Board," even though we don't really know what that means.

Boards can be confused and confusing. Individual Board member roles are often ill defined. One Board Chair I worked for told me at our very first meeting that he understood his chief role to be "to keep an eye on you" despite my decades of experience successfully running arts organizations and his almost complete lack of experience managing any organization at all. Board members will often say "give me something meaningful to do" and then leave when they find they are not having the impact they thought they would. Some join for the "prestige" of being on an arts organization Board and then realize that the prestige is directly connected to how much money they give or get.

Boards are also easy scapegoats for organizational failures, even though arts organizations that have failed, or are in serious jeopardy of failing, are most often in that position due to a complex combination of poor management decisions, structural defects, an outmoded artistic vision and a lack of attention to a changing external environment. A weak Board, one that did not pay attention to what was occurring, may well have contributed to the failure of the organization. But the idea that a strong and attentive Board could have averted disaster is at best only partly true.

We rightly expect a Board to be vigilant in its oversight, but Boards in general tend to be singularly ill equipped to do so, especially in the nonprofit arts sector. The more that organizations fill their Boards with "people with money or access to money" and

"people who are strong business leaders" the less likely they are to create a Board that understands the real purpose of an arts organization. Art and artistry become almost an afterthought at the Board meetings (artists are of course almost completely ineligible for the Board due to their lack of money or status), and when crisis points arise, as they inevitably do, organizations discover that the core values of the Board may not fully cohere with the core values of the organization. Often the result is that long time artistic directors are fired in favor of someone with a more "populist" approach, or artists' fees and/or salaries get cut while administrator salaries continue apace and the business plan achieves primacy over the artistic vision.

Recently, arts writer Anne Midgette published an article in the *Washington Post* entitled "The real motor of the performing arts isn't vision. It's the board, stupid" (Midgette, 2017), which notes that the work of the organizational leader is so deeply tied to maintaining the state of the Board that organizational and artistic vision are far less important to organizational success than managing the Board. While I accept this as a reality for many arts leaders, it seems a truly misplaced and misguided sense of priority around what really matters. The article rightly calls for a rethinking of the role of the Board.

There are indeed some arts leaders in the nonprofit sector who have figured out how to work with their Board and truly believe they add value to the organization and its activities. Such a circumstance is often a product of personal alchemy, almost happenstance, and therefore shifts with a change in Board or administrative leadership. The Board Chair I referenced earlier who thought his job was to "keep an eye on me," surely one of the worst Board Chairs in my career, was followed by a woman who, while holding me no less accountable for the success of the organization, truly understood her role was to collaborate with me using her specific talents and the talents of the rest of the Board. Under her leadership, the organization grew and thrived, largely because she enabled me to do my best work.

To the degree that a Board continues to be a legal requirement for a nonprofit arts organization, it is a necessity. And it can be extremely valuable for the leadership of the organization to spend time with this collection of volunteers, generally from fields outside the arts, when they are invested in contributing to the success of the organization – at least as valuable as time spent with other donors, artists, community members, staff and any number of other constituents engaged in the success of the organization and should be understood and "managed" from that perspective. We should not expect that a "strong Board" as it is generally understood, is an indication of the success and stability of the organization any more than we should think that an endowment will insure the stability of the finances or that a strategic plan will insure a successful future.

Another of the more persistent and problematic *best practices* is the idea that organizational growth is not just an indicator of success but a highly desired outcome. Growth's equivalence to success is an idea baked into our cultural consciousness, one we have enthusiastically adopted from the business metaphor model that dominates our current organizational thinking. Market capitalization, annually increasing revenue, budget size, employment numbers, even the square footage of office space used or number of employees hired are taken as indications of organizational health and the assumption follows that all organizations need to be on a growth trajectory to be judged successful. Conversely, any regression from previously established benchmarks is taken as a sign of poor health. As a result, we engage in behavior and practices, including the exploitation of both labor and resources, to support the continuous growth of the organization at almost any cost.

It's hard not to internalize and recreate these ideas in the arts sector. Even among arts leaders, organizational importance is frequently based on budget size. Ask almost any organizational leader about their success in their position and they will invariably recite their budget growth as a signal of their prowess as a leader. To say, "I grew the organization from a $6 million organization to a $10 million organization," a phrase I have myself said many times in reference to my work, is viewed as a success. When I say that I had to reimagine the same organization to continue its work with one third less staff than we had previously, I am met with looks of pity. Yet the latter was probably the most important accomplishment of my career and far more personally satisfying than the former.

Personal career growth is seen as ascending from smaller to larger organizations; prestige and influence follow. "Leadership" organizations are accorded that designation based largely on their budget size and thus their perceived impact. Smaller organizations and their artistic and management practices are often dismissed as exceptions at best, irrelevant at worst. Over the course of my career, I have worked in five different communities across the United States, urban, suburban and rural, where I have led variously a large, mid-size or small organization, depending on the context. Every community has obsessively engaged the conversation of the importance and/or viability of "major organizations" versus the "small or grassroots organizations" as a topic of discussion and too often controversy. Typically these controversies have centered on questions of resource distribution and led to questions of power, prestige and community leadership as we competed for media space, donor attention and even political clout. In almost all cases they have existed in a hierarchical rather than the ecosystemic frame I described in the last chapter, reinforcing the dominant patriarchal and exploitative system; the very system that is now being forced to adapt to a more horizontal, networked environment.

I once sat in on a conversation among arts professionals in Los Angeles discussing the "concert dance scene" in Los Angeles; one that is considered by many, including most of this group of dance leaders, to be "anemic." The causal analysis that emerged was that Los Angeles had never had a "tent pole" dance company (i.e. a major ballet company) that would provide the superstructure under which other companies could grow and flourish. Such reasoning is not only faulty (does the presence of a major ballet company in any city really signify and promote the development of a healthy dance community?) it also ignores the reality that Los Angeles actually has dozens of dance companies, dance programs and dance opportunities for anyone willing to seek them out, calling into question the very idea of an "anemic" dance scene in Los Angeles. Whatever growth occurs in dance in Los Angeles is more likely to come in the dispersed, diffused fashion represented by the multiple cultures and communities that exist here rather than from the desire to build that elusive Major Ballet Company. If we reframe our idea of success or of a thriving dance scene in Los Angeles, we recognize that the numerous small to mid-sized companies of various aesthetics are also more representative of the population that exists here and in greater harmony with the type of community that Los Angeles actually is. In that context, dance in Los Angeles can only be described as robust.

Once we let go of the idea that all arts organizations need to grow to survive, the conversation about the future of the organization can take a different, more relevant and more exciting turn, away from *growing the size* of the organization and towards *sustaining the purpose* of the organization. Sustaining a purpose – a concept, a passion, a vision of the art or the world – can become the singular driving force for creating a vibrant, adaptive organization that changes for and with the external environment. It may grow and it

may shrink, perhaps both over an extended period of time, and not in a formulaic, linear way. It is vital as a part of the entire arts ecosystem and not because it's at the "top of the food chain." For arts, artists and arts organizations, this is a much more engaging and satisfying construction within which to work.

These are some of the more pervasive and challenging *best practices* we have to deal with; there are many others. Primarily, I want to stress the need to let go of the very idea of *best practices*, that there can either be a singular approach to any organizational practice or that there is some "best" to which we should all strive. We see this in the way that the Internet has promulgated a diverse, networked approach to our thinking and working that equalizes multiple perspectives. We see it in the changing demographics that are deconstructing the idea that there is a majority, dominant culture that is establishing the so-called mainstream of art. And we see it in the idea of the ecosystem in which all parts of the system are unique but interconnected, interrelated and mutually dependent. The only *best practice* that matters is the one that an arts leader creates for the individual organization, enabling it to make progress towards its own particular vision. In most cases it can, and will, look remarkably unlike what any other organization is doing.

Critiquing the idea of *best practices* doesn't mean that we shouldn't strive to do our best possible work, nor does it mean we can't learn from other successful leaders and organizations. We must continually develop a range of diverse strategies that can move our organization forwards towards our agreed-upon vision, and make a continuous practice of watching, learning, absorbing, synthesizing and adapting impulses and ideas from multiple sources in order to create and implement the most effective structures and strategies that we need to sustain our organizations.

As a precursor to a discussion of how to determine and assert a vision and methodology for sustainability, it's important that performing arts organizations in particular relook at the larger picture of what happens in a performance, how it resonates in the world and why that act itself matters most and can serve as the foundation for the organizations we create to enable performances to occur. That is the subject of the next chapter.

4 Why performance matters[1]

Several years ago, I accepted an invitation to attend a contemporary dance festival in Europe. On this trip I would meet and talk with many artists, choreographers and artistic directors, primarily working in Europe with what I perceived to be a distinctly European aesthetic. I hoped this experience would help me find a better way to approach and appreciate this particular type of dance. It did not quite work out that way. In general, I found too many of the performances to be self indulgent, opaque and frequently poorly performed. I started leaving performances before they ended, something I try never to do. I was frustrated with the experience and began to think that perhaps this was just not performance work that would ever speak to me.

On the last day of my time at the festival, tired and discouraged, I searched for something different to experience. Buried in the program I found a listing for a dance company from Africa that was appearing in one of the smaller performance spaces. Since I'd had no experience of contemporary African dance, I was intrigued, believing that, at the very least, it would be a change from the work I had been seeing. So I decided to take a chance.

I joined a small audience of people in what was clearly one of the least desirable spaces of the festival venue. Sitting in bleachers in something of a crude "black box" environment, we watched as the performers made last-minute preparations. The lights dimmed, musicians appeared and the performance began.

What happened in the next 40 minutes I can only describe as transcendent. Even today, many years later, I still count this experience as one of the most meaningful arts experiences of my lifetime. Accompanied by live music both plaintive and powerful, four extraordinary women entered the space. Their physical appearances, while varied, conveyed an unmistakeable sense of internal strength. For the next 40 minutes or so, they took us on an unforgettable journey into their lives, their hearts, their souls and the soul of their country, Côte d'Ivoire.

Moving purposefully through the space, they performed a dance that seemed to possess both anguish and love. Their bodies made contact, separated and then came together again and again, embracing, slapping, falling and catching each other, reaching, it seemed to me, for a depth of connection and love that even physical movement did not seem capable of expressing. Through their dance they revealed anger, pain and betrayal, the depths of which we in the audience could only guess at as they touched, caressed, beat on and held themselves, each other, the floor, the space, the music. With breathtaking artistry, they made their experiences ours as much as theirs. As the work came to an end, the entire audience felt the power of their strength and their will to survive in what seemed a deeply painful world. We felt their need to dance, to dance in order to live.

Like them, I was, by the end of the piece, exhausted and overwhelmed. There was nothing to be done but to hold, breathless for a moment, and let the emotions pass through us before the audience responded with tears, shouts and wild applause. It was as if the dancers had touched us with their work and we were trying to touch them back; to sustain that deep sense of connection we all seemed to feel at that moment. It was an experience I'll never forget, even as I struggle now to relive it and describe it here.

The name of the company was Compagnie Tchétché, which means "eagle," and it is based in Côte d'Ivoire. It is composed entirely of women under the artistic direction at the time of Béatrice Kombe, a visionary choreographer who has since then, sadly, passed on. The piece, *Dimi* explores in the most intense and visceral way, the struggles of women, the strength required to confront those struggles and the love they share for each other while engaged in that struggle. Sitting in that small, darkened space, I was transfixed by the performance in a way that nothing else in the festival had managed to achieve. Despite my state of mind when it began, despite my lack of context for this company and this piece, I – along with everyone in the audience, it seemed – was profoundly transformed by the experience.

For me, this was the complete performance experience. It also caused me to think more deeply about the real purpose of my work as the leader of a performing arts organization. I thought about what happens during a life-changing performance like this one and how that experience, the connection established between artist and audience through performance, is the ephemeral, but also very real reason that art, artists and arts organizations matter in this world.

I reflected too on what really happened in the performance itself. What elements came together to create this unspoken but deeply felt connection between myself and the performers? Did the rest of the audience in the theater, I wondered, share my experience? Did their presence there influence my own experience? And what about the reverberations of the performance beyond the actual moment of its occurrence? If I say I was "transformed," how does that manifest in my life following the performance? Or in the lives of the others who shared this experience with me? In an even larger context, does this deeply personal experience, shared by a small group of people in a remote location in Europe, resonate beyond us? These were just some of the questions that I ruminated on in the days, weeks and months following the performance.

In our role as arts leaders, most of us have attended hundreds, perhaps even thousands of performances over the course of a career. What we seek in attending these performances, why we go and why we continue to go, even after many disappointing experiences that fail to live up to our expectations, is worth considering. As professionals, we have any number of different purposes: expanding our own aesthetic boundaries, assessing what our colleagues are doing, discovering new trends, seeking the sheer aesthetic joy of experiencing an expertly performed artistic work, following the careers of performers and more. These are all considerations we take into account when making decisions about what work we will create, present and support.

But what about "the general audience," the people for whom our organizations have been created and are sustained? What are they seeking in a performance experience? What drives them to keep attending performances? And when a performance "works," what is it that actually happens to the individual, to the audience, to the community and even to the world? Thinking about these questions can lead us to a more thoughtful and powerful understanding of what constitutes the "performance experience" and why it matters so much.

Begin with the individual

For any one of us individually, the performance experience is primarily about experiencing something unique and ephemeral that is not available to us in ordinary life. We go to the theater, the concert hall or the studio in search of an experience that will move us in some way. Once it begins, we become engaged in a relationship with the artist. I would even suggest that we conspire with the artist to create a separate but contemporaneous reality that exists under the very particular and carefully designed circumstances of our mutual creation. Ideally, as an individual audience member I become absorbed into what can be a multi-sensory journey that engages my intellect, my emotions and even my spirit. This is what happened to me at the performance of *Dimi*. At its best, performance can be for any one of us, a sublime experience and a moment of transcendent beauty.

Our desire for this unique, indescribable experience is what drives us to attend performances. I also believe this drive accounts for what is frequently described as our desire to be "entertained," which I would define here as our need to step away from the so-called real world into a heightened, alternate reality, at least for a time. This same desire accounts also for why we engage with performance opportunities that we know are going to be difficult, disturbing or provocative – they provide us with an opportunity to vicariously experience challenging ideas and unpleasant emotions without altering the real terms of our life. This desire for cathartic, transformative experiences seems to be an elemental need; one that we actively seek out.

A key part of experiencing this alternate reality, however, is that despite feeling "transported," we actually have not lost touch with reality. In fact, we are often acutely aware of the immediate surroundings, the specific environment in which the performance is being created and experienced. The best performances allow us to move between these two realities simultaneously in order to intellectually engage with and reflect upon what's happening, considering questions and negotiating ambiguities as we wrestle with the ideas raised by the performance.

The performance experience can also deeply affect us emotionally, often touching on feelings we have stored deep in our psyches. Performances help us tap into those feelings; being engaged in this alternate reality grants us permission to act and react in ways we might not ordinarily. Open demonstration of tears or laughter, joyous celebration, pain and sorrow too deep and profound to be "actually" expressed or shared even with our closest confidant – all these can and do find their place in how we respond to the performance experience.

The theater, the concert hall and other performance spaces have been described by some as spiritual places. Performance has deep roots in spiritual practice in most cultures, even if it has also been adapted to a secular world. Still, that spiritual source maintains. We may be only intuitively conscious of it at the moment of the actual performance. When we attempt to describe or characterize the experience later, as I have tried to do so many times with my experience of *Dimi* and others, we do not have the words to explain this experience of feeling fundamentally altered. I once presented a series of the Beethoven String Quartets featuring in one concert, the Muir String Quartet. At the introduction of the concert the violinist of the quartet, Bayla Keyes, in explaining the stylistic evolution of Beethoven's quartets said that in the late quartets "Beethoven speaks to God." When they played the work, you understood exactly what she meant.

If we think about the performance in these terms – as a profound experience of intellectual, emotional and even spiritual sensations – then to consider performance a

product to be sold is not only inadequate but deeply deficient as the foundation for our organizations and for the work we do as arts leaders. Instead, it is imperative that we recognize the activity we are engaged in is providing our community with profound human experiences through the medium of performance. So we need to rethink not just *what* we are doing, but *why*.

The communal experience

In describing my experience with Compagnie Tchétché, and their performance of *Dimi*, I spoke of the space (small, dark, out of the way) and the group of people with whom I shared the experience – also small in numbers and gathered somewhat haphazardly on what appeared to be makeshift bleachers. I emphasize this for a couple of reasons, one of which is that we have too often come to equate a "quality" performance experience with a similarly "quality" physical environment. No doubt many of us have had some extraordinary performance experiences in some of the finest concert halls of the world. But it is equally as likely that we have had transformative performance experiences in shabby, rundown environments like this one. Physical space matters, but not always in the sleek, "state-of-the-art" way that we might think.

The feeling of connection that occurs between the artist and the audience is a critical factor in our understanding of the performance experience. With few exceptions, the artist is concerned not just with the quality of his or her own artistry but the effect of that artistry on the audience members both individually and as an entity. If you speak with artists about a specific performance, they often speak about the audience in monolithic terms: tonight it was "responsive," or "with me all the way" and because of that the performance experience went from good to great. As audience members we have had similar experiences. When I saw the musical *Hamilton* during its initial run, the moment we went into the theater it was abuzz with excitement. People knew they were part of a phenomenon, an "event," and they were ready for it to be as amazing as it was purported to be. And it was. As I noted previously, in relation to Compagnie Tchétché, and their performance of *Dimi*, it seemed as if we, as a single entity, were trying to reach the artists and they were trying to reach us. In essence, we were building together a community of the moment and we as the audience are deeply affected by the artists' ability, or not, to engage us as a "community of the moment."

There's another dimension I want to add to this conversation about audience that goes beyond the relationship between artist and audience to the relationship established among the audience members as they share an experience together. Most of us can recount the really awful experiences we have had in a theater or concert hall when audience behavior – or the mere presence of other audience members – has somehow disrupted our individual experience. But we can also recount instances in which the presence of the audience illuminated and enhanced our own experience; in which the power of the experience was enhanced precisely because we were experiencing it with others. I can vividly recall the shared joy of experiencing a concert by the Emerson String Quartet in which the audience seemed to literally breathe together and in synch with the quartet. It was a profoundly moving experience that was made quite special by the presence of an audience. I could not have had it by myself.

The principal characteristic of the performance experience is this webbed relationship among the audience members, the art and the artist and the myriad ways in which the actions, thoughts, feelings and responses of each affect those of the others. In this

understanding of the performance experience, we see that a uniquely shared experience is created, one that can never be exactly replicated in another space or time. When we speak of "the unique joy of the live performance" this is what we actually mean: being in a space with others and having a uniquely shared live artistic experience together. The performance creates this temporary, fragile community of the moment; a deeply profound moment that subsequently dissolves and disperses with only the imperfect memory of that moment to sustain us. Outside the structured performance arena, these transformative collective experiences rarely occur, and no technological device yet created is capable of recreating that experience.

At the heart of any performance experience remains the desire of both the artist and the audience to connect in real time with real people assembled together in a real space. We see it in ancient rituals; in storytelling, in music and dance that has been passed down through cultural traditions of longstanding. No matter how artists enhance, extend or even manipulate their performance, no matter what degree of inconvenience the audience endures to arrive at a specific time and place, the fundamental concern of both artist and audience still rests with the individual and communal experience of the performance moment. As arts leaders, this is why our organizations exist; to create and support this unique, exceptional experience. But the impact of what happens in a performance extends beyond even this moment in time.

Engaging with community

In describing my experience with Compagnie Tchétché and *Dimi* I noted that I had attended the larger festival in the hope of attaining a greater understanding of contemporary dance from Europe. What I left with was a nascent interest in contemporary dance from Africa, an interest that soon became a passion. Following this experience with Compagnie Tchétché, I went on to attend festivals in Africa and Europe that featured the work of contemporary African choreographers like Faustin Linyekula from Democratic Republic of Congo (DRC), Qudus Onekiku from Nigeria, Boyzie Cekwana from South Africa, Opiyo Okach from Kenya and many more. I joined with a group of colleagues from the United States to form the African Contemporary Arts Consortium (TACAC) to help myself and others learn more about contemporary African performance, something quite unknown in the United States.

In 2009, a few years after TACAC was founded, the consortium attended a gathering in Tunisia where Cultures France was hosting one of their biennial festivals of contemporary African dance. At a meeting with the American arts leaders and several choreographers from Africa, an intense conversation ensued in which we, as Americans, were challenged by the artists to take on the task of delving more deeply into our understanding of the specific environments in which they were working in their home countries. The artists were quite passionate about this; that we could not really grasp what they were about or what their art was about unless we fully understood it in its community context. For them, the performance on stage represented something much more than just the experience of the moment. They urged us to see what they did as not just "doing a performance" but rather as community building of the highest order.

Several of us took on this challenge, and a year later I found myself in Nairobi for two weeks, exploring what it meant to be an artist in a community that was quite unlike my own. During that time I visited several different artists and companies and spent time

Figure 4.1 Faustin Linyekula, "Statue of Loss," Theaterformen Festival, 2014. Photo by and copyright by Andreas Etter

Figure 4.2 QDanceCenter, QTribe Iwa L'Ewa, 2015. Photo by Logo Olumuyiwa

with them in their specific communities. On one particularly memorable occasion I traveled with hip hop video artist Felix Gicharu into the heart of Nairobi to understand firsthand the impact he was having on the community in which he resided. We traveled by bus ("like ordinary people do" he insisted) into the community and made our way through a warren of housing to his home; a series of ramshackle structures that housed

him and his extended family. In one room he had created a makeshift video and audio production facility. He showed me the open space in which they performed; the rooftops upon which people gathered to watch and listen. Although my visit did not coincide with an actual performance, I saw videos of previous performances and talked with people there who spoke eloquently about how these young musicians created a sense of community in this corner of their world; how it motivated them and their neighbors to work together and care for each other. Clearly the effects of their performance extended well beyond the performance space and time.

One of the profound and far-reaching consequences of my engagement with TACAC and contemporary dance artists and companies from Africa was the recognition of how virtually all of these artists viewed their companies and their work as intrinsic to the life of their communities. Both Faustin and Qudus left lucrative careers in Europe to return to their home communities of Kisangani, DRC and Lagos, Nigeria (respectively) to build arts institutions there that not only enabled training for young dancers but also contributed to the very life of the community. Compagnie Tchétché in Abidjan, Côte d'Ivoire provided day care and support services that were vital to the women who were part of the company. Faustin's Studios Kabako won the 2014 Curry Stone Design Prize because:

> Studios Kabako presents art not as a form of entertainment but as a form of political empowerment. The studio uses different tools – among these, dance, theater, and music – to help local communities imagine an alternative to the hardships of daily life, and understand that they can have a hand in creating a better future.
>
> (Curry Stone Design Prize, 2014)

Qudus' QDanceCenter asserts that "[a]t its heart, QDanceCenter is also a community organization, over the years, the organization has proven to be an incubator and engine for the Nigerian creative scene, creating employments with its productions and engaging an often-restive Nigerian youth." (QDanceCenter, 2017)

Of course it was not necessary for me to travel to Africa to realize that the impact that a performance has on a community is as crucial a part of the performance experience as the individual attendee's experience or the communal experience of a given audience. Over the past several decades numerous artists in the United States have dedicated themselves to building performance pieces that actively engage members of the community before, during and after the performance itself. I have had the chance to work closely with several "community-based" artists and that work was instrumental in changing my thinking about the power of performance.

My first experience with community-based work was in 1990 when I was the performing arts presenter at Penn State University, located in State College a small town in the center of Pennsylvania. In the early 1990s I began the arduous but ultimately groundbreaking work of bringing *The Last Supper at Uncle Tom's Cabin/The Promised Land*, a major new work by the innovative and provocative choreographer Bill T. Jones, to our small rural community. In the early planning stages for presenting this work I, along with several other arts leaders from across the country, had several meetings with Bill and his management team. Right from the beginning it was clear that this was not going to be "business as usual." Bill gave us one of his typically eloquent disquisitions on what the piece was about and it was clearly tied up in racism, U.S. history, slavery, sexuality and what seemed to all of us as a hornet's nest of

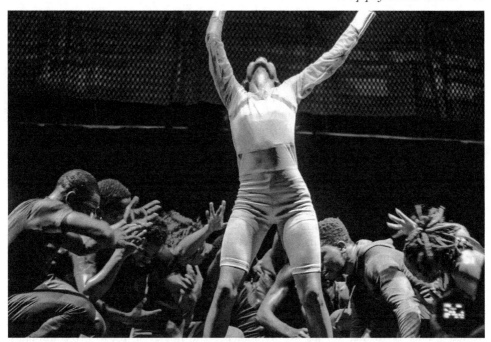

Figure 4.3 QDanceCenter, QTribe Iwa L'Ewa, 2015. Photo by Logo Olumuyiwa

provocative issues and ideas guaranteed to disturb the audiences that came to see it and the communities within which it occurred. I recall Bill telling us that every night that he performs he gets up on the stage and makes himself vulnerable; open to whatever response he gets from the audience. Meanwhile, he said, you presenters sit in the back of the theater, isolated and insulated, and give my work a thumbs up or a thumbs down. In this case, he went on to say, you wouldn't get that luxury. The nature of the work is such that you are going to join me in the risk taking and the vulnerability that art requires.

To start, there was the controversial nature of the themes in the work itself. In 1990, the United States was not used to seeing difficult issues played out on their stages, especially on the stages of the large, prestigious performing arts venues that were part of this project. Bill then went on to explain that we would have to recruit 32 local dancers from our communities who would spend two weeks rehearsing with a rehearsal director before being integrated into the performance along with Bill's company in the few days preceding the opening. Recruiting the dancers was our obligation but he very specifically insisted that they must reflect the racial and ethnic makeup of our communities; that we couldn't just get the 32 best white modern dancers. And, just to make the experience even more interesting, he let us know that the piece culminated in a lengthy section in which all of the dancers, his as well as ours from the community, would appear fully nude on stage. There was a moment of silence following this pronouncement before several of us swallowed hard and agreed to take the plunge.

What followed was a national phenomenon. More than a dozen sites across the country, from New York to Los Angeles to places in between like Chicago, Minneapolis and even State College, Pennsylvania, signed on for what turned out to be an

extraordinary experience. As the performance dates approached, Bill agreed to spend time in each community – a few days in some places, longer in others – meeting with and participating in talks, dialogues and discussions. To the best of my knowledge, at no place did this performance proceed without incident. Many presenters, myself included, found themselves in heated conversations with patrons, donors and university and government officials about what was about to happen. By the evening of the performance, the atmosphere in the entire community was charged, as it rarely is for a "modern dance performance" with anticipation, expectation and even dread.

Critical reaction to the performance itself was, not surprisingly, mixed. Many loved the performance; others found it obtuse; some found it offensive in more ways than simply the sight of all the naked people on stage. Public conversations were fraught as people grappled with how they responded to the work. In the end, when the company left town, I think it is fair to say that the impact in each community was profound and lasting. No matter what anyone thought, something important had happened; a performance had had an impact on our community, stimulating dialogue that continued long after the company left. Further, because it was part of a national tour, we became part of a national dialogue about issues like racism, homophobia, body image and more; issues that to this day are roiling the population of the country in devastating and complicated ways. For me personally, it was a moment in which I realized again that the work I did as the leader of an arts organization really mattered, not just to me, not just to my audience and not even just to my community but in a larger, more comprehensive way to a national discourse on what it means to be in and of America.

It was also a transformative moment for me in thinking about the role of the arts in our society. Bill's deliberate provocation had once and for all eradicated any idea that as an arts leader I could absent myself from the really powerful and important conversations that were happening, are happening and need to happen in the contemporary world. With this one project, Bill changed the direction of my thinking, emboldening me to take the risks and make the moves required of an arts leader in the contemporary world. There was more to come.

His next groundbreaking work *Still/Here*, which I presented at Penn State University in 1993, was derived from multiple video interviews he did with individuals in various communities who were suffering from and grappling with terminal illnesses. Also in the 1990s, David Dorfman Dance produced *Out of Season (The Athletes Project)* and *Familiar Movements (The Family Project)*, which emerged from his work with athletes and families in a number of communities, including Tucson, Arizona where I directed the performing arts center at the University of Arizona. Also while at Arizona, I worked with Liz Lerman, Artistic Director of the Washington, DC based Dance Exchange to develop and present one of the many "chapters" of her epic "Hallelujah Project" in which she and the company visited several communities to explore and create work around "what the community was in praise of." These are just a few of the more memorable and lasting performance experiences that have reached well beyond the theater to make an impact in the community and even, with their national scope, in the country as a whole. Artists like David Roussevre with *Love Songs* (1998); Stuart Pimsler Dance and Theater's *Out of This World; The life After Life Project* (1998); Jawole Will Jo Zollar's Urban Bush Women in *I Don't Know but I Been Told If You Keep on Dancing You Never Grow Old* (1989) and so many more helped us see that performance had a role to play in community learning, community health and community transformation.

Figure 4.4 Liz Lerman Dance Exchange, "The Hallelujah Project," Tucson, AZ. Photo by Stan Barouh

In 2010, I was invited to attend a gathering hosted by the Opportunity Agenda called *Creative Change* in Santa Fe, New Mexico. The purpose of the gathering was to bring together artists and arts activists from around the country to talk about their work. It was a stimulating experience but what struck me most was the large number of self described activists there who used art to promote their ideologies and the relatively small number of artists present, who saw themselves as artists first but were actively engaging social issues through their performance. I had several conversations with people in which the disconnect between the "activist community" and the "artist community" was glaringly obvious. Many of the activists that I spoke with had no idea of the number of artists doing community-based work. I attribute this less to activists "not knowing" and more to a generally insular arts community that has an ambivalent relationship with activism, particularly of the political kind, along with a desire to sequester performance as separate from the ongoing life of the community. The artist/activists that I have worked with, both in Africa and the United States, know the power of performance to make community change and they embrace their art for that reason.

Performance of all types, whether community-based or not, has the ability to surpass the boundaries of the moment; to extend what we "know" in order not only to change us as individuals but to change the communities within which we exist and even the world. It is because of this power of performance and its potential impact on the world that arts leaders are in positions of responsibility that are at once vast and meaningful. If, as arts leaders, we create organizations and programs that are stimulating, profound and provocative, that encourage audiences to reflect on and reassess their values and beliefs, then we create a similarly thoughtful and engaged community. How could we possibly think of seeing performance as simply a product to be sold or an event to be marketed?

The work of any arts leader is nothing less than making meaning for all of the individuals we can entice, audiences we can create and communities we can affect by connecting them with artists with something to say through their work. This acknowledgment of the scope of our work is the foundational idea of the organizations we create; literally our lifeblood from which we are compelled to create resilient, sustainable organizations.

Note

1 This chapter is adapted from my previous book, *Performing Arts Presenting; From Theory to Practice*, published by the Association of Performing Arts Presenters, Washington DC, 2006.

5 Art is life: ecosystems, resilience and sustainability

I recently traveled to Lima, Peru where I visited MALI, the Lima Museum of Art, which has an extraordinary collection of pre-Columbian art. As I wandered round the galleries I was drawn into an intense contemplation of each individual object. I found myself overwhelmed by the incredible beauty of these essentially utilitarian objects. Although nearly all had a specific functional purpose – drinking vessels, bowls, utensils – they were simultaneously and unmistakeably works of art. It's difficult to describe the aesthetic sensation of contemplating these objects and appreciating them for their sheer beauty. It was a revelation. I couldn't help reflect at the same time on the knowledge that these exquisite pieces of art were made by people living in the Central Andes from 1200 BC until the arrival of the Spaniards in the 15th century. We can only imagine the rigors of their daily life. Yet, they created art.

Several weeks later I visited the canyons of Escalante National Monument in southern Utah in the United States. There, I saw petroglyphs and pictographs created by Native Americans sometime between 500 and 1250 A.D. Scratched into the side of a rock on a remote mountain were images of animals and people, rendered with exquisite care and radiating with simple beauty. It was a breathtaking experience to see these expressions of the human impulse to create art from a time and place about which we have so little documentation. Yet we can see from the images they left us that they were artists. Had the recording technology been available at the time, I am quite sure that the ritual dances, songs and performances of humans from these and other ancient civilizations would be in evidence as well, and equally as affecting.

No matter how expressions of the artistic impulse have evolved over time, what form they take, how we have enhanced them with contemporary technologies, the fact remains that something inside even the earliest human beings motivated them to create art. We can only imagine the harsh circumstances of their lives, in the face of which they nonetheless had the impulse, the human need to express themselves through art.

Ancient Greek theater, African tribal rituals from centuries before the written word, Arabic music of the desert: it is hard to imagine that the people of any ancient civilization were creating art as some sort of luxury activity. Art as a human need, as essential to life, is as inherent to human existence as eating, drinking, finding food and creating shelter. Perhaps we can see that more easily in these ancient civilizations than in our own overdeveloped, overmanufactured world. The impulse to create has always been the essence of what it means to be human and alive.

If we accept that idea, then it would seem logical to think that creating and developing structures that support artistic creation would have more integrity of purpose if they were consonant with life-giving and life-sustaining structures and systems that already

exist. Thus, we might turn to the fields of biology and ecology, rather than business, for models of how organisms are created and sustained, even in a hostile environment. If we do that, and if we adopt the metaphors of survival that biology and ecology provide us, remarkable, exciting and energizing ideas emerge from which we can then build the organizations, structures and methodologies that will insure the sustainability of the arts organization.

Resilience and sustainability

In January 2009, I attended the annual Association of Performing Arts Presenters (APAP) conference in New York City. As a long time member of the organization, this conference has been a regular source of information for me as well as a chance to gather with colleagues, many of whom I see only once a year. Not surprisingly, at this particular conference the mood was grim. Presenters, managers, artists – all of us were struggling with the economic downturn and its effects. Programmatically, the conference was an unsettling mixture of "business as usual" for some and near panic for others. Horror stories abounded; solutions were hard to find. But when I attended a plenary session given by Robyn Archer, former Artistic Director of the Melbourne Festival (among other high profile positions), a glimmer of possibility emerged for me of how we might rethink our approaches and discover a new, more sustainable way of working that holds true to the principles and practices of the creative process.

In her session, Archer described how she was reframing her own artistic work from a resilient, sustainable environmental perspective. Driven by the growing recognition of our need to conserve resources, she had delved into resilience thinking as a foundation and a framework for the work of the performing arts. She recommended a book to us: *Resilience Thinking; Sustaining Ecosystems and People in a Changing World* by Brian Walker and David Salt. (Walker and Salt, 2006) This is not an arts book; it's a book about environmentalism, about survival through resilience. In simple, clear language it explains the concept of resilience as the key to creating a sustainable ecosystem. They also apply resilience theory to real world situations so that one can see how theory applies to practice. Reading the book provoked me to think about how an arts organization might adapt the concepts and ideas of resilience thinking so as to create sustainable organizations in a world of ongoing change, similar to how Walker and Salt show how ecosystems also adapt to ongoing change and through that adaptation are sustained over time.

Because we have for so long seen arts organizations as businesses, it may be difficult, even counter-intuitive, for us to imagine an alternative foundational construction for how we do our work. The business-model orientation causes us to think in a linear fashion; to understand our organization as a single entity aiming towards a fixed goal: to prioritize market share, profitability, sales revenue, etc. Everything else – labor, finances, systems, structures and processes – is in service of our progress towards the goal of making a profit. Resources are used (and abused) in order to reach this goal. At best, we may have a vision of "doing good in the world" but that vision is often subsumed into the structures and process of our business model goal of making a profit. These are core values embedded in the capitalist system that dominate our arts "industry" both explicitly and implicitly. But they have always felt to me like an uncomfortable match for what we do. Ultimately, we don't really share the same values.

The ideas and concepts expressed in Walker and Salt's book encouraged me to explore more deeply what it would mean if we were to follow an ecological model rather than

the traditional business model in how we think about the construction and operation of our organizations. Out of this exploration I developed some guiding thoughts and principles about organizational design and function that could help shape what we do in a more eco-friendly – and artistic-friendly – way than what is provided to us through the business model that is more common practice. I begin by looking at some key ideas from the environmental field that has remarkable resonance for the arts.

Ecosystems

In their book, Walker and Salt talk about viewing the world through a "systems perspective" that recognizes:

- we are all part of linked systems of humans and nature
- these systems are complex adaptive systems
- resilience is the key to the sustainability in these systems.

(Walker and Salt, 2006, p. 11)

If we think of our arts organizations as ecosystems then we also acknowledge that as systems, they are characterized by near constant motion; that the components of the system are continually interacting with each other and in so doing they produce a type of stability, the result of the dynamic equilibrium produced by the constant motion occurring within the system. Over time, and usually in response to both internal and external forces over which we may have little or no control, various components of the ecosystem might become stronger or weaker; more dominant or less so. In a healthy ecosystem, the individual components adapt accordingly in order for the ecosystem to thrive. The health of the system depends then on the health of each of the component parts.

One of the easier ways to see this in an environmental context is to think about what we now know about forests and forest fires. If we understand a forest as a dynamic ecosystem, it may, often due to external factors like drought, neglect, excessive usage, etc., occasionally get too far out of balance. Perhaps too much old growth forest is smothering the opportunity for new trees and plants to emerge. Something as seemingly devastating as a forest fire can serve the vital purpose of re-establishing the equilibrium of the ecosystem, allowing both the plants and the system itself to regenerate and thrive.

Applying this metaphor to an arts organization illuminates some things we know already and some we may not recognize. Internally, most arts organizations recognize the interrelated nature of their organization and the interactions of the various "departments" that are required for the organization to accomplish its work. How that occurs in practice can be another question entirely as we wrangle over the "silos" that we all work in and our ability to connect, communicate and work together. We set up retreats, all-staff meetings, department meetings and "cross functional teams" to try to stimulate (or force) interaction among the components of the organization. We know we need to work together as a system but we often struggle to figure out how to do that.

One key problem that tends to hamper if not doom our desire to collaborate internally is that our rhetoric and ideals about interrelatedness, cooperation and collaboration are in conflict with the fixed organizational structures we have created, making the dynamic interaction required for the ecosystem to survive difficult if not impossible. Often this conflict shows up in real and perceived established hierarchies, not only of roles (directors oversee managers who oversee associates who oversee assistants and

people need to "stay in their lanes") but also of individual departments (programming is not to be swayed in its choices by marketing; business and production have veto power over all new ideas, etc.) We become stymied by an organizational design that supports siloed thinking as we compete among ourselves for scarce resources, the approval of the CEO or even real and imagined "turf" issues of space, time, resources and prestige.

This was made very clear to me when I worked at YBCA and was the Artistic Director for curators from four different areas: visual arts, performance, film and community engagement. Our organizational intent was to provide an integrated programmatic vision for the organization. But doing that often eluded us as we ran up against entrenched structures, processes and belief systems in each area that proved intractable. Who was the "lead curator?" Who got to decide which art was in and which was out? Which area felt slighted and which one got more attention or resources than it deserved? At our best, we resolved these issues. At our worst, we bickered and argued, the overarching idea of an integrated approach to a program got lost in the squabbling and the lingering resentments simply fueled future conflicts. We struggled to behave as a system but because we were so used to operating as single entities with clearly defined borders and boundaries of what to do and how to do it, we never actually achieved the integrated state that I was striving for. I learned that unless we can think of and design our organizations as integrated ecosystems rather than singular, siloed entities, we would not be able to move past the status quo.

Extending this idea more generally to the larger "arts ecosystem" we can see the pattern continue. Large arts organizations like performing arts centers and similar "major" institutions are (returning to the forest fire metaphor) the old growth forest that may well have grown to dominate the system, keeping out fresher, newer ideas (cultures? art forms? artists? aesthetics?) that struggle for an adequate share of resources which they need to survive. With the world changing around us as described in Chapter 1, many of our major institutions are now struggling to survive. Some will not be able to because they will have waited too long to adapt to the change. Those that do survive will do so because they have built adaptability into their work.

The Los Angeles Philharmonic Orchestra is one example of this. Over the last several years they have adapted to the changing environment with programs like their Green Umbrella Contemporary Music series, or their YOLA (Young Orchestra of Los Angeles) program for young musicians based on the El Sistema model. They built an extraordinary new hall in downtown Los Angeles (the renowned Frank Gehry designed Walt Disney Concert Hall) which is street level accessible and inviting, unlike its neighbor the grandiose Los Angeles Music Center, built at an earlier time when exclusivity was preferred, which sits atop a raised platform, elevated from the street structurally, and therefore psychically distanced from the community. Even though the tickets to an LA Phil concert in Disney Hall can be quite expensive, they also have numerous discounted ticket purchasing schemes for students and others with fewer resources. And beyond that it has the very successful 17,000 seat Hollywood Bowl (which is actually in the city and not in a resort area a few hours away as many orchestral summer homes are), which offers extensive programming in an outdoor, friendly atmosphere that invites a huge range of people to attend. Underlying all this, of course, and from which all this emanates, is an extraordinary orchestra, a dynamic Music Director and smart, innovative and eclectic programming. These adaptations and others like them are what ensure their organizational health within the ever-shifting ecosystem of Los Angeles.

When an arts organization understands itself as an ecosystem, its perspective about organizational design and practice will shift from vertical and linear to horizontal and

omnidirectional, engaging with all parts of the ecosystem and not seeking to dominate "competitors;" valuing collaboration over competition. As part of the arts (and community) ecosystem, the organization interacts with other ecosystems in dynamic and adaptive ways to ensure the health and sustainability of the whole. A great example of this is the current season for East-West Players (EWP), "The nation's longest-running professional theater of color and the largest producing organization of Asian American artistic work." (East West Players, 2017)

Snehal Desai, the new Artistic Director for EWP has built the entire season around collaborations with other organizations featuring co-productions with Rogue Artists

Figure 5.1 East West Players, world premiere of Rogue Artist Ensemble's *Kaidan Project: Walls Grow Thin* – produced in association with East West Players – an immersive theatrical experience inspired by Japanese ghost stories, with performances held in a secret, Mid-City warehouse, 2017

Ensemble, The Robey Theatre Company, Japanese American Cultural & Community Center (JACCC) and the Los Angeles LGBT Center. The intent of this approach is to extend the theater more broadly into the other communities and ensure its relevance to a diverse and constantly changing population. Contrast this with the typical, "go it alone" approach of many theater companies that strive to build and sustain their organizations around a singular artistic vision, irrespective of, or perhaps gently nodding to, what is happening around them. With this ecosystemic framework of thinking, East West Players and organizations like it become fully engaged with what is happening around them, and are integral to the larger ecosystem that is their community and their world.

Resilience

Walker and Salt define resilience as "the capacity of a system to absorb disturbance and still retain its basic function and structure." (Walker and Salt, 2006, p. xiii) This is a key concept that has real significance for arts organizations. Typically, when we think of resilience we think of the ability to "bounce back" from adversity, with the implication that we will return to the way things were before the disturbance. But if we understand resilience from an ecological perspective, then our goal is not to bounce back to our previous formation but instead to adapt our organization in response to the external disturbance. More fundamentally our goal is to build an organization with inherent adaptability such that we can continue to thrive in an environment of constant change and "system disruption."

As someone who at the time was trying to figure out how to respond to the 2007–2008 recession's shock to our organization, this idea was a revelation to me. I saw that we needed to shift our thinking from the "problem-solving" mindset that is engrained in most arts leaders to "how do I manage an organization that exists in a context of ever-changing disturbance and recovery?" I realized that our task would be to reimagine our organizations as resilient, ecosystemic organizations that are flexible and adaptive; able to adjust, refine, remake and even reimagine themselves in response to ongoing environmental change.

Not only does this concept of resilience make sense from an ecological perspective, it also relates closely to how we think as artists and how we want to think as arts leaders. If we can dislodge the idea of "art as product" and instead reinforce the idea of art as a creative process, constantly in motion and constantly evolving, then we can also adapt that idea to the organizations we create and operate to support the art.

Sustainability

In his book, *Sustainable by Design,* J. C. Wandemberg defines sustainability as, "A sociological process characterized by ideal-seeking behavior." (Wandemberg, 2015, p. 11) He goes on to define ideal as "a state/process unreachable in a given time and space but infinitely approachable" and adds "[t]his continuous approach is what incorporates sustainability to the state/process."(Wandemberg, 2015, p. 11)

This concept, taken from the field of environmental sustainability, eloquently encapsulates the work of artists and arts organizations. The pursuit of the "ideal" is why arts organizations exist; it is our aspirational state. Artists and arts leaders strive always to create a better world, to appeal to our better selves, to create extraordinary art and with it extraordinary experiences that bring out our humanity and our spirits as individuals, as a community. We live for this ideal.

Sustainability derives from our ongoing pursuit of the ideal. It is the activities in which we engage as we pursue this essentially unattainable ideal that drive our work, that cause us to change and adapt, that keep us moving ever forward towards our ideal, adapting as we go to the changing environment. Paradoxically, it is not the achievement of the ideal but the work we do to make progress towards it that creates sustainability. This is a critically important distinction and one that, as arts leaders, we can lose sight of as we go about our work. Artists know it. It exists in their restless searching and reaching for the next creation, the next idea, the next iteration of their developing work. It exists also in the way we understand our own lives as essentially a work in progress; as a progression towards an ideal state that, in all likelihood, we will never achieve.

As a theater director, I always told my actors that we never actually "finished" the play, we simply abandoned it when we ran out of time. It is similar to the idea of my choreographer friend that "every performance is a world premiere" because the work is ever changing and evolving. Just like the world around us. This is what sustainability means; this is what "built to last" can mean to us as arts leaders

Too often, arts leaders lose sight of the ideal as we work to make our organizations function in what we know is an essentially hostile world. We have tried to accommodate ourselves to that world by adhering to the principles that it imposes upon us, those of the dominant capitalist business model. And while many of us have had great success in that process, too many others have not. Consider the artistic aspirations and potential accomplishments that have been lost to us due to lack of resources. Think about the artists and arts organizations that have succumbed to the pressures and demands of a system that crushes ideals. I think of this every time an artistic director says they need to create a "balanced" season, which usually means some performances that will sell tickets, even if they are far afield from our artistic intent. I think of this every time an artist tells me they have reduced the size and scope of the work to make it "tourable." And mostly I think of it, and am deeply troubled by it, when artists whose work is transformative and meaningful stop producing altogether because they simply cannot make it work within the system we have created. We should all mourn the loss of work for our culture when any of these accommodations to an essentially alien structural ethos occurs. It is vital as arts leaders that we reorient ourselves to thinking about sustainability in an ecological and artistic framework if we are to thrive.

These three concepts – ecosystems, resilience and sustainability – are the basis from which we can reimagine our organizational thinking in an ecological context. They emanate from two fundamental understandings:

- who we are as an organization
- identification of the ideal towards which we strive.

The methodologies that we use to create sustainability, to imagine our path forward will vary with our varied identities and the changing circumstances that we confront. But our work can, indeed must emanate from our core understanding of art as life. So we begin by considering these two questions through establishing what I define as Foundational Documents from which all of our plans, programs, action and activities will emerge to drive us towards the ideal to which we aspire.

6 Foundational Documents

As the Director of the Arts Leadership program at the University of Southern California (USC), I interview every student who wishes to join the program. In most cases, these are young artists who have an "idea" – a concept or a vision of some project they want to take on or organization they wish to create. Sometimes they are quite specific: one student wants to start a mixed instrument chamber ensemble; another wants to reinvent how music is taught in the secondary schools in the United States. Others have sought to start a festival, build a performing arts venue, create an after-school theater program and more. I am continually intrigued and excited by the range of ideas that they are considering and their level of commitment to making them become a reality.

Before I agree to work with them however, I try to get them to think about what motivating forces are driving them to take on this life's work. Often they have focused on the end product: the ensemble, the festival, the theater and what that will look like. But too often they haven't given much thought to purpose or what I call the "why" questions:

> Why do you (personally) want to do this?
> How do you intend to change the world with the work of your organization?

In many cases, they think this is self-evident – "I want to create a chamber music ensemble because I love chamber music." "I want to start a theater because I want to do the plays I like with the people I like working with." "I want to start my own dance company because I want to make dances, not just dance in them." While these might be good places to start the conversation, I push them to think more deeply about the "why" questions. I find that I especially need to push them to think about what impact they want their work to have in the world. Too often, concerned as they are with the creation of their "product," they have not given the question of external impact much thought. But if they want to build resilient, sustainable organizations, if they want to create organizations that draw audiences and funders, organizations that really matter to the communities within which they exist, then they need to really think about how the world will be changed by the work of their organization.

I take exactly the same approach with established organizations that want me to help them build, rebuild, develop, plan or remake their organization for the future. I am working right now with two organizations, one an extremely successful ensemble that has been in existence for more than 40 years and another that has had a recent Board/Executive change. Both are looking to re-envision their future. In both cases, we are beginning our work with a reconsideration of the "why" questions before we begin any

conversation about strategy, plans and where to go from here. Focused as they often are on the day-to-day challenge of continuing to operate, organizations that have existed for some time have often spent little or no time wrestling with these critical questions. Whether you are a start-up organization or a well-established entity, it's vital to know precisely why you are engaged in this endeavor. This will be the foundation from which you will build the resilient, sustainable organization that will fulfill those aspirations.

As the Director of five different organizations over time, this was something I imposed on myself and the organizations that I led. I learned early on that the corollary to the maxim "If you don't know where you are going any path will get you there" is "If you don't know why you are on this journey then it probably doesn't really matter." For the arts entrepreneur, the arts leader and the arts organization, the answers to these questions provide the ecological ideal to which you aspire and that will guide you through all the challenges and opportunities that you will face in your journey forward.

Within established organizations, we will sometimes find these ideas expressed in three statements – the *Mission, Vision* and *Values* of the organization. When I first began working in this field in the early 1980s, a surprising number of organizations did not have even these. They were like my students; they just "knew" why they were here and assumed it must therefore be obvious to others. Most of them thought it was hardly worth the time to wrangle over the wording of a mission statement. But my experience taught me otherwise. Whether it was the potential opening of the major events center down the street at the Town Hall Arts Center, the several recessions that have been a fact of economic life for us in the United States over the past few decades, the rise and fall of government funding, the culture wars of the 1980s and 1990s that made all art suspect in its intent; these external changes have inevitably caused crisis moments in whatever organization I was leading at the time. And at each of these moment, we had to revisit and reaffirm our purpose – who we were, why we were here and what mattered to us – in order to decide on a plan of action for continuing to make progress towards that ideal.

It can be surprisingly difficult to find well thought out and carefully articulated ideals or statements of purpose for most arts organizations. Nearly all arts organizations do have a mission statement; many have vision and values statements as well. But too often they are boilerplate and relatively indistinguishable from those of every other arts organization. Here are some sample mission statements from actual organizations, taken from their websites that illustrate my point. I have not credited them in order to protect the organizations; they are merely here to illustrate a point:

> _____ Performing Arts Center strives to present a broad global perspective through the presentation of high quality artistic work in music, theater, dance, film and visual arts.
>
> The mission of _____ Foundation is to support educational excellence in the public schools – through fundraising and operation of enrichment programs.
>
> The mission of _____ is to deliver exceptional vocal performances and exciting, accessible programs to diverse audiences, focusing on community engagement and the transformative power of live performance.

If you read these statements without their names attached, their inadequacy becomes obvious; they are essentially interchangeable with any similar organization and are filled with words like "diverse," "excellence," "high quality;" lofty ideas that lack any real specificity or

meaning. They read like boilerplate; pulled from a generic resource on "how to write a mission statement." Why do organization produce such inadequate statements?

One reason is that for many organizations the idea of writing mission, vision and values statements is seen as a waste of time when "there is work to be done." Statements like these are also often dismissed as a lot of "navel-gazing" and, besides, "we all know what we are here to do so let's just get at it." Additionally, the process has in many instances become something of an onerous one – usually involving a meeting of multiple "stakeholders" in a day-long "rewrite the mission statement" retreat that can be excruciatingly uninteresting for people who want to get things done.

The passion for action that fuels arts leaders is a good thing. But it has also been my experience that the process of taking the time to meet together and come to a shared understanding of who we are and why we exist reveals and strengthens the multiple points of view of the stakeholders and the complexity and contradictions that may exist within the organization. The ability of the organization to do the hard work of arriving at a consensus decision about its identity and its reason for existence is not easy. But this type of self-examination and critical reflection is vital to the health of the organization.

On a more practical level, if these statements are clearly articulated and well understood by all, they provide critical and invaluable guidance for staff to make decisions about their daily work. An axiom of good management is that decisions should be made at the "lowest possible level" in order to empower staff to have some control over their work and also to enable the organization to function effectively without requiring that every decision be reviewed and confirmed by "the higher ups." With a full and robust understanding of the Foundational Documents, staff are far more likely to make decisions that conform to the organization's purpose and intention.

For example, if building lasting, long term relationships within the community is a core value of the organization, then a patron approaching the box office asking for an exception to the rules will be accommodated by the box office staff on the spot ("Yes, we will exchange your ticket for last night for a ticket for a later performance because we want to keep you as a patron and not alienate you by rigid adherence to our policies") because box office workers know that this action on their part adheres to the values of the organization.

While that's a simplistic example, these statements really come into play when larger issues arise and collective decisions need to be made that can critically affect the direction, even the survival, of the organization. Often these will be about policy changes, programmatic direction and potentially risky ventures. Well thought out, clearly articulated *Foundational Documents* will establish the context within which sound organizational decisions can be made.

Over time, I've arrived at five key statements that collectively comprise the organization's Foundational Documents. These are: *Vision, Mission, Core Values, Artistic Intent* and *Community Context*. Each serves a particular purpose, but all five are necessary to fully articulate and understand the identity and purpose of the organization. The statements are also interconnected and achieve their effectiveness in the way that they interact with each other. Rather than thinking of them as a hierarchical list or traditional pie chart with five separate pieces, I see them as an ecosystem; each retaining its own character while also contributing to the understanding of the organization as a whole. The resilience and sustainability of the organizational ecosystem is built from these statements and one, the Vision, articulates the ideal towards which the organization is striving. So we begin there.

Vision

> *Every child deserves a chance*
>
> Street corners once occupied by gangs and overrun by criminal activity are now safe for visiting artists, teachers, alumni and volunteers. Drugs, weapons and spray cans are replaced with musical instruments, books, sports gear, paintbrushes and canvases. Everyone in the community is sharing lessons learned and the local schools and the surrounding neighborhoods are becoming strong foundations for fostering the next generation of productive and successful contributors. Heart of Los Angeles has become a beacon center of hope that unites partners with youth and their families to transform communities.
>
> (Vision, Heart of LA, 2017)

In describing the sustainable arts organization, I noted the need for an organization to strive for an ideal; a vision of the world that can serve as the organization's "north star," setting the overall direction for its development into the future. That aspirational ideal is represented in the organization's Vision. From its headline (*Every child deserves a chance*) to its vivid description of the world it envisions for its community, this Vision for Heart of LA, an arts organization in a Los Angeles neighborhood, does exactly that.

A Vision needs to be capacious, aspirational and idealistic, embodying the organization's most expansive hopes and dreams. It should represent an image, not just of the organization, but of the world that will come into being as a result of the work of the organization. For social service organizations this can often be a somewhat easier task as their organizations are often founded to solve a problem or address a crisis and the Vision of the organization is to do just that. When I lived in Tucson, Arizona I was the Board Chair for a time of the Southern Arizona AIDS Foundation. Our Vision, simply put, was a world without AIDS. We used to say that when we had achieved our Vision, there would be no need for our organization and we could dissolve ourselves.

While arts organizations are or should be engaged in doing work that has some salutary effect on the world at large, we are not usually interested in dissolving ourselves, and are rarely if ever engaged in specific problem-solving in the way that social service organizations might be. As a result, our Vision is less likely to be an outcome and more often an ongoing process. It's one reason arts organizations tend to avoid this conversation about Vision. It's hard and elusive. But in my mind this makes it an even more vital subject for discussion.

When writing a Vision, many organizations fall into two common traps. The first is the tendency to focus on a future Vision of the organization itself and not on a Vision for the world. This can seem appropriate given that the Vision is one of the organization's defining documents. And a vision of the future of the organization is often more concrete; something we can more easily imagine and state. But it's also a way to dodge the question of community impact that we often find so difficult to articulate. Here's a typical (and real) example:

> The _____ Opera Company will be recognized internationally as a leading example of adaptability, innovation and sustainability in the operatic arts, promoting diversified programming and unique performance venues with world-class and emerging talent.

Words like "internationally recognized," "world class," "model organization" and such predominate in these statements. While we can understand and appreciate any

organization's desire to be "world class," especially in the arts we need to also ask, "Is that enough?" Too often we become so wrapped up in ourselves and our aspirations, we fail to think enough about what impact we want our work to have on the public for whom we are presumably organized.

Many organizations and their leaders also believe that the "why" of their existence is obvious. It is not; and the endless struggle for societal recognition and support for the arts, especially but not only in the United States, should be proof enough of that. In effect, as I often say to clients to help them think beyond themselves, "As someone *not* involved in the organization, you are asking me to donate money to you. I want to know why. What difference is your organization going to make to our community?" In the Vision, the organization has the opportunity to assert its value to the community it serves, to the region and even the world. Too many arts organizations pass it up in favor of talking about themselves.

A second common mistake in writing a Vision is reluctance on the part of arts organizations to think expansively and idealistically about the future. Instead, we get a somewhat prosaic description of current activities. Here's an example of what I mean:

> The _____ Arts Council strives to be a model arts organization ensuring access to the arts for all ages, encouraging a community passion for the arts, and successfully supporting, partnering, and collaborating with others committed to the arts.

Nice enough words, but hardly motivationally aspirational or idealistic. The type of thinking and language required for a truly idealistic vision is often viewed, even by arts leaders, as mushy and soft and therefore of lesser value than the more concrete values of fiscal stability, for example, or artistic excellence. We would do well to seek to expansively imagine a different world and commit to its realization. It's one of the reasons I so admire the Vision of Heart of LA quoted above. They dared to dream of a world that from today's perspective seems wildly unrealistic. But is it? And, moreover, should it be? Isn't it the job of the arts organization to imagine something more than just the current "achievable" reality? Artists strive to venture into the unknown towards an unimagined future. Shouldn't we be as aspirational in our Vision as the artists who are at the core of our work?

At YBCA, following the economic crash in 2008 and our subsequent efforts to reimagine our organization for a changing world, we knew we needed to rethink our Vision. For several years we had been operating as a "contemporary arts center grounded in the San Francisco community" as a sort of shorthand understanding of why we were here. We also colloquially thought of ourselves as "the people's arts center" as a way of distinguishing ourselves from other, larger, more "elitist" institutions. We had an aspiration to "place contemporary art at the heart of community life" which was our Vision at the time. The financial crisis provides us with the opportunity not to contract, but to think more boldly and expansively.

We formed a diverse group of staff and Board and spent a daylong retreat working on writing a Vision. We laid out all the programs we were currently engaged in; we talked about what we wanted to do, what we couldn't do, what we didn't want to do. We talked about the world and our community; what we were lacking as a society and what we wanted to change about that society. People talked about the world they imagined for themselves, for their children, for their culture and community and what that would look like. We had dozens of exciting, passionate and, yes, often-contradictory ideas

about all of this which all served as the basis for moving to the next step. Based on what we had imagined and could imagine, we thought about a vision for our world with YBCA as an active and vital force in it. All of us, in one way or another, wanted YBCA to "change the world" making us more human, more compassionate and more provocative than we had ever been. It was a vital and enriching conversation.

With all these thoughts and ideas on the table, we began working to distill our thinking down into one phrase or sentence that we could all live with.[1] It was late afternoon; there were large pieces of paper covered with words everywhere. We were floundering to find the exact right ones; not because there was disagreement necessarily but because there was over-agreement; so many ideas up on the wall, all of them worthy and important. The continuing conversation narrowed down some ideas but we still had not found the flash of inspiration; the phrase that would dramatically articulate our vision. Then, one of our quieter members who worked at a software company suggested we look at a variation of a Vision that they had recently abandoned in favor of something new. Once he said it, and adapted it to our organization, everything clicked: *"YBCA revolutionizes how the world engages with contemporary art and ideas."*

Before we were able to get to full consensus though, we had extensive discussion about two specific words in this Vision. One was "revolutionizes;" some arguing that this was too radical, that revolutions usually do not end well, that incremental change is also good, etc. The second controversial word was "world," and there was strong sentiment for changing it to "San Francisco" or "the Bay Area" or "our community." We were, after all, a relatively small, locally grounded arts organization. How could we presume to change the world, let alone revolutionize it? For the next 30 minutes or so we haggled over words but it became clear that we were haggling over something bigger than just the words. Were we ready to "put a stake in the ground" that was this audacious? Did we dare to aspire to such an expansive Vision?

My strategy as a leader at times like these is to let the conversation happen while trying to keep people from straying too far off topic or repeatedly saying the same thing. By allowing the conversation to continue, people were forced to articulate why they did, or did not, want a particular word; what it meant to them, what they thought it would mean to others. I wanted to make sure that no one felt unheard, left out or silenced. By allowing the conversation to continue, people who might initially be thinking rather small get a chance to ruminate and allow their thinking to expand.

We had also designed the group to ensure that we would have several articulate, passionate people in the room who could share that passion with others who might be more reticent. Eventually, consensus emerged as people became more comfortable with the words; as they "lived with them" for a bit. There were still people not completely comfortable with the statement but for no one was it a "deal breaker." Additionally, a key tactic for conversations like these is our commitment to return to the conversation in another six months or year just to check in and see if people were still feeling good about the decision.

Through this process of arriving at a Vision we engaged the tough issues of both why we existed and what impact we wanted to create in the world. We had an energizing and important discussion; we settled on what really mattered to us and why the organization mattered to the world. After just one day, it was done and we all agreed it had been an important experience just doing this work. The Vision became our ideal; the driving aspiration for our organization as we moved forward into an uncertain future.

The session was also a real "community builder" for our organization. Board, staff and donors in a room working intensely together to talk about a "big issue" was a defining

moment for us. The participants felt more connected to each other and even more passionate and committed to the organization in which we all now had a deeper emotional stake than we had previously. We took that lesson and applied it subsequently to our Board meetings in which we always set aside an hour to discuss a "big issue" that would fully engage Board and staff in a conversation that really mattered to us on a higher level than the monthly financial reports.

This experience with YBCA mirrors what I have seen in similar conversations with other organizations with which I have subsequently worked and often this has not been as difficult to achieve as one might think. Yes, there are always the "realists" in the group, determined to pull everyone back to earth. But my experience has been that when given the chance to "think big" people ultimately will want to go there. Sometimes they just need the permission that a good arts leader can give them to rise to the challenge; and I believe that a Vision is not a true Vision if it doesn't make us a little uncomfortable, if it doesn't have at least a bit of presumption in it and if it doesn't make us swallow hard at its boldness and daring.

We live in an era in which goal achievement is highly prized, so another challenge of writing a Vision is to make sure it remains a *Vision* rather than a *goal*. The Vision is the "unattainable ideal" – the imagined future to which we strive and which drives our sustainability. We may set benchmarks of progress along the way, but if we just aim for a "goal" then we are setting limits to our vision. The other four Foundational Documents all exist in service of making progress towards the Vision so the symbiosis between them that we seek is truly centered in the ideal to which we strive. If you get the Vision right, the other four will emerge organically and far more easily.

Here are a few other sample Visions that I think succeed as ideal-driven aspirations. They think big, they describe an idealized vision of the community and they inspire the organization to action.

> The Broadway Center will energize and help lead a renaissance that brings shared joy and prosperity to our community.
> (Broadway Center for the Performing Arts, 2017)

> We envision a world where our commitment to a collaborative artistic process results in profound orchestral performances that inspire people to pursue cooperation and artistry in their own creative, professional and personal lives.
> (Kaleidoscope Chamber Orchestra, Los Angeles, CA, 2017)

> The Bellingham Chamber Chorale touches lives through memorable, life-changing experiences and has an enduring impact on our members, audiences and communities across western Washington and the nation.
> (Bellingham Chamber Chorale, Bellingham, WA, 2017)

Mission

The poor mission statement has been asked to do too much for too long. It's supposed to inspire the organization, describe what the organization does, who it serves, and contextualize artistic choices – all distilled into a single sentence. Luckily, with *five* Foundational Documents, we can take some of the pressure off the Mission and allow it to do what it does best: provide a short, comprehensive statement of purpose. The

Mission simply needs to describe what we do and for whom. Where the Vision is aspirational, even abstract, the Mission can be concrete, direct and clear about organizational design and purpose. Here are a couple examples that I think do that quite well:

> The Bellingham Chamber Chorale presents diverse, challenging and eclectic choral concerts to entertain and inspire our audiences and members; our passion is to bring world-class musical experiences to our Pacific Northwest community. We provide performance and mentorship opportunities for young musicians; we strive to be part of a firm foundation for local performing and developing artists. To this end, the Bellingham Chamber Chorale also frequently collaborates with other local artistic ensembles, and we also partner with local composers to debut new works.
> (Bellingham Chamber Chorale, Bellingham, WA, 2017)

> Through our commitment to building an arts sector rooted in justice, the mission of the National Performance Network and Visual Artists Network (NPN/VAN) is to foster a group of diverse cultural organizers (including artists) working to create meaningful partnerships and to provide leadership that enables the practice and public experience of the arts in the United States
> (National Performance Network, 2017)

You will note that these statements of the Mission are longer than a single sentence or phrase, and that's completely acceptable. One of the important tasks each of these statements accomplishes is to differentiate the organization from other similar organizations. That often requires more description than a single sentence or phrase. Reading these statements of the Mission gives you a very clear idea of what the organization does, for whom and what need it fulfills.

It's tempting in developing a Mission to go into a lengthy list of all the things the organization does. There is no need for this, especially since programs can, and should, change over time as the organization makes progress towards its Vision. It's good to describe the Mission in an open-ended manner to allow for this potential program change, as there will be room for ideas and projects to emerge that adhere to the parameters articulated in the Mission.

A phrase that has emerged in recent years that is often viewed as an organizational flaw is "mission creep." This is the idea that the organization has somehow drifted off track, purposefully or not, to pursue programs or potential revenue streams unrelated to its Mission. My view is that mission creep can and should occur; that it has a positive effect on the organization that evolves as circumstances change. I see this happen in three different ways.

The first occurs almost unconsciously, in the process of simply doing our usual programs. Imagine that you are a symphony orchestra dedicated to the western European classical music canon. You have the opportunity to bring in a guest conductor who will play the expected repertoire but also wants to perform a contemporary piece of popular music. Reluctantly you say yes ("it's not really part of our Mission") and it goes spectacularly well. You receive lots of positive feedback and before long you are doing even more popular programming. Mission creep? Or time to change the Mission?

A second example is when we tell ourselves that a new program or direction is related to the Mission but is in fact deviating from it. You are an ensemble theater company that is dedicated to the repertory system, and the audience is excited to see the same actors

performing multiple roles. You bring in a guest artist and the reaction is tremendously positive so you think, "Well, it's not *that* different from what we have been doing. And the actor's fame did help increase sales." So you do it again the next season, and the season after that. And seeing the success of this model you begin to think maybe you were misguided about the repertory model. Actors are happy as they have more flexibility to take other roles elsewhere and audiences are happy to see new faces. So you make a deliberate change and are no longer a repertory company. Mission creep? Or time to revise the Mission?

The third example is when you make a deliberate, planned decision to pursue a program or idea that you know full well is outside of the current Mission. In cases where you may feel your Mission has outlasted its usefulness, this choice may actually represent an innovation, an excursion into a new way of thinking or working. You are a classical ballet company and although the full-length ballets are doing well, the repertory programs are not. You decide to experiment with exploring forms of dance outside of ballet. You bring in a hip-hop dance company as a guest company one season to see what response you get. The response from the community is positive and strong, so you begin to explore ways to diversify the ballet company itself as well as its repertory. You keep the story ballets because they are popular classics that attract a dedicated audience. But you expand your other offerings to reach other audiences who might never attend the ballet at all. You do this because your Vision is for dance to be central to the community and you can't do that with just one specific form. Mission creep? Or time to change the Mission?

Looked at from another perspective, mission creep could be called adaptation, modification, innovation or experimentation; an attempt by the company to expand, diversify or otherwise adjust its Mission in response to external changes. We like to think that these innovations are all carefully designed and well planned. Sometimes they are. But sometimes they occur organically or even serendipitously, over time and almost without us realizing it – they creep up on us. Our goal is to be a dynamic organizational ecosystem, dedicated to pursuit of the Vision and not excessively constricted by a Mission that inhibits change. Missions are not etched in stone; they are simply descriptors of what you do, for now, as you work towards your Vision.

Changing the Mission should be a deliberate choice, even if the methodology that got you to that point was not. Organic change that emerges from action is as good, if not better, than our carefully pre-planned changes. In a resilient and sustainable organization, consideration and reconsideration of the Mission is an ongoing process informed by your activities and what you see happening around you.

Core Values

Core Values are the guiding principles for all of the actions that the organization takes. They exert an active influence on organizational behavior, providing direction on how to both create the work and make decisions for the organization. If the Vision is the "why" and the Mission is the "what" then the Core Values are the "how" or "under what conditions."

This is a challenging section for most arts organizations because we often confuse Core Values with artistic values. Although both are extremely important, Core Values are tied to the organization as a whole whereas artistic values more rightly belong in the next document, "Artistic Intent." With Core Values, we are dealing with the key principles that guide our behavior and our actions as an organization.

In determining their Core Values, organizations will also often focus on ethical or behavioral values. These would be commitments to things like honesty, transparency, integrity, etc. It has become increasingly important to have these as part of your Core Values, especially now when at the very highest reaches of government and business we see a deterioration of ethical behavior that does not speak well for us and our culture. In many ways we would wish that we did not have to insert values like honesty, integrity and respect for others in our statements of Core Values; that they would be "a given." But particularly in the current environment, it is absolutely necessary for arts leaders and arts organizations to claim an ethical leadership position that seems to elude many others. During the 2016 U.S. Presidential campaign, First Lady Michelle Obama, in responding to the personal attacks on her, her family, candidate Clinton and other leaders, uttered the famous words, "When they go low, we go high." These "high" values are the values that arts leaders also should claim for themselves and their organizations.

Another set of values that organizations often include are broadly organizational and programmatic in nature; values like representing the multiple cultures of our community, giving voice to those seldom heard or having a commitment to excellence and/or innovation. These are also important values that should be noted in your Foundational Documents. They too could show up here as Core Values or they could show up in one of the other sections –Artistic Intent and Community Context. The important point is to insure that these deeply held values that guide your work, organizational as well as artistic, are discussed, developed, articulated and shared, internally and externally.

Core Values must be so intrinsic to the idea of the organization that if they were to be breached or altered, you would no longer be the same organization. Core Values might include such ideas as commitment to social change, addressing historical inequities in programs and personnel, eradicating racism, a non-hierarchical approach to organizational design, commitment to collaboration and similar ideas that might be visionary, organizational, programmatic or some combination of these. As Core Values they are fundamental to our organizational identity and should infuse everything we do. A Core Value of "commitment to social justice," for example, might mean that we have an aggressive policy of recruiting and hiring people who have been historically excluded from our organization or art form, that we have a practice of socially responsible investing, that we serve as a sanctuary for undocumented immigrants, etc. If these are Core Values, they will infuse our decision-making on all levels and in all areas. They are not just a project that we work on from time to time.

I push organizations to have as vigorous a conversation about Core Values as they do about Vision. I also urge them to settle on a few Core Values that are truly definitional for the organization and to ensure that they are authentically synchronous with the other Foundational Documents. Here is an example of what I am driving at:

> *Bellingham Chamber Chorale: Core Values*
> **Excellence** – Through meticulous and disciplined musical preparation and annual evaluations, we strive to give performances of high-artistic quality and maintain the highest standards of the choral art.
> **Education and Learning** – Performance training and basic arts management is a vital component of our members' and the emerging musicians' development. We are committed to expanding and providing mentorship opportunities for our members and young musicians.

Innovation – We perform a diverse and eclectic repertoire of music that challenges our singers' abilities. We collaborate with other performance groups to reach a broader audience. We commission new works to expand the choral literature. We release high quality recordings that will develop and enhance our regional and national reputation.

Stewardship – We strive for responsible and sustainable use of the resources invested in our work.

Collaboration/Community Building – We strive to nurture beneficial relationships with the community and increase access to the choral arts to develop and expand appreciation of choral music.

Enjoyment/Enrichment – Our performances enrich the lives of our audiences while providing gratifying experiences for our members.

(Bellingham Chamber Chorale, Bellingham, WA, 2017)

Artistic Intent

When I began my career at the Town Hall Arts Center, I became involved in what was then the Association of College, University and Community Arts Administrators (ACUCAA), now known as the Association of Performing Arts Professionals (APAP.) As a new performing arts presenter, I quickly learned that the measures of success in our field were attendance, tickets sold and a balanced budget. The conversations I had with colleagues and the workshops I attended as a new presenter were largely focused on these financial issues, and we only occasionally talked about art and artists except in relation to their popularity or saleability. Indeed, I met many "old school" presenters who considered it a point of pride that they almost never engaged directly with artists. Their conversations were with artist managers instead and tended to center on scheduling, contracts, etc. I was taken aback by the lack of conversation about art and presenters' general reluctance to discuss the artistic intent of their organization. Only selling tickets mattered.

In 1990, I picked up a book by Nello McDaniel and George Thorn entitled *The Workpapers One; Rethinking and Reconstructing the Arts Organization*. This book introduced me to the concept that an arts organization should have an "aesthetic core." McDaniel and Thorn suggest that every arts organization needs to determine "the artistic point of view, the vehicle by which an organization realizes its philosophy. The Aesthetic Core is not the choice of plays, dance or music to be performed. It is the context in which these choices are made." (McDaniel and Thorn, 1990, p. 51)

Here was the concept I'd been seeking, which had eluded me since entering the presenting field. While McDaniel and Thorn were applying the Aesthetic Core concept to producing rather than presenting organizations, it seemed to me to be relevant to presenters as well. I wrote about it in my first book (Foster, 2007, pp. 67–73), and began to use it in my own work. A few years ago, I shifted away from the term Aesthetic Core and started using the term Artistic Intent as the fourth of the recommended Foundational Documents.

I define Artistic Intent as the organization's artistic point of view. In some ways it is the arts-specific Mission, the document that clearly sets out the artistic purpose of the organization. As with the other documents, the point of view often arises that this is superfluous, that everyone associated with the organization knows it and therefore so does the "general public." The Los Angeles Chamber Orchestra (LACO) "obviously"

performs classical chamber orchestra works; the Cornerstone Theater Company "we know" does community-based theater; the Lula Washington Dance Theater (LWDT) of course produces the work of Lula Washington. But a closer look at each of these organizations reveals that they are much more complex in their artistry and their artistic intent than the name implies. The range of work performed by LACO is astonishing; from traditional classical to contemporary. Cornerstone Theatre Company has a unique and specific intent to produce theater that involves professional actors, directors and playwrights integrated on stage with members of the local community with which it is engaged. LWDT produces primarily the work of Ms. Washington but other choreographers as well. Indeed most arts organizations would resist being characterized artistically simply by the descriptor in their name. But there are other good reasons for an organization to engage in the development of a specified Artistic Intent.

For one, just like the discussion around Vision and Core Values, discussions around Artistic Intent can be an important and defining experience for the organization and for the people committed to working in it and with it. I very often found that even Board members had only a vague idea of the artistic direction of the organization they were supporting, reducing it all too frequently to what is familiar to them about the art being created and presented, when it may be more complex than just "performing classical music," for example. In many organizations, discussing artistic direction in an open session can be a sensitive topic, as the Artistic Director often claims full providence over artistic decision-making. I don't necessarily disagree with that position. But if that's the case, the chance for the Board and staff to fully engage with the Artistic Director about his or her artistic vision; the opportunity for the Artistic Director to be called upon to articulate in more than platitudes what he or she is striving for with his or her work; these are serious and important conversations that will only strengthen the core identity of the organization. It also draws stakeholders, and especially Board and staff, more fully into the artistic vision of the organization. As external ambassadors, it is often the Board or staff member who is explaining the Artistic Intent of the organization to donors and public. The degree to which they have been fully engaged in that conversation, even if decision-making still rests with the Artistic Director, maximizes their ability to articulate and advocate for the organization. Moreover, being engaged in artistic direction conversations keeps them more personally engaged in the work of the organization and insures their deeper commitment to the sustainability of the organization.

Like the Mission, the Artistic Intent also can change over time. And just as mission creep is not always a bad thing, neither is a changing Artistic Intent. In fact, I encourage organizations to periodically examine their Artistic Intent and decide if they want to continue in this direction or not. An artistic shift can, and probably should, occur when there is a change in artistic leadership; the artistic vision of one director for the organization might be very different from that of another one. In the best cases, this decision is done deliberately and synchronously with the other Foundational Documents so that the full organizational integrity remains. Artistic Intent, Vision, Mission and Core Values are all critical, interrelated and mutually dependent parts of the organizational ecosystem.

Below is the Artistic Intent that we developed while I was at YBCA:

The specific artistic context within which curatorial decisions are made is as follows:
1. We are interested in artists whose work reflects, explicates, investigates, provokes and questions the profound issues of our time and of all time. We are

especially interested in work that subverts, questions and provokes current assumptions, pushing the spectator to revisit and rethink his/her own assumptions about art, identity and the world.
2. We are primarily interested in the work of living artists.
3. We are interested in artists whose work is exploring and altering the boundaries of art practice in the contemporary world. We seek out those who question and subvert the ongoing assumptions of current artistic practice and, by their work, extend the current artistic parameters, creating new artistic knowledge.
4. We recognize that the realities of identity: age, ethnicity, race, gender, sexual orientation, etc. are constitutive of the work of every artist. We acknowledge and celebrate those identities, their nuances and their complexities even as we seek out work that resonates with multiple audiences and constituencies.
5. A significant cohort of artists live and work in the Bay Area and we are committed to supporting the best of these artists in furthering their work and placing them in dialogue with their national and international counterparts.
6. We believe that the work of artists from countries and cultures other than the United States and regions other than the Bay Area is significant to our audiences. To that end, we aggressively seek out the work of these artists and strive to place them in a context that provokes new understandings for our audiences.

Community Context

Over the past few decades it has been interesting to see the changing nature of the relationship of the arts organization to its community. When I first began working in 1982, we were coming to the end of the "If we do it and it's good, audiences will attend" era. This era was characterized by the assumption that great art itself would carry the day. One of the critiques I received from the Board at the Town Hall Arts Center was that the reason so few people were coming to the performances we were presenting was not because we were a new organization and had no money to promote what we were doing, but because I wasn't making the right artistic choices for our community. If I had picked the right artists, if I really "knew and understood what the community wanted" audiences would come. Even as a neophyte I could see that this was an unrealistic expectation. The ascendance of marketing as a necessity for reaching the community had already begun.

Nonprofit arts organizations began to borrow and adapt for-profit marketing strategies to their work, but often with limited success. There are some specific reasons for this. First, we were producing a product that by definition could not make money. If it could, we would not be operating in the nonprofit paradigm! Additionally, in the classic marketing construction of the "Four Ps," Price, Product, Promotion and Place, our product was not going to be changed, at least not easily and willingly. Whereas businesses will paint the car yellow if that's what people want, artists are set on their own creation, often irrespective of audience desire. And, of course, a good deal of art is made to challenge or even provoke the audience/consumer, not soothe them or please them in the way of many consumer products. Nevertheless, we often believed that if somehow we could communicate the remarkableness of the art we were producing for the larger community through a sophisticated marketing campaign, they would buy it. Thus began the era of glossy brochures, extensive direct mail postcard campaigns, beautifully designed print ads and exciting television commercials; expensive strategies that made some

difference but often not enough to be worth their cost. We had to learn that having a transformative experience with a Bartok String Quartet is something that is not immediately accessible to many people who might find it boring, or dense, or even incomprehensible. No amount of "effective marketing" would help with that.

Price is another one of the Ps that causes problems for arts organizations, as we often cannot adjust the price to reflect the actual cost of producing the product, never mind the costs of overhead, marketing and promotion. If we did, tickets would soar to an unreasonable level even for the most committed lovers of the art. Many organizations are committed to keeping their ticket prices as low as possible, which works against price adjustments as well. For a period of time, and for many organizations still today, a maxim in the performing arts world was to charge the highest price that the market would bear, especially once we discovered that for some artists and some performances we could charge extravagant prices for highly valued tickets. Of course that leaves a substantial portion of the population out of the arts conversation, which is a mission conflict for most of us. Although a for-profit company can invest heavily in marketing with some hope of an expected return on that investment, most arts organizations cannot.

Organizations still spend significant portions of their budgets on marketing. But other strategies needed to evolve in order to expand the numbers of people attending our events, so what we now know as outreach and then audience development became a priority. Outreach meant reaching out to those who were not part of our current audience, using non-traditional methodologies to "bring the art to the people." We would send string quartets to play in the lunchroom of a local business, have artists do promotional appearances at malls and other places of business and, of course, send artists to perform in schools and community centers for "underserved" populations, all with the intent of enticing them to buy tickets and attend the performances at our theater. But this strategy also reached a limit of effectiveness.

We learned for example that often the populations we were "reaching out" to had their own arts organizations and arts experiences and were somewhat insulted by our presumption that they were "underserved" and needed to "reached." Similarly, what we began to call our "audience development" efforts still prioritized the needs of the organization over those of the community we were seeking to "develop." Education programs, pre-show talks, program notes and more were all designed to get you to come see the art we had selected; to join our club of arts lovers. The idea was that once someone "got" the art, they would come back for more. Outreach and audience development efforts continue today, but they too have limited effectiveness. Too often our audience development is focused on *talking at* or *selling to* our community rather than listening and responding to their needs and desires.

Eventually, community engagement emerged out of audience development, and at last we were beginning to get the idea. Community engagement meant that we were focused on the community as a community, not simply as a potential audience. Community engagement meant arts organizations finding ways to weave themselves into the life of the community, to be seen as active community members concerned with and working on the same issues everyone else was – issues like poverty, crime, education and gentrification that related to the quality of life in our community, both in and out of the theater. These community engagement efforts took many forms. On the most basic level, we joined business associations, we marched in holiday parades, we hosted political forums (though usually just about arts issues) and some of us participated more directly as volunteers in community organizations. But we also began to see the art itself as a

community building process and began exploring ways to engage artists in community building.

Some artists have been creating community-based work for many years; performances developed by knowing, listening to and working in communities and engaging them directly in the creation of the work itself. Liz Lerman's "The Hallelujah Project" which I mentioned previously was one such project. Over a span of many months, Liz made visits to Tucson to meet with a variety of different faith-based communities, few of whom had ever attended a performance at the University of Arizona's Centennial Hall, the home of UA*presents*, the organization I led. Liz and her company would interview members of these communities and engage them in listening, in conversation and in the choreographic development of the piece. When the final performance occurred, our theater was filled with people who had never been there before. They were there because the artists had gone to them and engaged them in the creative process.

Dan Froot is another artist who has taken the idea of community engagement to a radically new level with his most recent project, "Pang!" (Froot, 2017). Froot had noted and become concerned about the discrepancy between the enormous wealth in the United Sates and the significant numbers of people living with food insecurity, a condition that the Unites States Food and Drug Administration defines as " a household-level economic and social condition of limited or uncertain access to adequate food" (United States Department of Agriculture, 2016), Dan spent several years exploring what the impact of this socio-cultural phenomenon might be and how it might be addressed with integrity through a community-based artistic process. He decided to focus his attention on three cities: Los Angeles, California, Cedar Rapids, Iowa and Miami, Florida after first producing a prototype in Santa Monica, California. Over a period of three years he made several visits to each community, meeting with the performing arts presenters there who helped him establish relationships with the various nonprofit agencies working on issues of hunger and food insecurity. Through these partnerships he was able to develop relationships with families in each site whose stories he developed, with their consent and participation, into live radio plays. He chose this format because:

> I want our audiences to feel as if they are 'between the ears' of our family narrators. Performing the plays live in theaters allows us to expose the storytelling process, engaging the audience on a deeper level. I am fascinated by old-fashioned live sound effects, which often involve actions and objects that don't correspond visually with their aural effect. These sensory dislocations present rich opportunities for jarring and poetic associations.
>
> I believe life-stories have the power to dispel fear, challenge one's values, and inspire compassion. I want to understand, from street-level, forces that come between the world's abundance and so many of the people in our midst. There is urgency in the impulse to tell these particular stories. Bringing diverse groups of people together to listen to each others' stories is surely an end in itself.
>
> (Froot, 2017)

These are just two examples of performance projects created by artists that connect with community by going outside of the theater and discovering what matters to the people in our community and devising ways that they might actually become fully engaged with the art. In projects like this, people began to see themselves on the stage, often were performing themselves and began to feel embraced by and invested in the

Figure 6.1 "Pang!" Dan Froot's triptych of live radio plays about families hungering for change. Photo by Will O'Loughlin

Figure 6.2 Donna Simone Johnson in "Pang!" Photo by William O'Loughlen

work of the arts organization. When the community becomes part of the artistic process, arts organizations are also able to shift their intentions away from the typical arts attendee demographic (middle aged, middle class and usually white) and engage with the entire community.

It was against this backdrop that I decided it was time to incorporate the idea of "Community Context" into the Foundational Documents. Much as the Artistic Intent speaks to your artistic direction, the Community Context establishes the context of the community within which you work. This is made even more important if the obvious geographical community is not necessarily the primary community that you wish to serve. At YBCA, we embarked on an artistic and organizational mission to establish ourselves in the context of a global community of arts innovators. We joined national and international consortiums of organizations similar to ours to ensure that we were knowledgeable about what was happening in the world and that we participated – through commissioning and presenting – in the global circulation of contemporary performance work. Once we started working with the various tech start-ups in our community we expanded our community context even further to encompass "creatives" of all types who were exploring the boundaries of what was possible in their fields just as we were in the arts world. We met with our counterparts in Jakarta, in Mumbai, in Manila, in Seoul, in Nairobi, Johannesburg, Maputo and other cities of Africa and multiple locations in Europe in addition to cities in the United States. Our community context was a global one and we sought to provide a platform for artists of the Bay Area to engage in a dialogue with these global communities as well. But we also had more localized aims: to reach deeply into the local community and the various populations that comprise the Bay Area, understand what their needs were, what their indigenous cultural expressions were and see if we could create linkages among the local and the global.

In my final year at YBCA we launched a program that enabled us to serve as intermediaries between artists and some specific local communities: immigrants from east Africa, from central America and from the Philippines who had settled into enclaves in San Francisco. In each case, we spent several months building relationships through multiple approaches. We worked with social service organizations, cultural centers, drop-in after school programs, local small businesses like coffee shops and restaurants and more to discover what their priorities were; what mattered to them. We then talked with them about what artists might be of interest to them, focusing on artists who were willing and able to spend time working in the community to build a work of art together. In essence, we took the approach favored by artists like Liz Lerman and served as the catalyst to connect artists and communities around ideas that were driven by the communities themselves. The project was not at all about getting them to buy tickets to our shows. Instead, we deliberately shifted away from the transactional model that we had been working in for so long and into one of community organizing and community development through the arts. We needed to find a way to assert that in a clear statement, hence the emergence of Community Context as a Foundational Document.

More recently, arts organizations have become interested in civic engagement and "creative placemaking" – a strategy for physically and artistically embedding the arts into the life of the community – indicating a growing awareness of the need for arts organizations to also be community organizers, participants and even activists. But it hasn't been easy finding examples of community context statements as organizational definers; as a Foundational Document, which may mean that as arts organizations, we have not yet moved as fully into the realm of community engagement as we need to.

Below are two community contexts that give some idea of the organization's thoughts in relation to the communities they serve.

> **The Bellingham Chamber Chorale** serves classical and contemporary music lovers of all types throughout the greater Bellingham and western Washington community, both individuals who love and/or perform choral music and those who have not yet discovered its joys.
> (Bellingham Chamber Chorale, Bellingham, WA, 2017)

> **YBCA** understands itself as the people's arts center. We serve as many of the multiple communities of San Francisco that we can possibly discover, support and nurture, especially those who are often not included in the mainstream artistic discourse. As a leader in the global contemporary arts discourse we provide opportunities for artists from around the world to join us in that discourse as well.
> (YBCA, 2012)

Conclusion

Vision, Mission, Core Values, Artistic Intent and Community Context: taken together, these Foundational Documents make up an arts organization's identity. They describe the ideology and purpose of the organization. They are the organizational anchor, but they should never be the organizational albatross. Like the world in which we now operate, they need to be dynamic and malleable to meet the current and future needs of the community and the organization. In an ecosystemic sense of understanding the arts organization, they are also symbiotic, working together to create the living entity of the arts organism.

With these Foundational Documents in place, we can next turn to a specific methodology by which to create a resilient, sustainable organization. In the last part of the book, I will explore both what some of the specific characteristics of a resilient organization are and what some potential methodologies might be to facilitate starting, continuing or reinventing a sustainable arts organization.

Note

1 I don't necessarily recommend this, though debating the connotations and definitions of words can be a worthy exercise in linguistics. You learn a lot about where people are coming from with this process. But a longer 2–3 sentence Vision is perfectly fine if that's what it takes to really get at your ideas.

7 Creating a sustainable organization

In Chapter 5 I talked about how an organization achieves sustainability by the work it does to make progress towards achieving its ideal, its Vision. This is a very different idea of sustainability than building a fixed and unchanging "structure that lasts." Instead, we understand the organization as a dynamic entity; a developing, evolving organism. As I noted in Chapter 6, the Foundational Documents establish the organization's identity and articulate the Vision; the ideal towards which the organization is striving.

What truly differentiates sustainable organizations from those that have struggled or even dissolved begins with a meaningful purpose (Foundational Documents). In addition, the organization is defined and driven by the energy it creates when it engages with the external environment. The outward signs of a struggling organization – poor management, weak leadership, financial woes, etc. – are often just symptoms of more fundamental issues, issues most often related to either confusion about the core purpose of the organization, and/or a lack of engagement with the external world. Weaknesses in these fundamental areas inevitably lead to the inability to attract funding, to hire and keep good personnel, to create effective organizational systems and to take actions that are necessary for a sustainable organization.

One example of a company with a meaningful purpose that also connects with the external environment and that has sustained and flourished over time is the Cornerstone Theater Company. Founded in 1986 and settled in Los Angeles in 1992 (Cornerstone Theater Company, 2017). Cornerstone saw the need for the stories of multiple urban communities to be told, and for the people of those communities to be engaged in telling those stories themselves. Initially, under the artistic leadership of co-founder Bill Rauch, and now led by Michael John Garces, Cornerstone pioneered, and further developed over time, a unique professional/community collaborative approach to creating theater as the mechanism for progressing towards its Vision of a world in which "artistic expression is civic engagement and access to a creative forum is essential to the wellness and health of every individual and community." (Cornerstone Theater Company, 2017) Cornerstone spends weeks, sometimes months, embedded in a community; developing ideas, holding workshops, teaching classes and becoming fully integrated into community life. Eventually, a production emerges that features a combination of the professional Cornerstone actors and the community members, not professional actors, for whom the story being told is a deeply personal event. The performance result is unique both in its blend of the professional and amateur and the specificity with which it speaks to the community involved in its creation.

Kronos Performing Arts Association is another arts organization with a meaningful purpose that connects with the external environment and that has sustained and

flourished over time. Kronos holds tightly to its string quartet roots while engaging in both the music and the societal challenges of the contemporary world, pursuing its Vision of "combining a spirit of fearless exploration with a commitment to continually reimagine the string quartet experience." (Kronos Performing Arts Association, San Francisco, CA, 2017) Here is their "founding story:"

> Kronos' adventurous approach dates back to the ensemble's origins. In 1973, David Harrington was inspired to form Kronos after hearing George Crumb's Black Angels, a highly unorthodox, Vietnam War-inspired work featuring bowed water glasses, spoken word passages, and electronic effects. Kronos then began building a compellingly eclectic repertoire for string quartet, performing and recording works by 20th-century masters (Bartók, Webern, Schnittke), contemporary composers (Vladimir Martynov, Aleksandra Vrebalov, Sahba Aminikia), jazz legends (Charles Mingus, Maria Schneider, Thelonious Monk), rock artists (Jimi Hendrix, The Who's Pete Townshend, Sigur Rós), and artists who truly defy genre (performance artist Laurie Anderson, visual artist Trevor Paglen, filmmaker Sam Green).
>
> (Kronos Performing Arts Association, San Francisco, CA, 2017)

The strategies Kronos has employed to make progress towards its Vision have naturally changed and evolved over time. The ensemble has deliberately focused on the work of living composers and become one of the largest commissioners of new music in the world. Kronos has performed pieces that comment on and illuminate the AIDS epidemic, the war in Vietnam and all of the subsequent American wars, the wonder of space, the cultures of Asia, Africa and Latin America as well as worldwide indigenous communities, and an

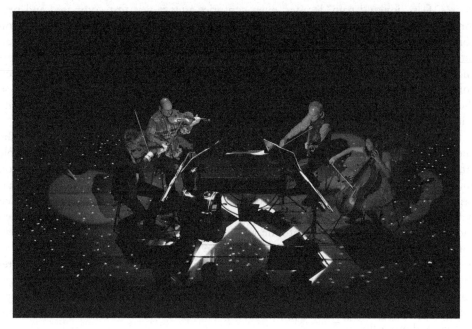

Figure 7.1 Kronos quartet, Kronos Festival. 2015. Photo by Evan Neff. Courtesy of Kronos Performing Arts Association

extraordinary range of the socio-cultural issues that have arisen over the course of its 40 plus years of work. And all this was driven through the medium of the traditional string quartet, a form that, not coincidentally, Kronos has also evolved over time. It has added amplification, and has supplemented the traditional instrumentation of two violins, viola and cello with dozens of other instruments, including many like the oud or the pipa, from non-Western cultures. It has deliberately designed lighting and staging for its performances and investigated an extraordinary range of electronic experimentations with sound. All of these strategies were undertaken with a singular focus: making progress towards the Vision.

Kronos, Cornerstone and others like them have a meaningful core purpose that has sustained their organization that emerges from their art while also organically integrating their work with the external world. Their organizations behave as dynamic ecosystems engaged with other ecosystems. There is nothing precious or insular about these organizations. Cornerstone has done its work in a wide variety of diverse communities from skid row to the communities of various ethnic identity groups that comprise Los Angeles. The Kronos network of artists, composers and arts lovers and social activists is worldwide and expansive in scope.

Contrary to much conventional wisdom in the arts field, organizations are not made sustainable simply through the creation of inspired programs or excellent performances, vital as these are. Being a "great" orchestra or "excellent" dance company or arts center is an important achievement, but it does not ensure sustainability. Classical music organizations do not survive simply because they have assembled an amazing group of players to perform the music they love. They survive and thrive only when they are able to fully engage with the external world. Many classical artists believe that the music to which they have devoted their lives still can speak deeply and eloquently to people's needs, desires, fears, joy and pain decades, even centuries after it was first composed and performed. But it is not a foregone conclusion that this will happen unless the organization commits itself to engaging with the other ecosystems within which it exists and can interact. Theatre companies do not survive only because they have great actors, directors and designers; they survive because they have something meaningful to say to their communities. The best ones are so fully integrated into the lives of their communities, so thoroughly interacting with other ecosystems, that we cannot imagine the community without them.

In addition to understanding why we exist and then being defined and driven by the energy we create when we engage our organization with external ecosystems, a sustainable arts organization privileges innovation and learning through systematic experimentation and failure. Here is where our inclination towards building stability can work against us. Especially when external circumstances are challenging us, we can become consumed with minimizing and mitigating risk. We "hunker down." When we lose funding, we often try to figure out how to redistribute the work within the established structure rather than considering that we might need to redesign the structure itself. Short-term responses might be effective for a time but the long-term sustainability of the organization requires that we think more expansively and creatively about all the possible strategies we might pursue to achieve our ideal. If old methodologies are no longer working, we want to be able to respond quickly and with a future orientation; to be proactive and innovative, not reactive and protectionist.

One of the chief objections I often hear to this emphasis on change and innovation is, "Well we don't want to make change for change's sake." Usually this is just code for

"We don't want to change." Not once have I heard anyone advocate for change "for change's sake" but I have all too often heard advocates for no change say, "Because that's the way we always have done it." An ongoing program of review and assessment complemented by an ongoing program of experimentation and trying new ideas is what sustainable organizations have embedded in their organizational methodology.

Artists and audiences are far ahead of us in this era of innovation. Younger audiences are increasingly drawn to new forms of art and new modes of presentation, responding to performances in unlikely places (classical music in bars, theatre performances in warehouses, etc.) and new forms of art that incorporate modes of technology that are very much a part of their world. Many artists and some performance companies are now employing hybrid mixes of music, theater and dance, not to mention visual elements and media to redefine the performance experience itself. They are repurposing unlikely buildings and spaces that were never meant to host performances to meet this need. I recently attended a collaborative theater production by the East West Players and the Rogue Artists Ensemble of a play by Lisa Dring and Chelsea Sutton entitled *Kaidan Project; Walls Grow Thin* that took place in a multi-story warehouse. It began when we took a freight elevator to the top floor and then wandered through various rooms experiencing aspects of a loosely connected narrative of Japanese myths. It was a confounding, disorienting and occasionally thrilling performance experience. It was also an experiment. I've already noted how East West Players is experimenting with collaborations with other companies under its new artistic director Snehal Desai. It is also trying out other artistic approaches to accomplishing its Vision of "Continuing the movement to develop, foster, and expand Asian Pacific performance into a major force on the national arts scene in the 21st century." (EastWest Players, 2017)

Given the fragility of many arts organizations, it is perhaps not surprising to see how many are risk averse, how the drive to "hold on to what works" predominates over the drive to "fail early and fail often," the credo of the start-up technology field. But like artists, organizations also need the chance to experiment, fail and learn from the failure.

Perhaps somewhat understandably, the larger the institution and the greater its available resources, the more risk-averse it tends to be. With more to protect, there is more to lose, so we adopt a conservative rather than an innovative position. Often this is stated as a commitment to preserving our artistic or cultural legacy, certainly a vitally important task. But the methodologies for effectively doing that in the contemporary world require innovative strategies for connecting with new and emergent audiences, not simply "playing to our donor base."

To achieve an innovation posture, some larger organizations dedicate a portion of their organizational, financial and artistic assets into "new works" programs or "discovery" events series. This is laudable; but too often these wind up as offshoots and special programs, positioned as supplemental or in opposition to the "core activities" of the organization rather than being synthesized into the organization's lifeblood. Some larger organizations create "innovation teams" responsible for generating new ideas and projects. This is a strategy we pursued at YBCA in order that we could at least begin the innovation process. But it soon became clear that it wasn't enough; we needed to embed the ethos of innovation throughout the organization if we truly wanted creative new ideas to surface. Having an "innovation team" produced some interesting projects. Having an "innovation ethos" changed the way we worked altogether. Ideas, not just for new programs but also for new and better ways of working as an organization began to surface when we established a mechanism (and a fund), easily accessible to anyone, that

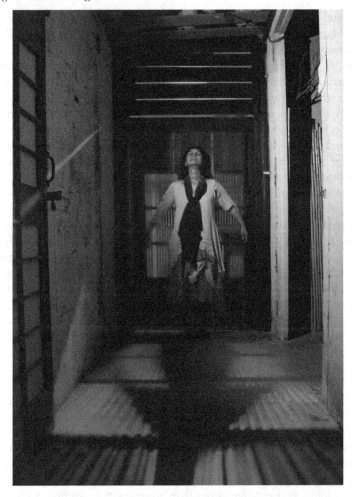

Figure 7.2 East West Players, world premiere of Rogue Artist Ensemble's *Kaidan Project: Walls Grow Thin* – produced in association with East West Players – an immersive theatrical experience inspired by Japanese ghost stories, with performances held in a secret, Mid-City warehouse, 2017. Photo of Randi Tahara by Chelsea Sutton

encouraged staff to try things out. Failure was an acceptable option as long as we could draw learning from the experiment. Innovation as a core institutional practice helped us find our way out of stagnation and into a dynamic future.

Another necessity for a sustainable organization is a deep and real commitment to diversity: diversity of thought and perspective as well as diversity of gender, race, ethnicity and age among the people working at and governing the organization. This seems self-evident, but it is more rare among arts organizations than we might wish it were. One particularly pervasive obstacle to creating organizational diversity is that in seeking people for our Boards and staffs who are committed to our Vision, we often wind up with people who look and think exactly the way we do. With an organization-based Vision as many arts organizations have of, for example, "creat[ing] a world-class contemporary dance company," we narrow rather than expand or diversify our choices for

potential participants in our work. If our Vision is both more expansive and externally focused – "to create a healthy community through the movement work we create and produce" – a much wider range of people can become involved in and committed to making that happen.

Such a Vision also means we need a wider range of skills, not just people who know (or think they know) how a "world-class contemporary dance company" needs to be built and sustained, but people within the community who fully understand the community, its needs and desires and think about potential strategies of meeting those needs. These individuals may not initially envision dance, or any art form, as a methodology for creating community. But they may be happily surprised when they see its power to connect diverse communities through movement. In turn, they may have ideas of other innovative methods for creating community that can be incorporated into the organization's artistic work. Long before it was popular, Liz Lerman understood this and was doing it through her multi-generational dance company. Virtuosity was not limited to young, lithe, attractive dancing bodies but centered in the dancer's ability to express ideas and emotions through movement in ways that connected with a similarly multi-generational community. Diversity as a concept can only be truly effectively addressed from a values framework in which every organizational decision is assessed for its ability to contribute to the diversity of participants and diverse points of view. When diversity is built into the DNA of the organization this way, it makes weak organizations strong and vulnerable ones resilient.

Actualizing commitments to experimentation, innovation and diversity are vital to creating sustainability, but they can only work in an environment of trust and empowerment, another characteristic of a sustainable arts organization and one of the hardest to achieve. Relatively early on in my tenure at YBCA I became deeply frustrated with my senior staff team and what I perceived to be our dysfunctionality; our inability to work together as a team. Empowerment came relatively easily; trust not so much. We had to go through a number of different events and even crises together before we could learn to trust that we could, and would, be there for each other. This was the case with every staff and team I have ever worked with. Through my own work, I realized that the arts themselves and artistic practice, particularly of ensemble based work, are more useful than any business book for establishing trust-based environments.

One of my best experiences with understanding trust and empowerment, and one I would urge all arts leaders to try, was participating in an improvisational theatre company. If you "do improv" you know that the mantra is "Yes, and." This is high-wire acting: you enter the performing space with no script and no direction. You wait for what the other person throws at you to begin the story, and then you have to respond, "Yes, and ..." adding to what has begun. In improv, you have to trust that the group will support you so that you can take the story in whatever direction you wish. Similarly, you are expected to provide that trust back to the group. Together, you can create something wonderful and inventive. When the exercise begins, as it often does, with characters, words or ideas spontaneously tossed to the group by the audience, the resulting performance is also responsive to the external environment. Becoming familiar with how improvisational action feels and what it demands of you can provide a model for the type of opportunities you can create within your organization for building an atmosphere of trust.

As the leader, your role in building trust in the organization is particularly critical. We lead by example, making sure employees know they are trusted and in turn ensuring that employees know that as leaders we can be counted on to "do the right thing." Ethical

leadership at the top sets a baseline for trust to which everyone associated with the organization strives. Ethical leadership also helps insure that the rest of the organization actualizes the organization's commitment to honesty and integrity, words that no doubt appear in your Core Values.

Like diversity, empowerment is a word that is so overused that it can lose real meaning, but it is still a critical component of building trust. Hierarchical organizations that operate with a structure and system of working that requires multiple levels of review and approval disempower individuals when they recognize that anyone "above" them can veto, slow down or alter their ideas or actions. If people know that they may be second-guessed or subjected to someone else's "20/20 hindsight" judgment, they become cautious and indecisive, which undermines the environment of trust and innovation that are vital to a sustainable organization.

Although organizations and leaders may understand in theory that trust and empowerment are necessary for a sustainable organization, creating this atmosphere requires intentionality and consistency. Empowering a staff means accepting a degree of risk that someone within the organization will make a wrong move, even do something that may seem detrimental to the organization. But missteps are not always fatal if they are understood as part of the innovation process; the iterative process of trying, experimenting and learning. This kind of experimentation and innovative practice can only happen when staff are trusted and empowered.

A more concrete example of real empowerment, and its risks, is something I learned early on in my career: if you create a "task force" to solve a problem, you only really empower the group if you agree to accept and follow their recommendations, whatever they may turn out to be. If you establish a process that mandates review and approval by higher-ups, you have disempowered the group, communicating that you don't trust them enough to make the right decision for the organization. The result will be a stifling of trust and empowerment.

I began my career as a theater director, and there is no better training for leading an arts organization than directing an ensemble theater piece. With the script in front of you (Foundational Documents), you next assemble a successful creative team comprised of members with a diversity of backgrounds and points of view. The skillful director works with the team, in an atmosphere of mutual trust and respect, to coalesce these diverse points of view into a coherent whole. For performers, especially actors and dancers whose physical body is their instrument of expression, trust in themselves and in each other is what enables them to create and perform together. The same is true of the arts organization.

Finally, a sustainable organization requires an organic, responsive organizational structure and working methodology that enables forward progress to be made without being constrained by excessively rigid policies and procedures. What this looks like will vary from organization to organization depending on resources, mission and vision. Your job as the leader of the organization is to consider your Foundational Documents, sort through the possibilities available to you with your team and see what structures and strategies you can create that will work most effectively, for now. Some you may be able to borrow or adapt from other organizations. I've spent many years talking to and examining other organizations to find out what works for them and deciding if I can (or should) adapt their processes to my organization. But some you will have to create on your own for your particular organizational circumstance.

During my tenure at YBCA I went through two major staff "reorganizations" and several "tweakings" as circumstances changed. Had I stayed past my tenth year, another

major reorganization was forthcoming. The first one was to take a sprawling, diffuse and dysfunctional organization and redesign it to create order out of chaos. So many individual fiefdoms had been built that there was no accountability and an extraordinary waste of resources to accomplish the work. When I realized that the Development team of five people was bringing in about $1 million per year, one of several such "underperforming" areas, the need for change was stark. That reorganization meant cutting almost a third of the staff. But it also became the baseline from which we would rebuild the organization.

A few years later I realized we were better organized but still operating in our silos, "next" to each other but not really "with" each other. I subsequently led us through a collaborative planning process that reorganized our functional areas into areas of strategic priority: program development, revenue development, operational concerns and community connection and appointed team leaders to guide the work in each priority area. This was better, but by preserving the departmental areas we also preserved the structures and hierarchies that were in place, so while people did actually work together better and more organically, issues of power and control remained challenging. Friction ensued about "who was in charge" and whose voice was most important.

Then came the crash of 2009 and we shifted into a more organic rubric of action and innovation, encouraging and allowing ideas to emanate from anywhere in the organization and to be vetted and prototyped by cross functional teams who had responsibility for implementation. Marketing ideas, program ideas, funding ideas could come from anyone anywhere and be considered, tried and assessed by the relevant teams, some of which were ad hoc in that they formed around the new idea that was being tested and not around the department. I saw some real value in this way of working, including empowering more staff to tap into their creativity and disruption of some of our traditional ways of working. For some staff this was a trying experience, especially older and more senior team members who had a great deal invested, personally and professionally, in sustaining pre-existing hierarchies. Before I left, I could see the next reorganization coming that would finally take apart the vertical structure, prioritize the cross functionality required for all of our work and complete the shift to a dynamic and horizontal way of working. No doubt this would be an experiment and how I imagined it might not be how it finally would appear. Nor would my initial idea be likely to have lasted as initially designed for very long. But that's the point of creating an adaptable organization; to allow and plan for organizational change to occur in response to the changing environment.

In each case of this organizational evolution, we did what was the best possible strategy for that moment. We could not have leapt from the organization in place when I arrived to the organization that was there when I left without organically working through the entire evolutionary process: learning as we went, responding to the external environment, building a wildly diverse staff, experimenting with new ideas; all focused on making progress towards our vision of "revolutionizing how the world engages with contemporary art and ideas." That revolution was internal as much as external. It was our ability to embrace each of these change opportunities that made us a sustainable organization at a time when many were falling by the wayside. In today's world we often hear about the need for organizations to be *nimble*; I think *flexible* might be a better word, and *adaptable* better still, for the image it creates of a dynamic entity that changes in response to evolving external and internal circumstances.

Returning to where I began this chapter, understanding our core purpose and recognizing the organization as an ecosystem that engages with other ecosystems defines the

sustainable organization. Adopting this paradigm means rethinking and reinventing strategies for organizational design and operation. It means finally letting go of the illusion that there is anything like a safe space, a fixed state to be achieved or a future that can be determined or managed through our careful planning. It means embracing the challenge, the risk, the excitement and the ambiguity that is at the heart of the creative process as the true foundation for our work as arts organization leaders.

A mentor once told me that a giraffe is the symbol of leadership, with its head in the clouds and its feet on the ground. To me, that fully describes a vision of arts leadership. I have spoken a good deal about getting our heads in the clouds. In the final chapter of the book, I will focus on keeping our feet on the ground and the work that we can and must do to achieve the ideals to which we all aspire.

8 Ideas into action

I began this book by looking at the external environment; the global trends that are occurring today and what the implications of this extraordinary degree of change are for today's performing arts organizations. I have noted throughout, my belief that the business-based model that has been the dominant approach for most performing arts organizations from at least the mid-20th century forward is no longer appropriate for this changed environment and will not serve us well for the future. In order to construct a new approach to how we do our work, I have suggested that we begin by revisiting what actually happens in the performance experience itself in order to re-establish what our core activity is and what its implications are for the greater society. It is on that basis, including the foundational idea that the performing arts are essential to life, that I suggested an ecological framework as a way of thinking about organizational design and methodology. Making this change in approach begins by establishing the organization's Foundational Documents so as to define very specifically why the organization exists and within what context it operates. I next noted some key principles required for the creation of a resilient, sustainable organization.

In this final chapter, I want to set out some specific strategies for taking the ideas and principles that I have established thus far and applying them to your work. By integrating ideas from ecological thinking, the creative process and even the business world, (albeit some more contemporary and alternative ideas than the ones that have dominated the performing arts thus far) we can translate ideas into action and build the sustainable organizations that we want and need.

What follows are proposals and not prescriptions. They suggest specific actions that organizations and arts leaders can take if they are to progress within a new organizational framework and in the context of a changing world. Each arts leader and each arts organization will need to find its own way; will want to determine and describe Foundational Documents for its specific organization, examine and analyze the specifics of the external environment within which it exists and develop strategies for accomplishing the work of building a sustainable performing arts organization that is continuously making progress towards its Vision.

Begin by knowing what the conversation is

I've spoken throughout this book about the challenge of working in a constantly changing environment and it is important that we begin there. I noted in Chapter 1 some of those transformational social shifts and what the implications of these trends are for arts organizations. These are trends that have been happening for some time and seem likely

to continue for the foreseeable future. To that end, arts organizations and their leaders will find it vital to be fully engaged with and attuned to what is happening in the world around them. A systematic methodology for continuous environmental scanning (ES) is therefore a necessary strategy for performing arts organizations.

There are many ways to think about ES as both a concept and a process. In its simplest form, ES is simply a methodology for gathering as much information as possible about what's happening in the world. The goal is to get a continuous look at what is transpiring, from which you can then draw some assumptions about trends – what are the major external trends that are occurring, how are these trends affecting the world and how might they ultimately affect your organization? At its best, ES can provide a loosely defined determination of future directions, insuring that the organization is cognizant of what's happening in the external world and can be responsive to the changing environment. Given the amount of information that is available to us, and our relatively unfettered access to it, ES can seem like a daunting process. It's impossible to be completely comprehensive, to note absolutely everything that is occurring around us; but paying attention as much as you can to external events is necessary for your organization to become and remain externally focused.

ES is generally a three-step process. *The first step is simply to accumulate and document information about what is happening in the world.* This should be an ongoing process that is workable for you and the resources of your organization. Ideally it should involve multiple people with multiple perspectives. One approach that works is to form a standing ES Committee comprised of diverse representatives of Board, staff and other constituents tasked with gathering and accumulating information about what they see happening in the world. Since the volume of information to gather is potentially enormous, I suggest using a reporting matrix that has areas of inquiry along the vertical axis and scope along the horizontal axis as a way to catalog and categorize the information that you are collecting.

Deciding on areas of inquiry simply means defining broad areas of investigation in which the ES team will be looking for news about "what's happening." A common way of thinking about areas of inquiry is through the lenses of political, economic, sociocultural, technological and environmental events. I would add "the arts" to this as a way of noting events happening specifically in the arts field that are likely to have a more direct impact on your work. Below are suggestions for how you might think about these topics.

Political

What is the political climate right now and where does it seem to be going? Try to go beyond a simple right/left, conservative/liberal analysis and get at the nuances of what you see happening, especially in today's world which is politically fracturing and fragmenting in so many ways. Topics to consider are: political trends, housing, business development, employment, support for the arts, transportation, small business development, legal developments and regulation, partisanship, etc.

Economic

What is the state of the economy now and what do you see happening in relation to the future: the next six months, year or even longer? Are things generally on an upswing,

static or headed down? Is there a bubble? Do people know it and recognize it? Is there an impending economic catastrophe that is unacknowledged? How imminent is it? Consider employment, cost of living, diversification, regulation, recession/boom and other signs of economic activity.

Socio-cultural

What are the major social changes that are currently having an impact on our world? What do we see happening in relation to values, lifestyles and cultural communities, and how do they understand themselves in relation to the status quo? How are the country's demographics changing? How are our relationships to work changing, if they are? Areas of specific interest might include such topics as demographics, cultural communities, education, religion, media and other subjects that you think are relevant to consider in assessing the changes occurring in the socio-cultural landscape.

Technological

What trends in technology are having the most impact? Which ones seem like they will stick? How is technology intruding into places where it formerly was not? Are there present endeavors that seem doomed to extinction as technology grows? Are there new fields of endeavor emerging that seem as if they will have an impact? How are human relationships to technology changing? How widespread are technological developments? Consider connectivity and Internet access, mobile and application development, social media, e-commerce, reactions against technology, game changing innovations, etc.

Environmental

What are the latest trends in environmental awareness and action and what do they reveal to us about the world, resource development and sustenance, etc.? What new areas of renewable energy are emerging and what impact are they likely to have? What about water supply and usage, food production and distribution, air quality and pollution, fossil fuel development, innovative renewable energy strategies, energy consumption, climate change and global warming, political attitudes towards environmentalism, etc.

The arts

What is happening in the organized arts world, its constituents and its audiences? Are institutions growing, diminishing, surviving, dissolving? How are aesthetics shifting? What new art forms are emerging? How are audience tastes and desires evolving? What art forms are young people interested in? What institutions seem to be thriving and why?

The horizontal axis of scope is especially important as the impetus for your organization to consider its place in the larger world. For scope I suggest global, national, regional, community and organizational. I include organizational on this axis as a way to ensure connectivity of thinking between what's going on in your organization and what's happening outside of it. I prefer this to a separate "internal strengths and weaknesses" analysis that is common among many strategic planners because it more easily enables you to connect organizationally with the external world rather than viewing your organization as separate from the world and then trying to figure out points of intersection.

Table 8.1 Environmental Scanning Matrix

	GLOBAL	NATIONAL	REGIONAL	COMMUNITY	ORGANIZATIONAL
POLITICAL					
ECONOMIC					
SOCIO-CULTURAL					
TECHNOLOGICAL					
ENVIRONMENTAL					
THE ARTS					

Table 8.1 shows what this matrix would look like and you can begin to see how intersections between areas of inquiry and scope can create a multi-dimensional picture of what is happening in the world.

Once you have established the matrix that works for your organization, spend some time thinking about sources of information for your scanning. If you have formed a scanning committee then definitely use the sources that are a regular part of each individual's life. Here is where diversity of participation can really make a critical difference, as different people acquire their information about the world from different sources. Some people read newspapers and other print media; others rely exclusively on mass media or online content. Some people are expansive in their sources, looking at information nationally and globally. Others are very locally focused, depending on local media like community newsletters. All of this is useful information. Participation in the ES Committee is a rewarding assignment for Board members whose experience and interests may vary widely. It's also a rewarding assignment for those people who like to think expansively about the environment and the future and are not interested in micro-managing the organization.

Recording and reporting on the information you acquire is a key part of your information gathering. Here too, various strategies can work depending on you and your organization. Perhaps the committee meets quarterly to have a discussion, share what they are seeing and physically record their observations in the matrix format using wall charts or paper and pencil. Another strategy might be to create an online document of the matrix into which individuals can "dump" what they find, whenever they find it, and include the source. This can be efficient, though it can also run the risk of becoming a bit of a "data dump" of too much information. It also requires some compilation and organization, as there is likely to be overlaps and duplications. Devise a methodology that works best for you and your organization.

The second step of ES is to *assess the information acquired and synthesize it into the larger trends* that seem to be happening. One simple way of doing this is to look at the compiled information and assess:

1 *What seems not to be changing* – what trends seem to be holding steady for the time being? Perhaps the economy is in a moment of slow but steady growth; your normally moderate city council looks like it will remain moderate for the time being; there is little movement in and out of your city; demand for your art form remains steady.

2 *Are there patterns of change that you are beginning to see* – what are the clusters of related movements that seem to signal a growing or more important trend? What trends and issues might be early indicators of major changes ahead? House prices are rising and formerly stable neighborhoods are changing quickly all across the city. More and more companies are moving out of or into your community. Civil unrest is occurring across the globe. Nationalist movements are growing in strength in multiple continents. Restaurants and coffee shops are moving out of downtown and into the suburbs.
3 *What are the game changers* – what events and developments happening right now are going radically wrong and/or where are innovations and new developments going successfully? What trends are operating across sectors to create upheaval? Self-driving cars? Artificial intelligence? Renewable energy sources?
4 *Rate of change* – how quickly are breakthroughs happening, causing potentially immediate or perhaps more long-term impact for your organization?

Establish periodic (quarterly?) gatherings in which the whole group comes together to review their findings and do the synthesizing. Remember, your work here is not to predict the future, but to characterize the landscape of issues that seem likely to have an impact on the work of your organization. As the organization's leader you should be there to listen and participate in the conversation and see what you learn from the varied people you have recruited to be part of this process. View it as a quarterly professional development activity that helps shape your own thinking about the external world.

The third step in the process is to *synthesize your relevant trends with your organizational identity and purpose* as represented in your Foundational Documents. Based on who you are and what your ideal is, discuss how you are likely to be impacted by the trends you see occurring. This can be an important annual "Board/staff Retreat" focus that can enliven your organization and help guide your organizational development. Distinguish your findings as:

- Trends worth watching but not immediately affecting us
- Trends likely to affect us in the near to mid future
- Trends we need to deal with right now.

Getting consensus around this can be challenging and also a real opportunity for you to guide the synthesis process. Using all of your team management skills, strive for a rough consensus among the group about which trends fall into which categories of urgency. Also strive to be concrete but not rigid, to recognize that you are creating a fluid document that you will revisit and revise periodically based on your ongoing environmental scanning. This is also a good process for getting people to become more comfortable with uncertainty and ambiguity as you look ahead at what seems to be coming your way.

Engaging in conversation about the future also helps establish a collaborative sensibility of shared purpose and direction among the staff, Board and constituents of the organization. The more you talk, the more you get clarity about what you value and what you are striving towards, even if you disagree about how to get there. At the end of each of your quarterly ES Retreats you will have, as an organization, established a

shared vision of the external world and what its effect is likely to be on your organization as you move forward. From there you can move to developing strategies that lead to actions.

A final thought about environmental scanning: recognize that some people will approach the process of looking at the external world from an intuitive perspective and others from a more analytic perspective. Both approaches are of value, though they do sometimes conflict. An intuitive approach relies on individuals' perception of what they see happening; what they are "reading into" the information that they are looking at. They will report on the "feeling" they have that this emerging technology is going to be relevant and that social trend is going to upset everything. This human filtering is often dismissed as untrustworthy for not getting at "what's real" because it isn't backed up by "facts." My belief is that human participation means embracing intuition and recognizing that perception is integral to reality creation; intuitive ES is as vital and viable as the more data driven methodologies. And I have already expressed my belief that we over-rely on data to tell us what is going on.

Nonetheless, it is still beneficial to integrate or supplement the intuitive approach with an analytical approach in order to get at a more complete picture. Data can give you good information; what you do with that information, how you interpret it, is where you need to bring your intuitive selves into the conversation. In addition, at the trend analysis phase, you are making assumptions about future directions, so intuition based on signals – including data – can be quite relevant to your decision-making about what is happening in the world. It's important for ES to be an ongoing process so that you get an evolving sense of directional change in the world.

Employ strategic thinking, not strategic planning

With your Foundational Documents and your ES in hand, the next step is to decide on your general courses of action; where do we go from here? It's usually at this point that organizations create a strategic plan. However, in keeping with the idea of creating a resilient, adaptable and sustainable organization, I suggest an alternative: Strategic Thinking.

Strategic Thinking is a process and a Strategic Plan is a product. Strategic Thinking is dynamic, evolutionary and responsive to the changing environment. Strategic Planning is a linear, fixed document that establishes pre-determined outcomes and a step-by-step approach for arriving at them. The Strategic Plan loses value almost immediately after it is written, when reality intervenes and changing circumstances derail the predetermined course of action.

Strategic Thinking is a dynamic process that begins with taking the time to assess what you know (the Foundational Documents and the ES), and from there, sketch out future focused *Strategic Directions*; broad categories of action that will be integral to moving the organization forward towards your Vision. I generally locate them within four broad categories: Artistic Programming, Community Engagement, Revenue Generation and Infrastructure. You may want to add to these but I would simply caution against being over-determined in your thinking. Broad categories also enable you to keep your options for specific actions wide open which is what you want in a continuously changing environment. Reflecting on each particular area, again through a synthesis of the Foundational Documents and the ES, work with your team to establish where your primary focus needs to be in each area, in order to make forward progress.

Below are the Strategic Directions that we developed at YBCA that would guide us towards our Vision of "Revolutionizing how the world engages with contemporary art and ideas":

Artistic Programming: Creating and evolving a holistic, integrated approach to artistic programming that illuminates YBCA's commitment to exploring art and ideas in a social context.

Community Engagement: Developing a continuously growing and diversifying YBCA community of individuals who become increasingly more deeply engaged in art and ideas and comprise a core component of a culturally engaged citizenry.

Revenue Generation: Sustaining an adaptive business and financial model that focuses on resilience and renewable growth including the ongoing exploration and development of creative strategies for revenue generation.

Infrastructure: Establishing and nourishing a resilient infrastructure with an adaptive capacity built into it capable of responding to an ever-changing environment through ongoing innovation.

Notice how each of these begins with an action verb. This is a deliberate signal of the ongoing nature of what you are going to be doing, with no fixed end in sight. The descriptive sentence that follows signals a future orientation as well. Language is crucial at this stage because you will refer back to these statements often and you want to insure that your intent to make ongoing forward progress towards your Vision is the driving idea behind your strategies.

Having established a Strategic Direction for each area, the next step is to develop the specific *Strategic Initiatives* in each area that you want to pursue starting now and continuing for the immediate future. Here's where the rubber meets the road about what exactly you are doing to make progress in the selected area. Consider the following in stating each Strategic Direction:

1 *Sustaining*: What are we currently doing? Should we continue in this way or do we need to stop? This type of periodic assessment of your current work is always of value, especially in developing strategy. For example:

 Our individual giving plan is working just fine, we are making progress, the environment is not showing signs of dramatic change, so we need to keep doing it as we are.

 Our corporate sponsorship plan is adrift; we are spending way too much time and energy on it. Besides, corporations are leaving our city so the opportunities are fewer. Let's drop it for now.

2 *Advancing*: What initiatives might we consider that would build on our current ones and will advance us towards our Vision, extending, enhancing, growing or diversifying what we are currently doing and create a greater impact?

 Our school programs are loved and appreciated and funded by the school district so we will keep doing them. But we also note more and more children in poverty are entering the school system due to our city's economic downturn. We should modify what we are doing to accommodate this change. We also will explore extending the program to private schools and the home schooled population.

98 *Ideas into action*

> *Our membership program is a success but we think if we tweak it or redesign it to be more user-friendly, our return will be greater.*

3 *Innovating:* What new ideas and strategies can we try that would take us in a different direction but could also have the potential to dramatically improve our progress towards the Vision?

> *Our ballet performances have always been in the high school auditorium. What if we launched an outdoor performance event at the county fair? What if we incorporated the parents of local children into the performance so they can have shared experience with their kids?*

> *Our community is wracked with a drug addiction problem. What dance programs can we imagine that would enable us to become part of the communitywide focus on addressing this issue, something we have never done before but we think will integrate us more deeply into the community?*

4 *Evaluating:* What are our metrics of success? This is less of a specific initiative in each area than a way to keep us focused on the results we are creating based on our work. How will we know that what we are doing is accomplishing our goals and helping us make progress towards our Vision? We need this information so that we can change and adapt our work as we go.

> *Have we spoken with the parents about the impact of the programs on their children? Can we find out from them what might be working, what isn't working and how we might improve?*

> *What return are we getting on our new membership program? Should we continue as is or should we rethink it? And what's happening that is causing us to think that?*

Strategy is a necessary guide to organizational movement. We have to think about how to turn our ideas into action in a way that coheres with the reality of the external world. Strategic Thinking allows us to do that without being "straitjacketed" by a Strategic Plan.

Finally, and perhaps most important, Strategic Thinking enables *Strategic Improvisation*. As we work towards making progress in each of our Strategic Directions, we are prepared to take advantage when opportunities arise, to move in new directions without worrying that we are diverging from "The Plan." We make sure that this ethos of adaptation filters throughout the entire staff so that all staff, at all levels, are supported in their efforts to be bold, that they are rewarded for taking risks and trying new strategies based on changing circumstance rather than doing things "by the book." If your staff understands the full scope of your organizational Vision and Strategic Directions they can fully inhabit their own role in ensuring forward progress for the organization.

Metrics

As I noted earlier, in today's world we have become obsessed with metrics. We, and the individuals and organizations that are supporting us, want to know if what our organization is doing is "working" or not. This is one reason why Evaluation is included as a

Strategic Initiative to be pursued and a key part of each Strategic Direction. However, establishing metrics of progress and accomplishment for each Strategic Direction is more complicated than usual if you are to move away from a data-based approach into something more meaningful. How this is structured will also vary from organization to organization.

At YBCA we used multiple evaluative criteria and they were different for each Strategic Direction. In the area of Artistic Programming, usually the most challenging one in which to establish metrics, we established a five-point assessment that included:

Audience response: we talked to people after the performance and gauged what they thought of the performance
Artist response: we asked the artists to assess the experience in its totality for them
Critical response: if critics wrote about the performance what did they say?
Curatorial response: what was the assessment of the responsible curator of the performance?
Data: how many people attended and how much revenue did we generate through sales and/or contributions with this performance?

Using all these different sources of information, we then had a conversation among the relevant staff, curatorial as well as support staff, to discuss the pros and cons of the event itself and from that we were able to make an overall assessment, noting both positive and negative effects without reducing a performance evaluation to either just the numbers or the "thumbs up, thumbs down" reductive metric so common in our daily lives.

In other more concrete areas, revenue generation, for instance, we did remain firmly, but not completely, tethered to data. If, for example, an innovation was to try selling food and drink before performances and during the intermission, we were largely focused on the cost-benefit of doing this. But we did also factor in the "amenities" value of this activity; the fact that having food and drink available made the performance experience more pleasant for patrons. We would run this over a period of time – several months or even a year – and then make a specific assessment of whether we should continue based on both of these evaluative criteria.

Gathering metric data in and of itself can be challenging, and it too needs to be assessed for its cost-benefit. In other words, is it worth the resources it takes to gather this data (the surveys, the compilations, etc.) and, most importantly, will we actually use the information to change behavior? Assessment data only contributes value from how it is interpreted and how it is used by the organization to determine future direction. In too many cases, assessments of programs are made, discussions are held and we continue on the way we had planned, regardless of outcome.

"Pivot or persevere" is a relatively simple concept taken from the tech start-up field that has relevance for the performing arts in how we think about using assessment and metrics. Having reviewed the available data and metrics as we have designated them, holding a deliberate "pivot or persevere" conversation enables organizations to move assessment into an action frame by frankly and honestly addressing the question of whether this program and/or others like it should continue to be part of our work (persevere) or whether we should "pivot" and move in a different direction entirely. This is a particularly useful conversation to have about innovative programs but it is just as important for all programs in order that the organization doesn't continue to do things because "we always have."

The "pivot or persevere" conversation can occur at various times and in different formats depending on your organization and the project you are assessing. The important

issue is to actually be deliberate about the conversation and not let it slide because "we're just too busy" or "we all think it's a failure, let's just drop it and move on." However at least annually, it is a good practice to look at every aspect of your organization, the assessment and evaluations you have done of each, and make a conscious decision to continue on the strategic path you have established, or change course and move in a different direction. This can be a challenging conversation to have because we all have projects or programs that we love more than the results we are getting. It is also challenging because it can devolve into short term thinking ("we tried it once and it didn't work so let it go and move on") when, especially in the performing arts, programs and performance often need a longer period of time to evolve before reaching their potential. This is where the confluence of environmental scanning and the metrics you have devised can really help. It may be, for example, that this particular performance did well – or did not do well – due to a specific external circumstance: unexpected competition from other events, oversaturation of the market and one time external disruptions like a severe weather event are just a few examples of factors that can distort results and skew your thinking. A decision to "pivot or persevere" should bring all of these factors into account before a course of action is decided. This is also where your personal leadership really matters. In synthesizing all of the factors in front of you, many of which will be ambiguous or contradictory, a decision will ultimately need to be made to "pivot or persevere" and no amount of data will guarantee the "right" answer. You can only use your best judgment based on whatever knowledge and data you have, keeping in mind the ultimate aim of the organization. This is the "art" of leadership and is the next topic for us to consider in relation to creating a sustainable performing arts organization.

Reconsider how you think about leadership

In designing the Arts Leadership program at USC, I spent a year immersed in as much of the research and writing as I could find about the principles of leadership. As someone who came from the *practice* rather than the *study* of arts leadership, this was both frustrating and energizing. Frustrating because there are so many theories and ideas about leadership, many of them repetitive, overlapping or even contradictory. Trying to sort through and synthesize them all into a succinct prescription for extraordinary or even effective leadership is an enormous task and also runs the risk of adding to the plethora of "checklist leadership" advice: Seven tips, Six ideas, Five commandments, Four practices, Three Habits of ... effective leadership, strong leadership, good leadership, etc.

Rather than adding to the many leadership checklists, I suggest instead a methodology, an ongoing process, by which you can continuously reconsider the idea of arts leadership and develop your own unique approach to it. There are three parts to this process and like your organizational strategies they too are ongoing:

1 Engage in serious self-reflection; know and understand who you are, what your values are and what contribution you want to make to the larger conversation
2 Be a learner; integrate what you know and what you are experiencing every day such that you are in a continuous process of learning on behalf of yourself and your organization
3 Build and work in partnership with a dynamic team of co-collaborators who are committed to joining with you in advancing the conversation.

I deliberately use the word "conversation" – among ourselves, our communities, artists and the world – because I believe it is the most dynamic, ecological and artistic way to characterize the work of arts organizations. Conversation is more than just talk. It is knowing yourself, building relationships with others, engaging with ideas, points of view, perceptions, dreams and realities that challenge and explore the issues of our time and of all time. Arts organizations need to understand themselves as active participants in this ongoing cultural conversation; arts leaders need to use their tools and talents to insure that their organizations are vital participants in that conversation, always advancing it in meaningful ways.

Engage in serious self-reflection

It's something of a cliché but also true that leadership begins with you. Unless you have spent significant time trying to understand who you are, what you want from your life, what your own core values are, what brings you joy, satisfaction and meaning, where you think you are headed – what your own personal Vision is – you cannot begin to lead others. You must do the hard, ongoing work of self-discovery and self-awareness. Start now if you haven't already and make this an ongoing practice.

There are dozens of avenues for self-exploration; find the one that works for you. The various leadership inventory tests like Meyer-Briggs Type Indicator® and others may be a place for you to begin if that appeals. Other arts leaders have moved beyond that initial assessment to a more activist approach that may be psychological or even spiritual in nature; a daily practice of meditation, for example. The key is to develop a heightened sense of self-awareness that evolves over time. We all change as we accumulate life experiences; sometimes our values and beliefs change along with our comfort with various strategies. It's important to be conscious of that evolution. People I meet now are surprised when I tell them that as a young adult I was quite shy, lacking in self-confidence and uncomfortable in social situations. Knowing this about myself, it took years of practice pushing myself out of my comfort zone to help me become more confident and at ease in social situations. This is now one of my leadership strengths, but it took continuous work to develop.

Knowing oneself means confronting and accepting those aspects of leadership practice with which you are less capable. I know that my strengths lie in vision and strategy; but I also know that once we get to the tactics I am far less capable. I need people on my team for whom this is their strength. Probably my most productive partnership was the work I did in my last few years at YBCA with our Managing Director, Scott Rowitz. Right from the beginning Scott made it clear that he was completely energized by and committed to doing what was required to make my Vision for YBCA a reality. When he told me this at the interview it sounded too good to be true. But in fact, from his first day on the job to the day I left, he was true to this commitment. He worked hard to find and enact the plans and details necessary to bring our ideas to life. The members of the staff who were frustrated with my inability to function at the tactical level were thrilled to at last have someone on board who spoke their language and understood their needs.

At the other end of the spectrum was our Director of Community Engagement, Joël Tan. Joël is the epitome of "out of the box" (sometimes out of the universe) thinking. If Scott challenged me to be realistic, Joël challenged me to be daring, to imagine and aspire to ideas that sometimes made me nervous. The most creative and innovative programs that came out of my time at YBCA emanated from Joël's fertile imagination.

Joël is a Filipino American who had extensive experience in doing AIDS education in communities of color before he came to YBCA; a fact that I sensed would make him an exceptional leader of our new Community Engagement Department. He did not come from the standard issue arts-education background at all, a decisive factor in my decision to hire him to join our team. I knew he had perspectives and ideas that I did not and that we as an organization needed. I hired for what I didn't have myself.

Working with Scott and Joël was never easy. We argued a lot and I spent a good deal of time mediating between them and various other staff who were frustrated with Scott's methodical nature or Joël's flights of fancy. Sometimes they even made me angry. But the energy that was created by our interaction together, and the rest of the team, was the lifeblood of YBCA. One of the best examples of this was when Joël suggested that we turn our opening night parties into happenings; performance events that lasted all night and were filled with experimental, often transgressive artists performing all over the building and all through the night. Scott, true to his nature, did not say no when the idea first surfaced, but he did point out to me the logistical and financial challenges this event would pose. Once we decided to go with it, he got to work organizing security, house management and even late night free rides home for staff who had to work after the public transportation had stopped operating. The result was a spectacular hit and boosted YBCA's community visibility in a significant way. The building was packed through most of the night and we entered the world of "hip place to be" in downtown San Francisco which had always been our desire but never our reality. This would never have happened had I not, as the Executive Director, had enough self awareness to know that I needed both of these people to actualize my Vision for the organization.

Strong arts leaders will spend a lifetime in self-reflection; drawing on their past, understanding their weaknesses as well as their strengths and compensating accordingly. Like the sustainable organizations we run, I think it's necessary for us as individuals to have our own Foundational Documents which include:

- *Vision*, our personal "ideal" to which we devote our lives
- *Core Values*, which guide our work and without which we would not be the person we aim to be
- *Mission*, how we intend to live and actualize our ideals
- *Artistic Intent*, the art that speaks most eloquently to us and our commitment to an ongoing engagement with that art
- *The Communities* within which we are embraced and with whom we wish to be and work.

As a young adult, I committed to a Vision: a lifetime of work that would somehow make a meaningful difference in the world. I am still defined and driven by a passion for social justice and equity and enabling that through the work I do as an arts leader. That commitment has sustained me and guided my work and life choices. Early in my career, I considered leaving the arts for something more directly impactful, a career in human services for example. Ultimately, I realized that my passion for the arts would be the avenue by which I could strive for social change.

Self-awareness also means recognizing the advantages you have that you can bring to your work. I had several advantages that some of my colleagues did not have, including an advanced degree, an unshakeable work ethic handed down to me by my hard working parents and extensive access to knowledge and education. But I also wrestled

with disadvantages that slowed my progress including coming from a working class background that often made me an interloper in areas of moneyed society where I struggled to find my footing. I made life choices that guided my work forwards towards my personal Vision, seeking and (fortunately) often finding job opportunities that cohered with that Vision.

In every position I considered, I needed to insure that there was coherence between my personal Vision and the organizational Vision. If there wasn't, I would not be able to succeed there. This too is an idea that I stress to all arts leaders with whom I work. In every organization I have led, I worked to diversify and contemporize artistic programs, to become more of a community partner, to give voice to the voiceless whenever I could in the context of a system that made revenue generation a never-ending task. In every case too, the organization had to become sustainable both artistically and financially, a core value of mine in life and in work. I learned to say no to opportunities that did not cohere with my core values and personal Vision.

I also realized that it was important for my employers, my organization, my staff, and my community to know what those core values were, because they would invariably guide my judgments and decision-making. And I learned very early on the importance of knowing and operating according to my own integrity, that the price for violating my core values was rarely worth it. If I agreed for example, as I occasionally did, that we would we take on a Board member whose money was substantial but whose vision was not in synch with the organization, or if I hired a staff member who had the direct experience but was not in alignment with organizational values, trouble would occur and usually quickly. I learned that adherence to my values and the organizational values had to underlie every decision I made. It is time well spent for arts leaders to think about and establish their personal Foundational Documents, revisiting them from time to time as you yourself grow and change.

Become a learner

Serious self-reflection only has value if it is coupled with an understanding of yourself as a continuously learning leader whose education never ends. That education comes in many forms.

I have read many leadership books but two that had particular influence on me are *Leadership Jazz* by Max DePree and *Authentic Leadership; Courage in Action* by Robert Terry. The overarching concept in DePree's book of organizational leadership being akin to a jazz ensemble really resonated with me as an arts leader who wanted to avoid the seemingly inevitable sports and military metaphors employed when talking about leadership, team building and organizational management. The chance to solo, to improvise and still be part of the larger organization, creating beautiful new music together, epitomizes for me what arts leadership is about.

Early in my career I was lucky enough to attend a leadership workshop with Bob Terry, the author of *Authentic Leadership; Courage in Action*, which completely reoriented my thinking about leadership. His emphasis on courage and authenticity and how vital it was to ground your personal leadership practice in these core values resonated with me very early on in my career. I continue to at least scan the ever-growing field of leadership studies not only to seek affirmation of my own values and beliefs about arts leadership but also to seek new insights and inspirations.

I can only begin to recount the numbers of performing artists whose exemplary work taught me to think differently about what leadership means. I was especially inspired by

artists whose work went against the grain of customary practice: people like Bill T. Jones who, throughout his career, has been pushing the boundaries of accepted and acceptable practice. Similarly, gay performance artist Tim Miller was an early inspiration for fearlessness in the face of widespread hostility to who you are and what you believe. Liz Lerman exemplifies what it means to connect art and community in organic, meaningful ways that have had a lasting impact. Seeing her and her work in action confirmed my commitment to the idea that the arts were vital to a vibrant and healthy community. David Rousseve inspires me because he never stops exploring the boundaries of his own work and pushing himself past his limits. Arts leaders need that innovative spirit to thrive as well. Dan Froot has the courage to reinvent himself and the way he works after dozens of years of experience. The contemporary dance artists from Africa that I have noted previously, like Faustin Linyekula, Béatrice Kombe and Qudus Onekiku, showed me what persistence looks like as they work against what seems to me to be insurmountable odds to accomplish their work. All of these artists, and many more, have so much to teach us as arts leaders about pursuing our work in the face of adversity and challenge. They are driven to do their work by something far beyond the management concerns that often consume the time and thinking of arts leaders. I learned from them and other artists like them that having a compelling sense of purpose about my work would keep me going under the most challenging circumstances.

"Learning by doing" is a crucial aspect both of developing self-awareness and being a learner. I mentioned earlier how valuable improvisational theater was in helping me become an arts leader. Being a practicing artist, professional or not, can be an especially valuable experience of "learning by doing." Too often, as administrators, our work is excessively left brain focused as we work through the details of our organizational challenges. Working as an artist exercises our right brain, strengthening our intuition and creativity, valuable but often neglected tools that enhance our leadership capabilities. In many cases, leaders are called upon to make quick decisions with a limited amount of information. This is where intuition can really help if you are able to quickly intuit the parameters of the situation and know "in your gut" what is the right thing to do. Our reluctance to trust our intuition may well be because we simply have not had the chance to practice. Engaging in artistic activity gives you practice not just in creativity but intuition and a developing ability to know what is the right decision to make.

We also learn about leadership by confronting the fear of not knowing: not having models to copy, templates to fill in or best practices to follow. Understanding what it's like to "perform without a net" is a humbling and often profound way to strengthen your leadership. These are skills and abilities that can't always be taught in a leadership class but are inherent to artistic practice with its engagement, failure, incremental progress and "aha" moments of insight.

Two additional ways of creating leadership learning through human engagement are through mentors and coaches. The current mentor-mania is a bit unsettling in the way that it tries to reify what really needs to be an unforced and spontaneous process, one that evolves organically through your work, your associations and your insights. I encourage all arts leaders to be open to discovering people who are doing extraordinary work, however you define that and whatever field they are in. Once you find them, observe what they say, what they write, what they do. If you can, engage them in conversation about their leadership and how they accomplish their work. Test that against your own actions and beliefs. The more external influences you are able to admit

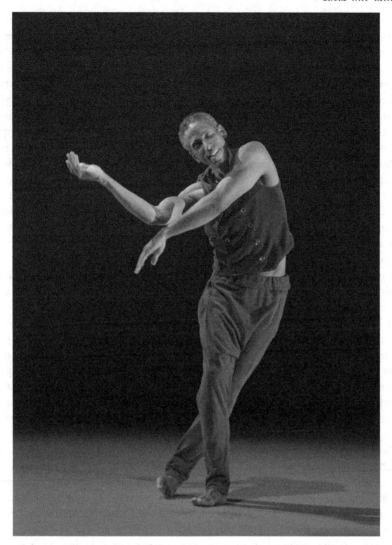

Figure 8.1 David Rousseve in "Stardust". Photo: Yi-Chun Wu

into your work – not just as a leader but also more generally on behalf of your organization and your own self-awareness – the better leader you can and will become.

Clearly learning from others, including other leaders, is an effective personal development tool. But I am also a bit skeptical of attaching oneself to a single mentor, primarily because of the complex nature of the world we live in and the need to have multiple sources of learning and mentoring. I am also skeptical of "senior leaders" who set out to instruct younger leaders in "the way things work." Too often I have seen this perpetuate both bad ideas and an entrenched system that needs disruption. Strategies that worked for me as a leader over the course of my career may be lessons that no longer apply and I wince when I hear senior leaders tell young people in the field the "tricks of the trade" from 30 years ago. It is true of course that not all senior leader/mentors take this approach. But it's a cautionary note nonetheless.

On the opposite side, I have had exceptional experiences with mentors younger and less experienced than me who provided me with fresh insights into how to lead in the contemporary world. I learned a tremendous amount by participating in two "Creative Change" retreats led by the Opportunity Agenda that brought together artists and activists from all over the country to share their work. In both cases I was one of the oldest people in the room, and also one of the few white people there. This was a revelation. I watched and listened as people much younger than me talked about how they created art and built community around art, social issues and issues of equity and fairness both directly and through technology. By being a white minority in a room full of people of color I learned in a visceral way what it felt like to be on the outside looking in, to be politely indulged when I spoke, to know I was not part of the majority culture in that room. It certainly helped me change my own behavior when I returned to an environment in which I was the majority, affecting the way I spoke, the language I used and the culture I sought to create in my own organization. Far outside my comfort zone, I learned to better understand and work with the challenges and accomplishments of those whose life experience was quite unlike mine.

Executive coaches, if you can find the right one, can make you a much stronger leader. No doubt my thinking this way is because of an extraordinary experience I had with a coach at a time when, even after more than 20 years of arts leadership experience, I needed help. I was literally in a position of deciding whether I would – or could – continue in the position I had. I was overwhelmed with intractable personnel problems, hobbled by a skeptical Board and working within a hostile external environment. When my ability to deal with the work situation was beginning to seriously impact my personal life, I knew I needed to get help. I contacted a local arts service organization that specialized in professional development tools for arts leaders. They gave me a list of a few names to contact and I talked to 3–4 possible people. I found I connected best with Rich Snowdon, intuitively sensing that he could help me. Rich became the one person I could talk to honestly and explicitly about the challenges I was facing, my fears of failure and my efforts to manage the various and complex situations I was facing. Rich had been an accomplished organizational leader of a nonprofit social service organization and had the insights and specific guidance I so desperately needed so that I could find my way through what seemed like an impossible situation. Over time, I managed to turn around the organization and myself and went on to have an extraordinary experience there and achieve the success I wanted for the organization. Having Rich as my coach was key to that accomplishment.

Organizational leaders frequently have no one with whom they can share the intimate details of their leadership challenges. Certainly not staff or Board because too much is at stake in other ways with those relationships. Colleagues may be sympathetic but also friendly competitors, active in your ecosystem in ways that may make you unwilling to admit your fears and failings. Spouses/partners can only take so much of your work issues before they get tired of hearing about them. A good coach is fully on your side, able to hear your vulnerabilities and not betray your trust, with enough experience to help you find your way to potential solutions and help you discover specific and strategic solutions to your challenges.

Clearly, listening and learning is a key not only to your personal growth but also to excellent leadership at all levels. I noted earlier that I was initially quite shy. In a group situation, I was never the first to speak. I learned to listen intently to everyone else first; especially those who feel compelled to be the first to speak. While listening I kept an

open mind and tried to see if I could synthesize different points of view and see the larger picture. Only then did I venture to comment. Little did I realize that this was a key leadership attribute that would serve me well as my career advanced.

People tend to talk more than listen, and in discussions will often seek validation for their point of view; aligning themselves with those who think like them. This groupthink can be damaging for the organization, which is yet another reason to ensure that you are working with a diverse staff of strong people, unafraid to express their point view. Effective leadership requires you to be open to hearing and acknowledging all of these contrary points of view and finding the points of consensus. Not only will this lead to better decision-making but others will begin to look to you for this very rare leadership skill. I have found this to be true in every staff I have ever managed; my most crucial leadership ability was to be able to listen, hear alternatives and synthesize points of view into a workable solution. This is a skill that takes practice; and a strong sense of both self-awareness and sensitivity to those with whom you are working. Which leads me to the third key to effective arts leadership: building your team.

Build and work in partnership with a dynamic team of co-collaborators

Leadership only *begins* with you. The real work is with the people you can get to join you. I mentioned the key roles that Scott and Joël played in my success at YBCA but they were far from the only ones who were part of a dynamic team. I am always both amused and a little disheartened when I hear arts leaders complain about "all the time I spend dealing with staff when I could be getting real work done." Working with staff and Board, donors, artists and community members and other sector leaders is your work; it is what it takes to "get things done." What could be more important than assembling, nurturing, guiding and coaching your team; leading a group of people to accomplish the work that you have collectively set out to accomplish? Every minute you spend with staff – hiring, orienting, evaluating, listening, problem solving, scolding and even sometimes firing – is time well spent. These are the keys to your organization's ability to make progress towards your vision. My suggestion is that you spend more time, not less, with your staff and never stop seeking, finding and learning better ways to lead them.

Empowering people to be their best possible selves is vital to building a successful team and begins when you get out of the way. Ensure that your staff fully grasp the intentions embedded in the Foundational Documents of the organization, are completely in alignment with them and then you make it possible for them to find their own way forward within that framework. You can also create deliberate strategies of empowerment. This starts with being able to see potential in staff even when they don't, and providing growth opportunities even when they may be hesitant to take them on.

I once had an Executive Assistant who was firmly kept in her place by the previous director. When I came on board and realized that she aspired to do more, I opened the way for her to do so. At the time, we had no development staff and although she had no direct experience with development as a practice, I nonetheless suggested to her that she explore possible development strategies related to individual giving and sponsorships, an area in which she had expressed interest. She took this task on with enthusiasm, and I got out of the way. Eventually she grew out of the Executive Assistant position and moved on to work very successfully in development.

There are two structural impediments to empowering staff – job descriptions and performance appraisals – and I urge you to abandon them. Job descriptions are the

concrete delineation of what your limits are. By their very nature, they hold people back. Too many times over the past 30 years of working with staff, I have seen work within the organization come to a halt, if not be fully subverted, because someone dared to color outside the lines of their job description. This deviation from the prescribed job limits causes "a problem" for someone else, often revealing deep personal insecurities as well as an excessive desire to protect turf. Order is preserved we believe, when we know what the rules and boundaries are and everyone stays within them. That philosophy both implicitly and explicitly ensures that an organization, while orderly, is going to struggle with the flexibility, innovation and adaptability that is required to achieve sustainability.

I had an interesting revelation about this some years ago on a trip to Cuba with a group of colleagues, during which we visited several contemporary dance companies. We were uniformly impressed with the talent and ability of the dancers who clearly had extraordinary training. But we were disappointed in the choreography, which seemed mundane and even banal. I found this very curious and disheartening. Later in the trip, we met with government officials and asked them about the reconciliation of creative activity with the controlling governmental system. Their response was, "Within the revolution, everything. Outside the revolution, nothing." That idea helped explain the lack of imagination we saw in much of the choreography. It also mirrors the usual organizational thinking embodied in job descriptions – within the job description everything, outside of it nothing – and it shows how job descriptions can be innovation and creativity killers.

For those who find the prospect of "no job descriptions" alarming, I suggest a loosely defined "job narrative." Use the story format for the employee to describe for themselves what they are doing, what they aspire to do, how they hope to grow, what values they bring to the organization and how they can use their energy and skills to make progress towards the organizational vision. Share these narratives widely within the organization. Engage in active, ongoing conversations about the expansiveness rather than the limits of what they describe; encourage them to revisit their narratives frequently in light of changing circumstances both for the employee and for the organization. Talk about the progress they are making to achieve their personal goals and visions, and the areas in which they could make further progress. Empowering employees means helping them determine with you what their needs are, what your organization's needs are and how those two can coincide. My experience has always been that people respond better and perform better when they understand themselves to be empowered to be full active participants in the organization and not just holding down a job, or meeting the limits of the job description.

Performance appraisals are another block to empowerment and adaptability and I am happy to say that I am not the first person to question their value to a dynamic organization. Performance appraisals infantilize employees and I have yet to see the payoff except perceived legal protection in the case of having to let someone go. From the defined goals to be met ("let's set a ceiling on what you can do") to the "report card" nature of them, they tend to bring out everyone's inner child and fear of failing or disappointing the parent/boss, a really unproductive paradigm to fall into for an organization that needs responsible adults in the room working together to experiment, grow and adapt to changing circumstances if it is to succeed.

Performance appraisals also tend to perversely work against building a team as individuals are too often punished or rewarded for their individual effort and rarely seen in the light of larger collaborative organizational objectives. Employees are subtly (or in the case of

things like bonus structures, not so subtly) encouraged to work on behalf of themselves first, while the organization as a whole can become something of an afterthought. Occasionally "effective teamwork" is one of the rating categories, but more often than not it is only a small piece of a larger individual appraisal. In this structure, we encourage employees to not only work to the job description but to also work to the performance appraisal. They know, or want to know, exactly what to do to get what they want (higher ratings equals higher raises and promotions) and can end up working for themselves rather than on behalf of the organizational vision. This is not "human nature," but learned behavior and it is not a value that contributes to either a collaborative team or to creating a sustainable organization.

The alternative to performance appraisals is open, transparent, ongoing conversation, at and across all levels with all employees: "How are we doing?" "How are you contributing?" "How can we all contribute more effectively to achieving our vision?" In a free-flowing conversation, you can replace judgment with collective assessment and even inspiration. Your aim as a leader is to get people to *want* to do better; because they will be personally fulfilled, because they are inspired to do so, because they are invested in the organization's development and success and not because it gets them a higher rating on their performance appraisal.

Of course, sometimes the organization will benefit if an employee leaves. I have faced this situation several times, and my strategy has always been to try to help the employee come to that realization on his or her own. That requires more than an annual performance appraisal; it requires ongoing conversation and reflection on the part of the employee, the leader and the organization. I view it as a success when an employee recognizes that a specific circumstance or the culture of the organization is a poor fit for who they are and what they want. A choreographer friend of mine related the difficulty she had with dancers who wanted to be told exactly what to do, versus dancers who wanted to engage with her in the creative process. No matter how exceptional the dancer was, if he or she could not contribute to the full development of the work, everyone would be better off if that particular dancer went elsewhere. This holds true for administrative activity as well. Arts leaders of sustainable organizations need people willing and able to engage in the ongoing organizational development and contribute to the work of striving towards the Vision of the organization.

Actively soliciting, considering and working through diverse points of view, especially about organizational direction and big picture decisions, is time-consuming and can be frustrating. But as a leader, doing this effectively and enthusiastically will lead to a stronger, more vital, more sustainable organization. My choreographer friend knew that the dancers who actively contributed to the development of the new work were crucial to her vision of what they were trying to accomplish. With their contributions, the work was better, stronger and more impactful than it would have been if they had simply taken instruction from her. But this approach also required her to take the time to actually consider their contributions. It required her to be willing to hear ideas that she may not like or may not find of value. The process of engaging in this collaborative way insures that people will continue to contribute, even if their ideas are not immediately accepted. This also requires a leader whose ego does not get in the way of accomplishment, who takes more pride in the group effort than the realization of his or her specified idea.

My coach Rich also taught me that when a situation arises that you finally do have to ask someone to leave, your objective should be for that person to see your releasing

them from the organization as a gift. Firing someone means that no more can be done together and that everyone involved – employee, leader and organization – need to be freed from each other. I was essentially fired from my first position at the Town Hall Arts Center (we mutually agreed that it was time for me to leave) when I had lost the confidence of most of the Board. It was scary and painful and I was unemployed for several months before I was able to find a new position. But it was also the boost I needed to break out of my limited view of who I was and what I could do and move on to greater challenges. It took some years for me to admit it, but that organization did me a favor by letting me know that it was time for us to part ways.

A common misperception about building a strong collaborative organization is the idea that turnover is bad for the organization, that it is costly, disruptive and results in the devastating loss of institutional memory, among other consequences. At one organization I led, the Human Resources Director was quite concerned about turnover. People were coming to us, staying for a year or two and then moving on. Through her Human Resource lens, she viewed this as an organizational problem. My belief, however, was that when we looked at our organization in light of the larger ecosystem, the reason many people left was most often because they had reached as far as they could go in our organization and wanted to move on to a more challenging environment. So they went to another arts organization, which provided them the chance to grow more than we could. Instead of seeing turnover as a problem, we should consider it as a success. It was clear that our role in the larger arts ecosystem was to create a baseline of experience and training for young people, who could then take it with them to other organizations where they could learn more, do more and make a greater impact. Nothing made me happier than knowing that an employee left us for a better position and that happened quire frequently.

Turnover creates new energy and vitality. It also allows organizations to evolve in a messier, more organic way. Even when I lost a highly valued staff member, I always knew that it was also an opportunity to inject new energy into the organization. That thinking also guided my hiring process as I went looking for someone who would bring that new energy and not simply be a replica of the person who left.

To me, staff turnover was always an opportunity more than a loss. But sometimes staff turnover is indeed symptomatic of deeper cultural problems that need to be addressed. It can also be a sign of poor hiring practices that get the wrong people "on the bus" in the first place. Your role as the leader is to be open to both of these possibilities, to honestly engage with the departing staff member as well as the remaining staff to try to get a nuanced feel for the situation and the reasons behind the staff departure. This does not mean taking the word of either a perpetually disgruntled staff member or the reassurance of your closest staff allies. Your job is to listen and synthesize, take in all of the feedback, then come to a conclusion that will guide your future hiring process and/or the culture that has merged within the organization.

As the organizational leader you also need to ensure that the big picture point of view – ecosystemic as well as organizational – is brought to bear on the planning and decision-making process. Other staff, focused as they are on the day-to-day work in front of them, may not always have the long view that you do and may not consider external, environmental factors and their implications for your organization. You are the key player in holding to the Vision; in preparing the organization to respond proactively to the opportunities that you see. By forecasting and imagining potential scenarios, you set the sights on which your team focuses its work.

One final important thought about team building which is also related to the core tenants of a sustainable organization is diversity and its role in creating a sustainable arts organization. Strong arts leaders embrace and welcome diversity in every sense of that word. They actively and aggressively promote diversity, especially in team building where it can literally make or break an organization. In the current environment, diversity and organizational coherence are too often seen as contradictory rather than complementary. Hiring committees look for "fit" – the person who will most easily slide into the organizational culture that has been established. This is a danger zone. "Cultural fit" has been used as a reason to systematically exclude women and people of color from positions of leadership and authority for decades. The culture created by a mono-cultural staff can easily become self-referential, self-defining and even toxic. Building a team that is diverse in every sense of that word helps ensure a creative and energetic environment in which the arts can flourish. The senior management team I had at YBCA was extraordinarily diverse. Given our widely different backgrounds, histories, cultures, ways of working and modes of interaction, it was a challenging team to manage. But the energy that came from this group and the passion they brought to our work ensured that the organization would thrive.

Especially in hiring decisions, diversity only happens with intentionality. As the leader, you need to be vigilant about processes that are inclusive. Group decisions often tend towards the comfortable, and authentic diversity can sometimes be uncomfortable. Arts leaders cannot allow their organization to step away from that discomfort. Ensure that your hiring committees not only "cast the net widely" in recruiting, but also actively and specifically bring into the organization people who challenge them and make them a little uncomfortable. This was absolutely the case with Joël when I hired him against the wishes of most staff. I knew he had talents we needed but I also knew he would cause internal disruption. Hiring Joël meant that I would need to expend extra effort working with him and other staff to ensure he was supported to be able to do his best work. Over time, people began to see the value of his creativity to the organization and were able to adjust their working styles and expectations accordingly. He too grew and learned during his tenure there and adjusted to their working styles and expectations. The energy created by this dynamic of working together as a collaborative team, difficult as it often is, is the energy that drives a successful and creative organization.

For many arts organizations, correcting historic inequities and imbalances, especially around race, gender, sexual orientation and class, are important mandates, especially those that seek to connect with and become embedded in a changing community. Since arts organizations are culture creators, making reparations for historic inequities may also be in your core values (and probably should be). Structural inequities that have existed for generations within society and within arts organizations need to be acknowledged, deconstructed and rebuilt in equitable ways. Aggressive hiring decisions that address historic inequities and ensure a diverse workforce, program redesign that highlights work by artists who are redefining the "mainstream" and ongoing, focused efforts to communicate, connect and collaborate with formerly marginalized communities are strategies that arts organizations of today must take on if change is to occur. As the leader, your job is to set the tone, establish the Strategic Directions for the organization, live the values you espouse and the values of the organization and ensure that others join with you in doing so. In this way, you begin to assert the leadership and build the team that is required for a sustainable arts organization.

112 *Ideas into action*

Putting it all together

Foundational Documents, Environmental Scanning, Strategic Directions, Initiatives and Improvisation coupled with a renewed vision of your leadership; now you are engaging in the work that is required to build a sustainable arts organization. With this in mind, listed below are a few additional thoughts to consider as you go about remaking your organization for a changing world.

Rethink organizational operation

In the ten years that I was in San Francisco working at YBCA, from 2003 to 2013, I was surrounded by the energy, passion and creativity of the tech start-up world. At one point I was told there were more than 100 tech start-ups within a six-block radius of YBCA. Whether that was true or not, we were certainly immersed in that culture and it was hard not to be influenced and excited by being surrounded by so many (mostly young) people trying to make "the next best thing." Annoyed as I was at the way this sector had coopted the term "creatives" to mean "people who make cool stuff" I could also see how their work was analogous to performing arts organizations and what we strive to do. I began investigating how they work to see if it might be applicable to the arts.

Part of what drew me to looking at the tech sector was the recognition that whatever I thought of the "product" that these start-ups were creating, there were two core values that they share with the arts: they are interested in new ideas and they are interested in solving societal problems. Tech start-ups often talk about finding the "problem" that needs to be solved or the "pain" that needs to be relieved with an innovative, new product. The idea that our first challenge in creating an arts organization is to think about a societal problem to be solved or, in the context of an arts organization, a societal need to be fulfilled, is very much aligned with what our organizational Vision is or should be.

But another aspect of the start-up model that attracted me was its emphasis on moving quickly from idea to implementation through an iterative process of trying and learning and trying again, with a focus on the process itself which enables us to become a "learning organization." Essentially this idea is to do much less thinking and planning about what we are going to do ("analysis paralysis") and get right to the doing. This suits artists quite well. Most artists like to jump in and get working and see what happens, where that takes them, what they learn. They also tend to operate on a highly intuitive level and are impatient to wait for the "evidence" to come in before making change. By their very nature artists are "learning organizations" in the way that they keep growing and evolving and learning and developing their practice over time. Arts organizations need to be learning organizations as well.

In exploring various tech start-up ideas, I found a YouTube video by Ash Maurya called "Capture Your Business Model in 20 Minutes" (Maurya, 2013), which is based on Eric Ries' groundbreaking book, *The Lean Start-Up*. Watching the video and reading Ries' book convinced me that his approach to "creating your business model in 20 minutes" could be adapted to the work of an arts organization. The Lean Start-Up and models similar to it are, I was interested to discover, business-based adaptations of the creative process that artists have always used to create their work. Essentially they formalize a way of thinking and doing that establishes a framework for the arts

organization to behave as an artist: find the need, imagine a response, build it, evaluate, learn, try again.

Although the Lean Start-Up model is suitable for a start-up arts organization or even an innovation project within an established arts organization, many of us are running arts organizations that can be quite large and entrenched with settled ways of working. Our task – to transform our organizations to become more adaptable – is akin to but a somewhat different task from launching a start-up business. The Strategic Directions/ Strategic Thinking model that I described previously however is based on this same concept. In either case, an assessment or reassessment of processes and strategies that more closely cohere to an artistic or ecological paradigm are essential for building a sustainable arts organization.

Rethink the organization chart

I have executed several different staff reorganizations over the course of my career. Sometimes these were driven by financial considerations – we needed to "downsize" to meet the funding realities – but always they were also about creating an organizational design that cohered with our values systems in order to effectively accomplish the work. If you think about staffing and structure in that way, the opportunity for an innovative and still effective staffing structure emerges; one that is not centered around "departments" but is instead designed around your Strategic Directions and the human resources required to make progress in each of these areas. Looking at your Strategic Direction for artistic programming, for example, decide on a strategy for moving forward, then assemble staff who are equipped and empowered to execute the strategy. They will have specialized knowledge in specific areas (curatorial expertise, for example, or community engagement) but the focus of their work is to be on advancing the strategy not building the department.

Structuring staff and systems around strategy rather than departments, means finding people who are able and willing to work in multiple areas and with a diverse team of fellow professionals to make progress on the larger strategy. Someone with marketing expertise for example could well be positioned to work on both your community strategy and your revenue generation strategy. An operations person would be a vital part of the Artistic Programming team but also the Infrastructure Development team. The team's passion and loyalty, both individually and collectively, will be directed towards achieving progress within the Strategic Directions. Such an approach calls for a structure and strategy in which a designated team leader guides a diverse group of professionals towards making progress on the strategy. In place of reporting lines or supervisor accountability, there is a need for shared responsibility, horizontal communication, transparency and an unwavering commitment to the Strategic Directions. The most highly developed skills of creativity, cooperation, compromise, listening and group process are required for this approach to be a success.

For some staff this is a challenging way to work. From a generational perspective, Millennials are much more at ease with this approach to organizational design than Boomers who have invested most of their lives and careers in building expertise in a narrow niche and they generally want to stay in that niche. The challenge of arts leadership in this environment, the challenge to you, is to manage a workforce with this range of values systems and build a cohesive team. Thus, the ongoing work of managing people within the organization becomes a primary task.

Institutionalize innovation

Another high priority for the leader of a sustainable arts organization is to institutionalize innovation; to make it an institutional priority and embrace and encourage innovative thinking everywhere and at all levels. Creating a culture of innovation is based on your ability to create a culture of acceptable failure; to recognize that there will be dozens of failures for every success and that failure is not failure in the way we tend to think about it but rather is an experiment from which we can learn based on the results of what we tried. Institutionalizing innovation also means creating a process by which any staff member can advance an idea, test it out through a prototyping process, get feedback and then participate in a "pivot or persevere" conversation that establishes the next step. With such a process in place, "off the wall" ideas can be tried, failure can be an acceptable option and a collaborative approach should underlie it all. At YBCA this is precisely the approach we took and over time it began to pay off. No longer was Joël the only person spinning out new ways of achieving progress on our strategies; others came forward as well with ideas drawn from their experience and their unique perspectives within the organization. By now we all know that the front line staff usually have the best, most effective solutions to problems we are experiencing; that senior staff do not possess all of the wisdom or creativity that the organization needs.

One obstacle you may well encounter is the "expertise" issue. People who have spent years studying a particular aspect of the field, marketing, for example, or finance or development tend to have little patience with "amateurs," even coming from within their own organization. This is a particular problem in the artistic programming area because, of course, most everyone thinks they are an expert on "what people want to see" or "what programs we should do" and at some point curators simply do not want to hear what your opinion is unless your knowledge of the art or the art form matches theirs. This is an understandable response, but not a helpful one in that it prevents curators, or any "expert" within the organization, from receiving feedback from the most valuable source of information that you have, the "insider/outsider."

The insider/outsider is someone inside the organization but outside the specific area of expertise. They are likely to have extensive knowledge of the organization's history, purpose, practices and priorities and can often hold a perspective that the "expert," focused as they are on their specific niche, may not have. These people can be the greatest source of innovation because they have enough knowledge to suggest innovations that are grounded in the reality of the organization but extend beyond the confines of the specific niche. They need to be given room to express and share their ideas and not be immediately stifled by the person with the "expertise." Phrases like "that's not the way it's done in our field" or "we tried it that way once before and it didn't work" or "no one thinks that's a good idea" are always suspect and deserve to be vigorously challenged. An insider/outsider is often the one who can successfully make that challenge and often make a strong case for "let's try it and see what happens," which is all you need to get started.

Once you institutionalize innovation and staff begin to see the seriousness with which the organization takes and expects innovation you can unleash the power of creative thinking throughout the organization. The energy created within the organization through innovation will insure that you can keep making progress toward your Vision, sometimes in unexpected ways.

Strive for benevolent chaos

It is true that some people find it difficult to function in a disruptive or chaotic environment. On more than one occasions I have had staff say to me, "Can we please just stop all these new ideas for a while. There's too much going on!" This is an understandable point of view and you certainly don't want an environment in which people feel frightened or intimidated by what feels like a chaotic workplace. There are ways to mitigate this however; creating what I call an atmosphere of benevolent chaos that is built into the organizational structure. Regular check-ins about what's happening, diffusing difficult situations before they get out of hand, rewarding cooperation over competition, creating an atmosphere of fun and excitement all go a long way towards assuaging people's worries that the organization is out of control. Everyone should feel confident that we are all headed in the same direction and that productive progress is being made towards achieving our goal.

Continuously engage the community

As an arts organization your walls with the community need to be porous. You want to be focused outward, paying attention to and engaging continuously with the external community that you serve. Nothing bad will happen by letting the community be a part of your work; in fact the essential idea of a nonprofit organization is that you are providing a necessary service to the community that the business world can't or won't provide.

There are multiple ways this can happen, even beyond the "community advisory councils" that are endemic to many arts organizations or the volunteer Board of Directors (and their committees). If you have a facility, keep your doors open at all times. There is a theater company in Los Angeles, 24th Street Theater, which does that and people from the neighborhood do actually wander in. There is free coffee and water in the lobby; you can come in and watch rehearsals if you want. The staff are there and available to listen and engage with you, not because that's their "job" but because that is the ethos of the theater. Remember that the majority of your community feels you are *really lucky* to work in the arts – share your joy and passion about what you do with them. They are the reason for your work.

Creative curatorial thinking

Pity the poor curator. Years of study of and experience with an art form have made them experts in their field just as expertise has become devalued in favor of the "wisdom of the crowd;" gatekeepers no longer wanted. Everyone has an opinion, everyone's opinion is valuable and "the fact that you know more than I ever could about contemporary dance doesn't mean your opinion as the so-called expert is any more important than mine" is a prevailing ethos of our time. Especially in the arts, when we all think we know "quality" when we see it.

The counter to this however is that, in fact we all would welcome a bit of curatorial guidance from time to time. Curators can and do have an important role to play in the arts of today. Rather than their past position as arbiters of taste, successful curation today is a function of sifting and selecting, of reviewing possibilities and providing lightly guided pathways to understanding and appreciation for an audience that may otherwise

sink under the weight of choice. We need and want curators who can point us in directions that are of potential interest to us.

We especially need curators to help us connect with art and artists that we may not know and not because "they are great" or "new" or "cutting edge" or "legends in their time" but because who they are and what they do is really relevant to us and our lives. Serving that connective function as a curator is a challenging position to be in, but also immensely rewarding. It's not enough that you find exciting new artists; it matters even more when you can connect those artists to the individual, to the community and to the global discourse. Can there be a more exciting and important role for the curator?

Generate revenue from multiple sources

How much revenue you need and where you get it from are the twin challenges of arts leadership and, you will not be surprised to learn there is no one singular prescription for doing this. Young arts leaders ask me all the time, "What is the correct ratio of earned to contributed revenue?" My answer is that there is no answer to that question, despite the "more or less half and half" that seems to predominate. When I was at the University of Arizona as the performing arts presenter, we operated a well-respected, highly valued program with great artistic integrity that received 85 percent of its revenue from ticket sales. When I went to YBCA the percentages reversed and we received only 15 percent of our revenue from ticket sales. Both were successful organizational models that did exceptional work for their communities. But each revenue model was adapted to the circumstances of the community and the organization.

One precept I have always lived by is that the more strategies you develop for bringing in revenue, the more resilient your organization will be. This is both opportunistic and protective. It's protective because if you are overly reliant on one source, even a perceived stable source like city tax revenues, you are at graver risk of devastating impact if something happens to that source of revenue. It's opportunistic because if you are open to multiple sources, and if your revenue generation strategy team is focused on finding and exploiting new revenue sources, you may find many opportunities to change your revenue picture for the better. Once you let go of the set categories of ticket sales and donations and begin to imagine other possibilities, you will be surprised at what is possible.

At YBCA, we made significant revenue gains through theater rentals to tech companies for product presentations. We did a house raffle that made millions for our organization. Arguably, neither of these were "mission driven" activities, and we received much criticism from our colleagues because of that. But I reject out of hand the idea that all revenue-generating activity needs to be mission driven or else you are diverting resources from "what really matters." It's true that if unchecked, this attitude could lead to revenue generation becoming the organizational purpose rather than the programs themselves. Yet I have seldom seen that happen, and usually when it does it's under the guise of "expanding artistic focus" like pops programs, well-known but over produced plays and musicals, "warhorses" of the classical music world and big name celebrities that can come to dominate the programming construction because "we have to do something that makes money." I would prefer to run a house raffle or rent to a corporate party than bend my organization's artistic vision to suit what I think will "make money." Revenue generation absolutely needs to be managed. It is the air we need in order to breathe. But

it isn't and it can't be our reason for existence. Part of your leadership challenge is to make sure that never happens.

Leading an arts organization is like creating a work of art. You begin with an idea; you pursue that idea and see where it takes you. You know that your work is embedded in the pursuit of the idea. Sometimes you reach a point of conclusion, leave the project and move on to another. Other times the art stays with you for years and years, always creating challenges and opportunities, some of which you never imagined. Sometimes you are immensely satisfied with what you've accomplished. Other times you feel a nagging sense of incompletion or disappointment that you came close but never quite achieved what you intended. To the degree that you release your hold on the need to predetermine outcomes and embrace the creative possibilities inherent in innovative organizational design and operation, you are an arts leader.

Conclusion

On Tuesday November 8, 2016, like many Americans, I left work, drove home and turned on the television to watch what I thought quite certainly would be the election of the first U.S. woman president. We had twice elected a black American as President, something most of us thought would never happen in our lifetime. Now it seemed, another barrier was about to fall.

Also like most Americans, that evening I sat in front of the television and watched in horror as state after state fell to the most unqualified presidential candidate in history. It wasn't just that a Republican beat a Democrat; his election was a repudiation of the ideas and ideals that many of us thought we had affirmed with the previous elections; of the progress as an enlightened society that we thought we had been making. For many of us, it was a profoundly disturbing sign that in fact, we did not, as a country and a culture, hold at least some shared values of basic decency, respect, justice and equality. The election was not just a loss or a political setback in the long arc of history. It was a catastrophic undermining of what we had thought were our core values and a shock to our system like no other.

On the day following the election, still stunned by what had happened, I had to board a plane for Anchorage, Alaska where I was set to facilitate a strategic planning retreat with the Board and staff of the Anchorage Concert Association (ACA). Jason Hodges, the Executive Director of ACA had been one of the Leadership Fellows the previous summer in a program that I developed and ran in collaboration with APAP for mid-career leaders who want to re-examine the work of their organization, the context within which they were working and remake their organization in a changing environment. Jason, who had been the Executive Director at ACA for many years, was eager to take on this challenge. He was aware of the external changes occurring in his community and the world and he knew that ACA itself had to make change if they were to continue to be an organization serving the whole community. He asked me to help him work with his Board and staff to redirect the work of ACA.

On the day after this cataclysmic election, flying to Alaska to facilitate a planning retreat was one of the last things I wanted to do. But the commitment had been made and there was nothing to do but follow through. So off I went to Anchorage.

I arrived on Wednesday evening and was immediately taken to a house concert sponsored by ACA and featuring HAPA, a music duo from Hawaii with one member of European descent and the other Polynesian. Their wonderfully unique music blends

traditional Hawaiian music with modern rock and they are quite popular both in Maui where they live and work, and in Alaska (this was their second or third trip to Anchorage.) The setting for the concert was a beautifully designed house on the shore of a lake, well suited for such an event. I expected the usual "high-end-donor" event in which mostly white, wealthy folks would stand around with glasses of wine, chatting and casually listening to nice music. Imagine my surprise to discover a remarkably diverse group of people there, many of them young volunteers for ACA who worked day jobs as bank tellers and similar entry-level positions. Alaska is a magnet for people from all over the world, especially Asia, who come there to make a life for themselves and this was evident in the room. It is also home to Alaska Natives, indigenous people who had been there since long before it was "discovered" and native Alaskans, people of non-native descent who were born there; two completely different groups I was pointedly told at one stage. Right from the beginning, I felt that if there is a "real America" this is it.

The house concert that evening was remarkable. To a person, the people in the room were raw from the election results; not one was pleased with the outcome, and the music, although not at all "political" spoke to these deep feelings of loss and despair. But as music can, and often does, it also provided a bit of hope, sustenance and even joy as we, a disparate group of people brought together randomly and fleetingly for this one evening, shared a performance experience together. The sadness and despair that I had been feeling since early that morning lifted, and I realized again the power of the arts to transform. That evening, as I returned to my hotel room, I decided that being in Anchorage for this event on the day after this disastrous election, was probably the best thing that could ever have happened to me.

The following morning, we started the retreat with a "check-in;" a chance to go around the room and for each person to express "where they were" and how they were feeling at that moment. One by one people talked simply, eloquently and often passionately of their dashed hopes, of their deep personal despair, at the shame they felt for what had happened, their fear of what would come next. Tears were shed; hugs of sympathy and compassion were exchanged. By the time we got through everyone, we had become a cohesive group of people, bonded together and seeking a way forward for ourselves, for each other and for their community.

We moved on to a quick version of an ES and people talked a lot about the economy. Alaskans don't see themselves, as many of the rest of us do, as living in some far-flung outpost of civilization. Rather, they view themselves at the center of a global environment with extensive trade between the United States and (especially) Asia as the thread that connects them to the world and centering Anchorage in that world. What would happen, they worried, with the "anti-trade" and "anti-China" talk of the new President? Being a global hub, people were here from all over the world and they wanted, they needed, to live and work together. The Board very much saw one of their organization's functions as being a site of arts activity that brings people together and builds bridges among disparate cultures.

As we moved on to setting Strategic Directions, the commitment of this group of people to inclusivity, to being that place where multiple stories are told, multiple heritages celebrated, multiple points of view expressed, came out in the form of a redoubled effort to take on the task of community building in Anchorage; of directly addressing the urban issues familiar to all of us of alienation, poverty and sometimes violence, through the work of the ACA. In retrospect, it is probably not surprising that the response to this devastating election was a renewed commitment to fight against what seemed to be a

repudiation of the values that everyone in that room shared and that were enacted in their lives and work.

That evening I attended the public concert of HAPA. The audience of several hundred people was even more diverse than what I had experienced the night before at the house concert. Just from looking around the theater, it seemed clear that ACA was reaching a full spectrum of the people living in Anchorage. HAPA, being themselves a "mixed culture" ensemble, speaks to that in their music and reinforcing the commonalities and the synergies that occur when cultures come together. They were joined on stage at one point by a young, local hip-hop ensemble which simply added to the joy of inclusion and even optimism that was created in the concert hall. The concert concluded with people on their feet cheering, singing and dancing along with the music. It was a beautiful and humbling experience; one of those all too rare "this is why I do this work" experiences.

The next day, on the plane back to Los Angeles, I reflected on the whole visit and what it meant. I thought a lot about resilience. Maybe it has to do with being in Alaska, whose extremes of weather make ventures of any sort a challenge; that people there were used to struggling and would continue to do so no matter what external events came their way. I reflected too on the strength of diversity; the way in which I saw people of diverse backgrounds sharing arts experiences together; experiences designed to bring them together not drive them apart. I'm not under any illusion that Anchorage is a conflict free zone of love among cultures; I know there are challenges that can seem intractable in people's lives. But there was hope there as well, and optimism that they could work through their lives together.

What I especially thought about was how that hope was centered around art; around music, around a performance experience that was, in a remarkably simple way, transformative for these people at this time and this place. And although I was humbled by the experience, I also was reaffirmed in my belief that the work we do as arts leaders and arts organizations is meaningful, is profound and is vital to our civilization and our humanity. Our job, our mission, our passion as arts leaders must be to do everything we can to build the organizations we need to sustain this meaningful work for ourselves, our communities and the world.

Bibliography

Bauerlein, Mark and Grantham, Ellen (eds.) (2009)*National Endowment for the Arts: A History 1965–2008* [pdf],Washington, DC: National Endowment for the Arts. Available at https://permanent.access.gpo.gov/LPS113863/LPS113863/www.arts.gov/pub/nea-history-1965-2008.pdf (accessed 17 Nov. 2017)

Bellingham Chamber Chorale, Bellingham, WA (2017) http://bccsings.org/about-us/vision-mission-core-values (accessed 1 Dec. 2017)

Broadway Center for the Performing Arts (2017) http://www.broadwaycenter.org/about/vision-mission-values (accessed 1 Dec. 2017)

Carlson, Nicholas (2010, 5 Mar.) At last – the full story of how Facebook was founded, *Business Insider* [online]. Available at http://www.businessinsider.com/how-facebook-was-founded-2010-3?op=1/#-can-talk-about-that-after-i-get-all-the-basic-functionality-up-tomorrow-night-1 (accessed 17 Nov. 2017)

Carrington, Damian (2016, 29 Aug. 29) The Anthropocene epoch: scientists declare dawn of human-influenced age, *The Guardian* [online]. Available at https://www.theguardian.com/environment/2016/aug/29/declare-anthropocene-epoch-experts-urge-geological-congress-human-impact-earth (accessed 18 Nov. 2017)

Colby, Sandra L. and Ortman, Jennifer M. (2014) *Projections of the Size and Composition of the U.S. Population: 2014 to 2060, Current Population Reports* [pdf]. Washington, DC: U.S. Census Bureau, pp. 25–1143. Available at https://www.census.gov/content/dam/Census/library/publications/2015/demo/p25-1143.pdf (accessed 19 Nov. 2017)

Cornerstone Theater Company (2017) http://cornerstonetheater.org/about/history (accessed 1 Dec. 2017)

Curry Stone Design Prize (2014)http://currystonedesignprize.com/winners/studios-kabako (accessed 1 Dec. 2017)

DePree, Max (1992) *Leadership Jazz*. New York: Dell Publishing

East West Players (2017) Available at http://www.eastwestplayers.org/about-us (accessed 18 Nov. 2017)

Egan, Matt (2017) Record inequality: the top 1% controls 38.6% of America's wealth. Available at http://money.cnn.com/2017/09/27/news/economy/inequality-record-top-1-percent-wealth/index.html (accessed 18 Nov. 2017)

Emanuel, Rahm (2008, 19 Nov.) https://www.youtube.com/watch?v=_mzcbXi1Tkk (accessed 1 Dec. 2017)

Esthimer, Marissa (2014) Top 10 of 2014 – Issue #1: world confronts largest humanitarian crisis since WWII. Available at https://www.migrationpolicy.org/article/top-10-2014-issue-1-world-confronts-largest-humanitarian-crisis-wwii (accessed 19 Nov. 2017)

European Commission (2011) EU population older and more diverse – new demography report says (online). Available at http://ec.europa.eu/social/main.jsp?langId=en&catId=502&newsId=1007&furtherNews=yes (accessed 19 Nov. 2017)

Foster, Kenneth (2007) *Performing Arts Presenting; From Theory to Practice.* Washington: APAP

Froot, Dan (2017) Artist statement. Available at https://spark.adobe.com/page/vYQMyKqLuwsvh (accessed 2 Dec. 2017)

Fry, Richard (2015) *Millennials Surpass Gen-xers as the Largest Generation in U.S. Labor Force* [online]. Philadelphia, PA: Pew Research Center. Available at http://www.pewresearch.org/fact-tank/2015/05/11/millennials-surpass-gen-xers-as-the-largest-generation-in-u-s-labor-force/ft_15-05-11_millennialsde ned (accessed 18 Nov. 2017)

Fukuyama, Francis (1989) The end of history, *The National Interest* 16: 3–18.

Granberry, Michael (2017, 7 Sept.) Hurricane Harvey pummeled the Houston arts district, but like a fighter, its resilience remains, *Dallas Morning News.* Available at https://www.dallasnews.com/arts/arts/2017/09/07/hurricane-harvey-pummeled-houston-arts-district-like-fighter-resilience-remains (accessed 18 Nov. 2017)

Heart of LA (2017) Mission and values. Available at https://www.heartofla.org/mission-vision (accessed 17 Nov. 2017)

Isherwood, C. (2011, 3 Feb.) Theater talkback: what Rocco Landesman should speak about next, *New York Times.* Available at https://artsbeat.blogs.nytimes.com/2011/02/03/theater-talkback-what-rocco-landesman-should-speak-about-next (accessed 18 Nov. 2017)

Iyengar, Sunil (2015) *A Decade of Arts Engagement: Findings from the Survey of Public Participation in the Arts, 2002–2012* [pdf]. Washington, DC: National Endowment for the Arts. Available at https://www.arts.gov/sites/default/files/2012-sppa-feb2015.pdf (accessed 18 Nov. 2017)

Kaleidoscope Chamber Orchestra, Los Angeles, CA (2017) http://www.kco.la/about (accessed 1 Dec. 2017)

Kozinn, Allan (2012, 28 Dec.) Art insurance losses from Hurricane Sandy may reach $500 million, *New York Times.* Available at https://artsbeat.blogs.nytimes.com/2012/12/28/art-insurance-losses-from-hurricane-sandy-may-reach-500000-million/?_r=0 (accessed 18 Nov. 2017)

Kronos Performing Arts Association, San Francisco, CA (2017) http://www.kronosquartet.org/about (accessed 1 Dec. 2017)

Maurya, Ash (2013) Capture your business model in 20 minutes. https://www.youtube.com/watch?v=7o8uYdUaFR4 (accessed 1 Dec. 2017)

McDaniel, Nello and Thorn, George (1990) *The Workpapers One; Rethinking and Reconstructing the Arts Organization.* New York: FEDAPT

Midgette, Anne (2017, 30 June) The real motor of the performing arts isn't vision. It's the board, stupid, *Washington Post.* Available at www.washingtonpost.com/entertainment/music/the-real-motor-of-the-performing-arts-isnt-vision-its-the-board-stupid (accessed 18 Nov. 2017)

Morton, E. (2014) How an underground fire destroyed an entire town, *Slate* [online]. Available at http://www.slate.com/blogs/atlas_obscura/2014/06/04/centralia_a_town_in_pennsylvania_destroyed_by_a_mine_fire.html (accessed 18 Nov. 2017)

National Performance Network and Visual Artists Network (2017) https://npnweb.org/about/mission (accesssed 1 Dec. 2017)

Page, Larry (1998, 8 July) Google search engine: new features. Google Friends Mailing List. Archived from the original on 1999-10-09. Available at https://web.archive.org/web/19991009052012/http://www.egroups.com/group/google-friends/3.html (accessed 17 Nov. 2017)

QDanceCenter (2017) http://www.qdancecenter.com/who-we-are (accessed 1 Dec. 2017)

Ries, Eric (2011) *The Lean Startup.* New York: Crown Business

Sidford, Holly (2011) *Fusing Art and Social Change; High Impact Strategies for Philanthropy* [pdf]. Washington, DC:National Committee for Responsible Philanthropy. Available at http://www.giarts.org/article/fusing-arts-culture-and-social-change (accessed 18 Nov. 2017)

Terry, Robert W. (1993) *Authentic Leadership; Courage in Action.* New York, NY: Jossey-Bass Publishers. Chapters 12 and 13

United States Department of Agriculture (2016, Jan.) *Calculating the Supplemental Nutrition Assistance Program (SNAP) Program Access Index: A Step-by-Step Guide*. Washington: United States Department of Agriculture.

Walker, Brian and Salt, David (2006) *Resilience Thinking; Sustaining Ecosystems and People in a Changing World*. Washington, DC: Island Press

Wandemberg, J. C. (2015, Aug.). *Sustainable by Design*. ISBN 1516901789, wandemberg@msn.com

YBCA (2012). Document available from the author.

Index

Abidjan 52
activism 55
administrative structures supporting arts organizations 27
"aesthetic core" of an arts organization 74
African Contemporary Arts Consortium (TACAC) 50, 52
age-related differences 13–14
Alaska 117–19
alternative realities 48
analytic perspectives 96
Anchorage Concert Association (ACA) 117–19
Anthropocene era 17
Arab Spring 7, 21–2
Archer, Robyn 58
artist and audience, connection between 49
artistic creation 57, 62
artistic directors 8, 43, 63, 75
artistic excellence xiii
Artistic Intent 72–6, 80–1; definition of 74
Artistic Programming 96–7, 99
artistic values 72
artists' fees and salaries 43
artists' impact on the world 64
"Arts for all" concept 16, 23–4
arts organizations: core sense of purpose of xii; reasons for the existence of 64–6; use of the term xvii
arts world 93
assimilation 2, 13
Association of Performing Arts Presenters (APAP) 58, 74
audience analysis 35–6
audience development 26, 77
audience members, relation-ships established by 49

Baby Boomers 13–14, 113
balanced budgets 40–2
ballet 14–15, 72, 98
Beethoven, Ludwig van 48
Bellingham Chamber Chorale 70–1, 73–4, 81

"benevolent chaos" 115
Berlin Wall, fall of (1989) 20
"best practices" 37–45
"big picture" viewpoint 110
Black Lives Matter 21
Boards of Directors of arts organizations 42–3, 86, 115
"booking the work" 34
brain function, *left-side* and *right-side* 104
Brexit xi
Broadway Center for the Performing Arts 70
Brown, Willie ix
Buena Vista Social Club 23
business models xiii–xiv, 58–9, 63, 91, 112–13

capitalism xii–xiii, 20–1
Cekwana, Boyzie 50
"celebrities" 7
Centralia (Pennsylvania) 3
chamber music 7
"change for change's sake" 84–5
China xi, 20–1
classical art forms 13–15, 84; *see also* chamber music
climate change 4, 17–18, 22
Clinton, Hillary 14, 73, 117
Coddington, John 3
collaborative processes 7–8
color, people of 34–5, 106
commodification of the arts 16
"communities of the moment" 49
"community-based" artists 52, 55
Community Context 73, 76–81
Community Engagement 50–6, 77–8, 96–7, 115
Compagnie Tchétché 46–52
contemporary dance 7, 23, 46, 50, 52, 108
conversation 101, 109
core activities/purposes of arts organizations 89–91
Core Values 72–4, 81, 88, 103, 112
Cornerstone Theater Company 75, 82, 84

corporate business model xiii–xiv
Côte d'Ivoire 46–7, 52
Creative Change (gathering, 2010) 55
"creative placemaking" 80
critics, role of 8
cross-functional teams 89
crowdfunding and crowdsourcing 8, 40
Crumb, George 83
Cuba 23, 108
"cultural fit" 111
cultural icons 12
cultural identity 12
cultural traditions 50
cultural values 21
Cultures France 50
curators, role of 8, 114–16
Curry Stone Design Prize 52

Dance Exchange 35–6, 54
data, use (and over-use) of 36–7, 96, 99
demographic change 3, 10–18, 34, 45
DePree, Max 103
Desai, Snehal 61, 85
destabilization of cultures 3
devolution of institutions 23
"digital natives" 6
Dimi (African dance piece) 47–50
diversity and diversification 33–4, 86–7, 111
Domboski, Todd 3
"donor tyranny" 26
Dorfman, David 54
Dring, Lisa 85

East-West Players (EWP) 61–2, 85
economic situation 92–3
ecosystems 29–30, 45, 58–66, 84, 89–91, 110
education systems 23
electric vehicles 17
email 5
Emanuel, Rahm 31
Emerson String Quartet 49
empowerment 87–8, 107–8
endowment-building 41, 43
ensemble theatre 7
environmental change 4, 16–19, 22
environmental scanning (ES) 92–6, 100, 118
Escalante National Monument, Utah 57
ethical behavior 73, 87–8
European Union x–xi, 20
executive coaches 106
experts and expertise 114–15
external environment for arts organizations xv, xvii

Facebook 5
failure, learning from 114

firing people 110
flood damage 16–17
food insecurity 78
food production 18, 29
forests and forest fires 59–60
Foundational Documents 63, 66, 70, 73, 75, 91, 95, 107; personal 102–3; *see also* Artistic Intent; Community Context; Core Values; Mission; Vision
fracking 17
Froot, Dan 78–9, 104
Fukuyama, Francis 20
funding of arts organizations 16, 27, 65
fundraising events ix

Garces, Michael John 82
"gatekeepers", diminished power of 8, 115
Gehry, Frank 60
"Generation X" 13–14
Gicharu, Felix 51–2
globalization, definition of 21–3
governance models xiii
grant receipts xiii
grassroots arts organizations 17
Great Recession (2007–2009) x–xi, xiv–xv, 41, 62, 89
groupthink 107
growth, organizational 43–4

"Hallelujah Project" 54, 78
Hamilton (musical) 49
HAPA (music duo) 117–19
Harrington, David 83
Heart of Los Angeles 67
hiring decisions 111
historic inequities 111
Hodges, Jason 117
Houston 17
human response to art 37
Hurricane Harvey (2017) 17
Hurricane Sandy (2012) 17
hybrid culture 13

immigration and immigrants 2–3, 12
improvisational theater 87, 104
inequality, economic 15–16, 20
Infrastructure for the arts 27, 96–7
innovation, institutionalization of 14
"innovation teams" and "innovation ethos" 85–6
"insider/outsider" role 114
institutionality, redefinition of 25–6
internally displaced persons (IDPs) 11
Internet technology 4–8
intuition 96, 104, 112
Iowa City 16–17
Iyengar, Sunil 15

Japanese American Cultural and Community Center 61–2
job descriptions 107–8
Jones, Bill T. 52–4, 104

Kaleidoscope Chamber Orchestra 39, 70
Kaypro computers 5
Keyes, Bayla 48
Knerler, Dave 6
Kombe, Béatrice 47, 104
Kronos Performing Arts Association 82–4

Landesmann, Rocco xiv
The Last Supper at Uncle Tom's Cabin / The Promised Land 52–4
Latin America xi
leadership 87–90, 100–14, 117
Lean Start-Up model 112–13
learning: by doing 104; by listening 106; from failure 114; from other people 105
learning organizations 112
Lerman, Liz 35, 54, 78, 80, 87, 104
Linyekula, Faustin 9, 50, 52, 104
listening skills 106–7
"live" performance 1–2, 9, 50
"loosely-organized" works in progress 27–8
Los Angeles: concert venues 60; dance scene 44; LGBT Center 61–2; orchestras 60, 74–5; theater scene 82, 84, 115; *see also* Heart of Los Angeles

McDaniel, Nello 74
"mainstream" art and culture 13; redefinition of 34–5, 37
MALI Museum, Lima 57
market-based ideology xiii–xiv
marketing 76–7; four Ps of 76
mash-ups 28, 30
Maurya, Ash 112
mentors 104–6
metrics, use of 98–100
Metropolitan Opera 29
middle-class endeavors 16
Midgette, Anne 43
migration of people x, 2–3, 11–13
Migration Policy Institute 11
"Millennials" 13–14, 113
Miller, Tim 104
Mission 70–2, 81; making changes to 71–2
"mission creep" 71–2, 75
mission statements 65–6, 70
Muir String Quartet 48
multinational corporations 20–1

Nairobi 50–1
National Committee for Responsible Philanthropy 11

National Endowment for the Arts (NEA) xii–xiv, 15, 34
National Performance Network (NPN) 71
National Theater of Great Britain 29
Native Americans 57
neoliberal economics xiii, 16
network effects 7–8, 21
"nimble" organizations 27, 89
nonprofit organizations xii–xiii, 76, 115

Obama, Barack xi, 14, 117
Obama, Michelle 73
Occupy Wall Street 7, 21
Okach, Opiyo 50
Onekiku, Qudus 50, 52, 104
"openness" 8
opera 14–15
Opportunity Agenda 106
orchestras 39, 60, 71, 74–5
organic change 72
organization charts 113
organizational capacity xiii
Orman, Suze 27
Orpheus Chamber Orchestra 39
outreach programs 16, 77

"Pang!" project 78–9
"pay what you can" or "pay what you think it's worth" 39
paying for the arts 16
Penn State University 52
perceptions of individuals 96
The Perfect Storm (film) 18
performance appraisals 107–9
"performance experience", the 47–52, 91
Pimsler, Stuart 54
"Pivot or persevere" 99–100, 114
political climate 92
popular music concerts 15
program evaluation 37
purpose of an organization, the, sustaining of 44–5
pursuit of the ideal 62–5

QDance Center 52

rapport between artist and audience 29
Rauch, Bill 82
Reagan, Ronald xiii, 14
recessions 65; *see also* Great Recession
"reframing" 33–7
refugee flows 11–12
resilience, concept of 58, 62–5, 81, 116
revenue sources for arts organizations 96–7, 116–17; *see also* funding
"riding a wave" 27
Ries, Eric 112

risk-aversion 85
Robert's Rules of Order 38
Robey Theatre Company 61–2
Rogue Artists Ensemble 61–2, 85
Rousseve, David 54, 104–5
Rowitz, Scott 101–2, 107

Salt, David 58–9, 62
San Diego 2
San Francisco 80, 102, 112
security concerns x
self-knowledge 101–3
self-reflection 101
shared experiences 50
silos, organizational 59–60, 80
Sloan, Lenwood (Leni) 34
SMART goals 35–6
Snowdon, Rich 106, 109–10
social change 91–3, 102
social media 5–7, 18, 21–2
"soft power" 22
Southern Arizona AIDS Foundation 67
Soviet Union, collapse of (1991), 20
"start-up" organizations and businesses 31, 112–13
Still / Here 54
Strategic Directions / Strategic Thinking model 96–9, 111, 113
strategic plans 41–3, 96
struggling organizations 82
Studios Kabako 52
success, markers of 35, 37, 40, 98
sustainability xvi, 58, 62–5, 81–90, 111–12; definition of 62
Sutton, Chelsea 85
SWOT analysis 32–5

Tan, Joël 101–2, 107, 111, 114
task forces 88
team-building 107–11
technological change 5–9, 21–2, 93

Terry, Robert (Bob) 103
"thinking big" 70
Thorn, George 74
ticket prices 16, 77
touring performances 9
Town Hall Arts Center (THAC) 4–5, 31–3, 74, 76, 110 (Littleton, Colorado)
tribalism x
"trolling" 7
Trump, Donald xi, 17–18
trust-based environments 87–8
Tucson (Arizona) 67
turnover of staff, benefits from 110

"underserved" populations 77
United States xii, 21, 23, 52–3; Census Bureau 10–11
University of Arizona 35, 54, 78, 116
University of Southern California (USC) 64

values 72–3, 100; core and artistic 72; *personal* and *organizational* 103; *see also* Core Values
Virtual Reality (VR) 1, 9
Vision 82, 86–7, 91, 97–8, 109–14; as distinct from *goals* 66–71, 81; *personal* and organizational 102–3
"vision and values" statements 65–6
Visual Artists Network (VAN) 71

Walker, Brian 58–9, 62
Wandemberg, J.C. 62
Washington, Lula 75
Wheeler, Jed 35

Yerba Buena Center for the Arts (YBCA) ix–xi, xvii, 37, 60, 68–70, 75–6, 80–1, 85, 87–9, 97–102, 107, 111–16

zero-sum games 33
Zollar, Jawole Will Jo 54